The World of Cézanne

TIME
LIFE
BOOKS ®

*This volume is one of a series that surveys Western painting and
sculpture from the end of the Middle Ages to the present.*

TIME-LIFE LIBRARY OF ART

The World of Cézanne

1839 - 1906

by Richard W. Murphy
and
the Editors of TIME-LIFE BOOKS

TIME-LIFE BOOKS, Alexandria, Virginia

Time-Life Books Inc.
is a wholly owned subsidiary of
TIME INCORPORATED

FOUNDER: Henry R. Luce 1898-1967

Editor-in-Chief: Henry Anatole Grunwald
President: J. Richard Munro
Chairman of the Board: Ralph P. Davidson
Executive Vice President: Clifford J. Grum
Chairman, Executive Committee: James R. Shepley
Editorial Director: Ralph Graves
Group Vice President, Books: Joan D. Manley
Vice Chairman: Arthur Temple

TIME-LIFE BOOKS INC.
MANAGING EDITOR: Jerry Korn
Text Director: George Constable
Board of Editors: Dale M. Brown, George G. Daniels,
Thomas H. Flaherty Jr., Martin Mann, Philip W.
Payne, Gerry Schremp, Gerald Simons
Planning Director: Edward Brash
Art Director: Tom Suzuki
 Assistant: Arnold C. Holeywell
Director of Administration: David L. Harrison
Director of Operations: Gennaro C. Esposito
Director of Research: Carolyn L. Sackett
 Assistant: Phyllis K. Wise
Director of Photography: Dolores A. Littles

CHAIRMAN: John D. McSweeney
President: Carl G. Jaeger
Executive Vice Presidents: John Steven Maxwell,
David J. Walsh
Vice Presidents: George Artandi, Stephen L. Bair,
Peter G. Barnes, Nicholas Benton, John L. Canova,
Beatrice T. Dobie, Carol Flaumenhaft, James L.
Mercer, Herbert Sorkin, Paul R. Stewart

TIME-LIFE LIBRARY OF ART
EDITOR: Robert Morton
Associate Editor: Diana Hirsh
Editorial Staff for *The World of Cézanne:*
Text Editor: Harvey B. Loomis
Picture Editor: Kathleen Shortall
Designer: Paul Jensen
Assistant Designer: Leonard Wolfe
Staff Writers: Marianna Kastner, James MaHood,
Carolyn Tasker, Bryce Walker
Chief Researcher: Martha T. Goolrick
Researchers: Gail Hansberry, Patricia Maye,
Ann McLeod, Rosemary O'Connell
Copy Coordinators: Muriel Clarke, Laurie LaMartine
Art Assistant: Nancy Earle
Picture Coordinator: Barbara S. Simon

EDITORIAL OPERATIONS
Production Director: Feliciano Madrid
 Assistants: Peter A. Inchauteguiz,
 Karen A. Meyerson
Copy Processing: Gordon E. Buck
Quality Control Director: Robert L. Young
 Assistant: James J. Cox
 Associates: Daniel J. McSweeney, Michael G. Wight
Art Coordinator: Anne B. Landry
Copy Room Director: Susan B. Galloway
 Assistants: Celia Beattie, Ricki Tarlow

For information about any Time-Life book,
please write:
Reader Information
Time-Life Books
541 North Fairbanks Court
Chicago, Illinois 60611

About the Author

Richard W. Murphy was born and raised in New York City. After graduating from Yale, he studied English literature at Columbia University and at the University of London. He is a former music editor of TIME. While writing this book, Mr. Murphy lived in Paris and in Cézanne's Provence, where he visited virtually all of the sites that Cézanne had painted.

The Consulting Editor

H. W. Janson is Professor Emeritus of Fine Arts at New York University. Among his numerous publications are *History of Art* and *The Sculpture of Donatello.*

On the Slipcase

Madame Cézanne in the Conservatory was painted about four years after Cézanne married Hortense Fiquet, who had been his mistress and model for 17 years. (See page 105 for the complete painting.)

End Papers

Two still lifes illustrate the fluid touch and vibrant brushstroke characteristic of the masterful watercolors of the artist's last years. *Front:* Collection Norton Simon, Los Angeles. *Back:* Courtauld Institute Galleries, London.

The Consultants for This Book

Jean Leymarie was associated with the Louvre from 1945 to 1950 and is still affiliated with the directorate of the French national museums. A distinguished teacher and critic, Mr. Leymarie has written books on Corot, the Fauve movement and French 19th Century painting. He has been the organizer of many important exhibitions, including the monumental *Hommage à Picasso* in Paris in 1966-1967.
Theodore Reff is a professor of art history at Columbia University. In 1977, he mounted an exhibit for the Museum of Modern Art on Cézanne's late work. He has written dozens of articles on Cézanne and other 19th and 20th Century European artists.

CORRESPONDENTS: Elisabeth Kraemer (Bonn); Margot Hapgood, Dorothy Bacon (London); Susan Jonas, Lucy T. Voulgaris (New York); Maria Vincenza Aloisi, Josephine du Brusle (Paris); Ann Natanson (Rome). Valuable assistance was also provided by Friso Endt (Amsterdam); Alex des Fontaines (Geneva); Barbara Moir (London); Carolyn T. Chubet (New York); Traudl Lessing (Vienna).

Library of Congress Cataloguing in Publication Data
Murphy, Richard W.
 The world of Cézanne, 1839-1906, by Richard W. Murphy
and the editors of Time-Life Books. New York,
Time-Life Books (1968)
192 p. illus. (part col.), ports. 31 cm. (Time-Life library of art)
Bibliography: p. 187.
1. Cézanne, Paul, 1839-1906.
I. Time-Life Books. II. Title.
ND553.C33M8 759.4 68-17688
ISBN 0-8094-0214-9
ISBN 0-8094-0272-6 lib. bdg.
ISBN 0-8094-0243-2 ret. ed.

Contents

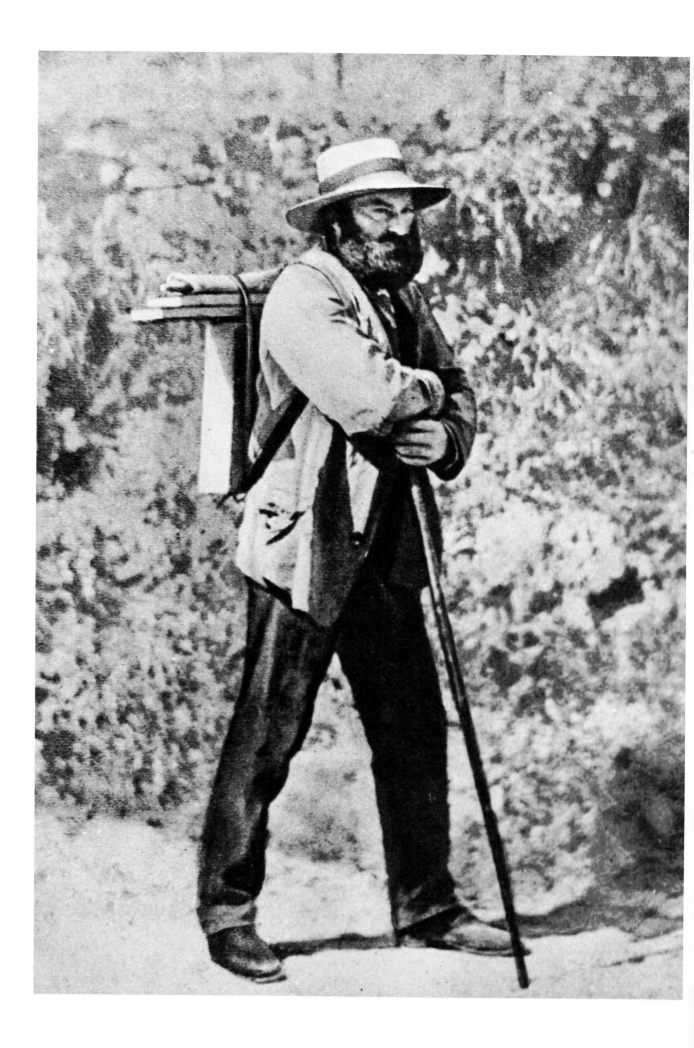

I

A New Way of Seeing

This snapshot, one of only 23 extant photographs of Cézanne, shows the artist when he was in his thirties. With rolls of canvas and a box of paints and brushes strapped to his back, Cézanne is prepared to strike out across the French countryside in search of landscape subjects, a practice he followed nearly every day of his career.

In the cemetery of St. Pierre near Aix-en-Provence in southern France lies the grave of Paul Cézanne. Beyond the grave, to the north, is the undulating line of the Étoile Hills, and farther still, rising blue in the clear Provençal air, is the mountain called Sainte-Victoire.

A visitor walking this country knows at once that it was, in a sense, created by Cézanne. The bleached outcroppings of rock, the swiftly slanting forests of pine, the aromatic scrub, the limpid sky, the long roll and pitch of the land—all this and more Cézanne fixed on canvas so compellingly that to visit the country after experiencing his paintings is to see with Cézanne's eyes and to feel with Cézanne's lonely temper. It was Cézanne who discerned the genius of this landscape, celebrated its forms and colors, and revealed in it a profundity that no eye before his had seen.

Yet a visitor soon becomes aware that what lies before his eyes is not, after all, what Cézanne put on canvas. Cézanne's Provence is simpler and more structural than the country that inspired it. Things in the paintings that should be far away seem near, and forms in the foreground are presented as if they lay at an indefinable distance. The colors are the colors of Provence, but when the visitor stands where Cézanne presumably stood with his easel and looks across the country, he will not necessarily find the colors Cézanne painted in the sequence in which he painted them. Everything is clarified and concentrated.

This power of Cézanne's to convey the essence of a landscape while eliminating much of its detail tells us a great deal about the man and his works. The simplest and truest thing that can be said of him is that he taught the world to see in a new way.

He was not interested, as many of the academic painters of his day were, in reproducing the visible world with photographic exactitude. Nor was he interested, as his contemporaries the Impressionists were, in recording the passing effects of nature. Cézanne believed that in the natural world there were enduring forms and colors, and enduring relationships between them.

These forms, colors and relationships were to Cézanne a language

for expressing the emotions aroused in him by nature. That, he believed, was the whole purpose of painting. A picture was not an impression of nature or a bit of social commentary or an illustrated story or a piece of decoration. It was an expression of the emotion evoked in the artist by the enduring forms and colors of the natural world.

This view of painting put Cézanne at odds with most of his contemporaries. The personal feelings of the artist obviously crept into the work of a great many mid-19th Century painters, but its expression was regarded as incidental to some larger purpose in the painting—moral, political, social or whatever. Cézanne shifted the emphasis in painting from the things viewed to the consciousness of the viewer. He thus helped guide painting into a path that would lead, in the 20th Century, to a so-called "abstract" art that is wholly dependent on the feelings of the men who created it.

In portraits and still lifes as well as in landscapes, Cézanne produced an art that lay somewhere between simple representation and pure abstraction. It has sometimes been described as "geometric," and certainly when Cézanne gave his now-famous advice to a young painter to "see in nature the cylinder, the sphere, the cone," he was suggesting that geometric shapes offer one means of imposing form and order on nature's endless confusions. But his art was far more complex than the term "geometric" implies. In its unconventional handling of space and its equally unconventional use of color it was a highly intellectualized art. To a public schooled in the idea that exact imitation was the goal of art, Cézanne's liberties with ordinary visual experience were surprising and often shocking. Few major painters of the 19th Century were so violently attacked—"madman" and "anarchist" were among the epithets applied to him—or so widely misunderstood.

Some people thought he was a fraud; others, while granting his integrity, agreed with a Belgian critic that his work was little more than "sincere daubing." It was quite apparent, wrote a critic in 1877, that "when children amuse themselves with paints and paper they do better." The same opinion of Cézanne was still being expressed in 1910, four years after his death, when the British art historian Roger Fry arranged the first showing of Cézanne's works in England; he soon began receiving in the mail childish scribbles sent by parents who insisted that these scraps were far superior to the works of Cézanne.

It is easy to condemn such judgments, but it is also easy to understand them. Cézanne's painting is very much the kind of work that a viewer must train himself to see. To 19th Century viewers this was an alien idea. They regarded Cézanne as a wild revolutionary bent on destroying the values of established art. Actually he thought it essential that he relate his art to the past. "One does not substitute oneself for the past," he once wrote, "one only adds a new link." If he shook the very foundations on which the art of his time rested, it was because he was challenging ingrained habits of seeing in order to restore to art certain pre-Renaissance concepts that he valued.

Chief among these was the classical concept of space—that is, a concern for representing the three-dimensional world without denying

the two dimensions of a picture surface. Another was the concept of a painting as an autonomous structure that was harmonious and logical in all its parts. Like Giotto, Uccello, Piero della Francesca and Poussin before him, Cézanne was one of the great constructors of painting. He was, in this sense, a regenerator rather than a revolutionary. As the painter Paul Sérusier wrote a year before Cézanne's death: "He cleaned away from pictorial art all the mold that time had deposited upon it; he restored all that was sound, pure and classic."

Cézanne's genius—and his historical importance—was his ability to fuse the "sound, pure and classic" with elements of the Romantic tradition. He brought together two great and seemingly incompatible styles that had divided French painting since the 17th Century.

Classicism implied an art that celebrated the intellect, Romanticism one that exalted the emotions. Where the impulse of Classicism was toward structure, the impulse of Romanticism was toward color. Cézanne responded equally to both impulses: he was not only a great constructor but a great colorist of the caliber of Titian, Rubens and Delacroix. In its maturity his art combined the emotional intensity of Romanticism with Classical clarity and restraint. In fusing the two traditions, Cézanne's work also summed them up, and, in this sense, closed an epoch. It also opened one: after Cézanne had completed the masterpieces of his maturity, the vision of the men who were to shape modern painting was never again the same.

Cézanne's role as the "father" of modern art has been persistently acknowledged by subsequent generations of painters. Yet it is well to remember that his influence on countless individual artists and on such movements as Symbolism, Fauvism, Cubism and Expressionism does not necessarily have any bearing on his own intentions. Nor does his importance stem from his influence. He transcended both his own and later eras, and he stands alone, complete, as one of the giants of European painting.

If Cézanne was the strongest artistic personality of his time, he was also one of the most unstable of men. The apparent discrepancy between the artist and the man mystified the people who knew him, and it has intrigued students of Cézanne ever since.

According to one story about his early childhood, he was entrusted with the care of his younger sister Marie when they began to walk to school together. But very soon Marie became the leader. After that her brother's attitude toward her swung violently between total dependence on her in all practical matters, and wild rage at what he came to regard as her interference in his affairs. "If I touched you," he would warn her, "I might hurt you."

In this dependence and this fury is much of the mature Cézanne. All his life he would alternately reach out to people and thrust them away. He did not want anybody, he said, "to get his hooks into me." He meant this so literally that he developed a morbid fear of being touched. Once when the painter Émile Bernard innocently put a hand on his arm, he exploded in rage. And as abruptly he apologized. "Don't pay any attention," he said rather pathetically, "these things happen

This self-portrait, first of the dozens that Cézanne painted, was based on a photograph *(page 22)*. Cézanne was still a young man at the time, and his eyes reveal an intense and somewhat hostile expression. This was possibly a reflection of the social ineptitude that plagued him all his life, made him suspicious of people and once prompted him to confess that "as for me, I must remain alone, the knavery of people is such that I could never cope with it. . . ."

in spite of me. I can't bear being touched. It is something that dates from very long ago."

What happened in that "very long ago" we shall never entirely know. It is clear, though, that Cézanne's relationship to his family had a great deal to do with his lifelong anxieties. He was terrified of his father from a very early age and excessively dependent on his mother. It was his mother, and later his sister Marie, who supported him against his father in his struggle to become a painter. Apparently, Louis-Auguste Cézanne regarded his son as incompetent, and all his life treated him as a child—even when Cézanne was middle-aged his father took it as his prerogative to open his son's mail.

Cézanne's letters and the testimony of his friends indicate that he deeply resented not only his financial dependence on his father but also his parallel emotional dependence on his mother and sister. He complained that when he was with his family he was "no longer free," and he called them "the most disgusting people in the world." Yet all his life he returned home often and for long periods. To the adult Cézanne, his family remained always a torment and a necessity.

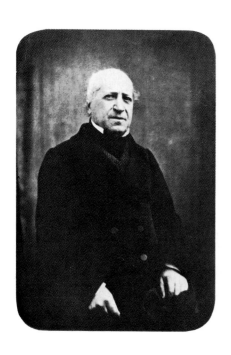

Louis-Auguste Cézanne, Paul's father, spent a sickly, poverty-stricken childhood in a small, provincial town. By the time he reached his teens, Louis-Auguste had grown into a healthy, ambitious young man who knew his aspirations could not be realized in his birthplace. Striking out on his own, he moved to nearby Aix-en-Provence where he began his climb to financial success.

Fear of a domineering father and dependence on an over-protective mother are familiar enough ingredients of a neurotic personality. In Cézanne's case, the insecurities engendered at home caused him to become increasingly antisocial and misanthropic as he grew older. Friendships were difficult for him at best; relationships with women virtually impossible. He was past 30 before he found any kind of rapport with a woman outside his family; by early middle age he would no longer paint from a female model, since the presence of nudity made him uneasy.

"Life's so terrifying!" he said again and again. He was haunted by thoughts of an early death, and when only 43 spent considerable time drawing up his will. Fear also led him to become a church-going Catholic in middle age and kept him one for the rest of his life, although he described going to Mass as taking his "slice of the Middle Ages."

From childhood on he was convinced that the affairs of the world were beyond his competence—that "isolation," as he put it, "is all that I'm good for." His letters show not the remotest interest in the public issues of his time. He had little to say about politics, the theater, music (although he had a youthful passion for Wagner), the social structure, the government of France, the morals or the scientific wonders of his day. If he had any concern at all over the Franco-Prussian War in 1870 it was only as it might affect his freedom to go on painting.

Insecure, morbidly shy, he hid his remarkable intellect, his considerable classical learning and his sensitivity behind a façade of provincial boorishness. He could be extremely vulgar at times, but the desire for rejection implicit in this vulgarity was offset by an almost equally strong desire for acceptance by the very people—the academicians, the bourgeois citizens of Aix—he scorned. Mixed with the rebel in Cézanne, Roger Fry justly noted, was "a timid little country gentleman of immaculate respectability who subscribed wholeheartedly to any reactionary opinion which might establish his 'soundness.'"

Alternately arrogant and servile, Cézanne could say, "In France there are over a thousand politicians in every administration, but only once in two centuries is there a Cézanne," and at the same time could fall on his knees before the sculptor and Légion d'Honneur member Auguste Rodin to thank him for shaking his hand. Significantly, Cézanne was paying tribute not to Rodin's art (he did not particularly care for it) but to the fact, as he confided to friends, that Rodin was "a man who has been decorated."

He sought salvation in painting. His work, he insisted over and over again in his letters, was the only thing that could give him lasting "mental satisfaction." It also offered balm for his insecurities. At a time when his painting was under violent attack he wrote his mother: "I begin to find myself superior to those around me," and there is little doubt that he was profoundly convinced of the particular excellence of his artistic vision. Remarkably, there is little reflection in his mature paintings of the instability of the man who created them: when the world betrayed Cézanne, his painting sustained him.

Yet even his art caused him anxiety. Although convinced of his genius, he was constantly beset by fears that he could not find a way to express it. He was forever talking of his inability to "realize" his visions, and each new painting became not only a challenge but also a crisis: "It's so good and so terrible to attack a blank canvas," he once said. When he thought the attack had failed, as he did much of the time, his reaction was often extreme. In disappointment and rage, he slashed and trampled canvases that he declared "just wouldn't come." But he could also say: "One does not kill oneself for a spoiled canvas; one begins again."

Cézanne's persistence in his work was born of his belief that art was a "priesthood." In fact, his whole life had about it a dedication, a single-mindedness and a kind of epic completeness. Both his work and his life were to prove extraordinarily moving to later painters. To the 20th Century he was to appear as the great hermit of art struggling courageously in isolation. "What matters is not what the artist does but what he is," Picasso said of Cézanne in 1935. "What is of interest to us is Cézanne's restless striving—that is what he teaches us."

Cézanne was born in Aix-en-Provence on January 19, 1839. It is believed that his forebears emigrated to southern France from the small Italian Alpine town of Cesana Torinese in the 17th Century. For the next 200 years they achieved no notable successes. They were cobblers or wigmakers or tailors, and so far as is known, none of them rose above their humble origins.

But the artist's father, Louis-Auguste Cézanne, was quite another case. Ambitious and assertive, he journeyed to Paris to learn the hat-making trade. Several factories in Aix had begun to process the hair of rabbits into felt for hats, and Louis-Auguste understood, with a shrewdness that was to prove markedly absent in his son, that there was money to be made in the trade. Back in Aix after several years' apprenticeship, he invested his savings in a wholesale and retail hat shop, prospered and eventually began lending money to the breeders who sup-

Cézanne's sister Rose *(above)* was 15 years younger than her brother and played a small part in his life. She married a wealthy man and lived quietly near Aix. Marie *(below),* however, was a dominant force in the family. Forced by her parents to reject a naval officer who proposed to her, Marie remained a spinster, helped her father run the household, took over family affairs after her parents' death and ultimately sold the estate. She managed Cézanne's finances, kept a watchful eye on his behavior but admitted not understanding his paintings.

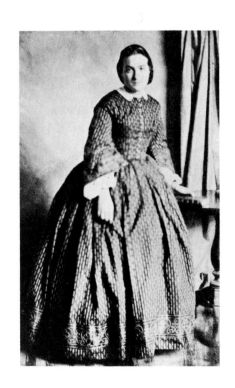

plied skins to the felt-makers. Very soon this "tough and rapacious" man, as he was characterized by a childhood friend of Cézanne's, was the most successful moneylender in Aix.

When he was 40, Louis-Auguste took as his mistress one of the girls in his shop, Anne-Élisabeth-Honorine Aubert. He married her in 1844, when Paul was five and the elder of his two sisters was three. Within a few years Louis-Auguste had become wealthy enough as a moneylender to found his own bank, a move facilitated by the recent failure of the only other bank in Aix. As he prospered, he first rented and later bought a 37-acre estate outside the town with an 18th Century manor house that had been the country residence of Honoré-Armand, Duc de Villars, governor of Provence under Louis XIV. The property, called Jas de Bouffan, Provençal for "Habitation of the Winds," was to have great importance for Louis-Auguste's son. He returned to it periodically until near the end of his life, spent more time painting there than in any other single place, and found in it a wealth of subject matter: the big, tall-windowed house, the avenue of chestnut trees, the square pool adorned with stone dolphins and lions, the cluster of farm buildings screened by mulberry trees at the side of the house, the low walls enclosing the property.

As a bourgeois on the rise, Louis-Auguste was both resented and scorned in Aix. In many ways he was the prototype of the "new man" of France, the spearhead of a social upheaval born of both the French Revolution and the Industrial Revolution. The French Revolution would not have been possible without the support of the common people, but the section of society that most immediately benefited from it was the emergent middle class. The bourgeoisie had come into their political rights with the fall of the Bastille in 1789; economically, they began to come into their own with the industrialism that gathered momentum in the mid-19th Century. By the time Louis-Auguste was making his mark in Aix, the Emperor Napoleon III ruled France under the Second Empire. Behind its deceptively tranquil facade, men of the working class were seizing their economic opportunities and becoming powerful factors in French life. They were resented by the traditional ruling classes and envied by the proletariat from which they came.

In Louis-Auguste's case, the resentment and envy were apparently compounded by the fact that he had married a shopgirl and that he had acquired an estate long in the hands of local aristocrats. The ostracism the family suffered may have been partially responsible for Cézanne's social insecurities. It may also help to explain the mulishness with which the town later rejected its most distinguished citizen.

Mid-19th Century Aix was a typical French provincial town, very much out of the mainstream of French life. It had a small university; it manufactured hats and a type of almond candy; it served as a marketing center for farm produce from the surrounding countryside. It was a town of many cobblestoned streets, many plane trees, many churches, baroque fountains, and old houses with red-tiled roofs and walls of ochre-colored stone cut since Roman times from the nearby quarry of Bibémus. Not much ever happened in Aix. "A habitual and regular

calm envelops our dull city," wrote Cézanne once to an absent friend.

It is unlikely that Cézanne saw many first-rate paintings while he was growing up. The churches of Aix contained some interesting works, among them two well-known altar panels, one of the Annunciation, the other of the Burning Bush. There were also murals of some distinction in a few of the older private residences, although Cézanne probably did not have access to them. Otherwise, there was the Musée Granet, founded the year before Cézanne was born, in the Priory of the Knights of St. John of Jerusalem. This museum was named after the painter François Granet, who, as a winner of the Prix de Rome of the École des Beaux-Arts was the only native of Aix who had achieved any artistic reputation. Granet died when Cézanne was 10, and his competent but rather conservative works were on display in the museum, along with dozens of inconsequential contemporary works, such as Edouard-Louis Dubufe's *The Prisoner of Chillon* and Félix-Nicolas Frillié's *The Kiss of the Muse*, both of which Cézanne copied. The rest of the collection consisted mostly of 17th Century religious and genre paintings by minor French and Italian artists, including a *Cardplayers* that is sometimes said—with no real evidence—to have served as the inspiration for Cézanne's famous *Cardplayers* series.

While Cézanne's exposure to good painting was slight, his education in most other respects was excellent. After grammar school he attended St. Joseph's School and then, from age 13 to 19, the public secondary school, the Collège Bourbon. His education there was a traditional one that stressed the humanities and religious instruction. Cézanne was a good if not brilliant student, and he won numerous prizes in mathematics, Latin and Greek. He remained a devoted reader of the classics all his life, wrote verses in Latin and French and to his death could recite pages of Apuleius, Virgil and Lucretius from memory.

He had an early enthusiasm for art, but apparently no particular aptitude for it. He took drawing lessons as part of the curriculum at both St. Joseph's and the Collège Bourbon, and he began attending the town's free drawing academy when he was 15. But the prize awarded annually at the Collège Bourbon for drawing never went to Cézanne; it was won in 1857 by young Paul's best friend, Émile Zola.

A year younger than Cézanne, Zola had been born in Paris of a French mother and a father of Greco-Italian origin. The elder Zola, who had served in the Foreign Legion, was a talented engineer and had been assigned by the government to the important project of canalizing the water supply of Aix, which suffered from chronic drought. He designed a canal system and a dam, still known as the *Barrage Zola*, but died before construction was completed. Émile was six at the time; his mother lost the money she had been left in lawsuits involving the estate.

By moving to progressively poorer dwellings in Aix, she was able to send her only child to the Collège Bourbon. There he formed the friendship with Cézanne that was to last nearly a lifetime. At the peak of his literary fame years later Zola recalled that although he and Cézanne were "opposites by nature," they were "attracted to each other by secret affinities, the as yet vague torment of common ambition, the

awakening of superior intelligence in the midst of a brutal mob of dreadful dunces who beat us."

Cézanne and Zola were drawn together by shared literary enthusiasms. They particularly admired the Romanticism of Victor Hugo, Alphonse Lamartine and Alfred de Musset. They also talked of their respective futures and encouraged each other to follow artistic careers. Both thought of themselves at the time as future poets. With other friends, they tramped the countryside around Aix, swam, climbed and, according to Zola's fond middle-aged memories, shouted poetry under the trees. A nostalgia for that idyll of his youth stayed with Cézanne until the end of his life, when he would recall "sentiments stirred in us by the good sun of Provence."

The friendship of Zola and Cézanne undoubtedly had a profound influence on both men. Zola played an important role in getting Cézanne launched on a career as a painter. Somewhat later, Cézanne's thinking about painting was to affect Zola's taste in pictorial art. Zola was to become—along with Cézanne's mother, his sister Marie and finally his son Paul—an important, although not always trusted, confidant and advisor and prop to Cézanne in practical affairs. Ironically, in much later years, each man came to hold the conviction that the other had betrayed the artistic visions they had shared in their youth.

The Cézanne known to Zola in those early days was moody, passionate and compulsive. He was given to sudden enthusiasms and just as sudden depressions. "When he hurts you," wrote Zola to a mutual boyhood friend, Baptistin Baille, "you must not blame his heart but rather the evil demon which beclouds his thought." In his sunnier moods, Cézanne was extravagant and unpredictable. "That poetic, fantastic, jovial, erotic, antique, physical, geometrical friend of ours," was how Baille described him at 19.

The word "erotic" doubtless had reference more to Cézanne's desires than to his actions. Although he spoke often to Zola of visionary loves—"you would invent love," Zola wrote to him, "if it were not a very old invention"—he was excessively shy and even apprehensive in the actual presence of women.

Some of the most valuable information we have about him as a young man is contained in the notes Zola made many years later for his novel *L'Oeuvre*, whose protagonist was largely modeled on Cézanne. Zola noted that his friend was always wary of women. "I do not need any women," Zola quoted Cézanne. "That would disturb me too much. I don't even know what they are good for—I have always been afraid to try." In the novel itself Zola remarks on his protagonist's barely suppressed eroticism as follows: "It was a chaste man's passion for the flesh of women, a mad love of nudity desired and never possessed. . . ."

Cézanne's turbulent adolescent anxieties are reflected in the macabre and violent poetry he wrote at the time. In one poem, titled *Une Terrible Histoire*, we find the poet at midnight in a pitch-black forest pursued by Satan and embraced by a corpse. In another poem, illustrated by one of Cézanne's earliest existing sketches, a family sits at table and devours a severed human head, served to them by the father, while the

Before he decided to become a painter, Cézanne thought he would write. Only a few samples of his early efforts exist: the first two poems translated below are taken from letters that he wrote to Zola when he was about 20; the last example of his poetry was found scribbled on the back of a sketch.

Rather a diver
splitting rivers
like the Arc;
and from its pools
snatch a fish if I'm lucky.

* * *

Dark, thick
unwelcome mist
covers me up;
the sun withdraws
its last handful
of diamonds.

* * *

What a girl, what flesh: voluptuous.
She parades the meadow
like a heifer in season.
Nothing alive is more curvilinear.
The sun, round itself, warms
warm girl and round flesh.

children cry for more: "Give me this ear/ Give me the nose/ Give me this eye!" It is scarcely surprising to find in yet another poem the word *crâne*, "skull," rhymed with "Cézanne."

Most of these bizarre poems Cézanne addressed to Zola, who went to Paris to live in February 1858, just after Cézanne had turned 19. Zola's move had been forced by poverty: his mother, unable to support herself and her son any longer in Aix, had decided to seek the help of her husband's old friends in Paris. Zola hoped to find in Paris "the reward and the lover which God keeps for us at twenty," but his first months in the capital produced neither lover nor reward. In his loneliness and unhappiness he wrote frequently to his friends in Aix, most notably to Cézanne, initiating a correspondence that lasted for nearly 30 years.

Cézanne himself was a steady writer of letters all his life. He wrote not only to friends with whom he had grown up but to fellow painters, to critics, poets and a few collectors and, in his last years, to young admirers of his work and to his son Paul. Withdrawn in his personal relationships, he apparently relied on correspondence as a line of communication with the world.

At the time his correspondence with Zola began, Cézanne was finishing his secondary schooling and was continuing to study at the local drawing academy. But despite his interest in art, he apparently had at this time very little notion of what he was going to do. He missed Zola and was depressed by his own inaction. "I am heavy, stupid and slow," he writes in one letter, and in another: "A certain dejection accompanies me everywhere, and it is only for moments that I forget my sorrow —when I have had a drop to drink."

This air of apathy is not common to all of the letters, however; some of them—scrawled in Cézanne's nervous, angular hand and illustrated with pen-and-ink sketches and watercolors—are mock-heroic or youthfully exuberant in tone. They describe Cézanne's studies, his struggles to pass the baccalaureate examination at the Collège Bourbon, the activities of mutual friends, the girls Cézanne has admired from afar. In these letters there is none of the suppressed violence of the poetry. Nor is there any mention of any desire to be a painter.

In the fall of 1858, after he had passed his baccalaureate examination (which he had failed once), Cézanne entered the law school of the University of Aix. He did so at the insistence of his father. "Alas, I have taken the crooked path of the law," he wrote Zola in December. " 'Taken' is not the word—I have been forced to take it!"

He remained at the law school for two years, always against his will, and his rather hesitant decision to become a painter was apparently made during this period. Why he decided on painting rather than writing as a career we do not know. He had thought of himself as a writer throughout most of his adolescence, and Zola believed that of the two of them Cézanne was potentially the better poet. "My verse," said Zola, "may be purer than yours, but yours is certainly more poetical, more true; you write with the heart; I, with the mind."

Perhaps Cézanne did not want to compete with his friend, who was already pursuing a literary career. In any event, it is certain that he

had begun to think of turning to painting by the spring of 1859, for, in a letter of June 20th, in which he describes his hopeless infatuation for a local girl who will not look at him, he writes: "Ah, what dreams I have dreamed, the maddest ever! I said to myself if she did not detest me we should go to Paris together; there I should become an artist, we should be happy. I dreamed of pictures, a fourth-floor studio . . . But faith, that was a great dream!"

He detested the law, and he was temperamentally unsuited to succeed his father in the family bank. He was not strong enough to defy his father openly, however, and he vacillated so in his decision to become a painter that Zola, who had been urging him to come to Paris to study art, finally burst forth in an angry letter: "Is painting only a whim which took possession of you when you were bored one fine day? Is it only a pastime, a subject of conversation, a pretext for not working at law? If this is the case, then I understand your conduct . . . But if painting is your vocation . . . then you are an enigma to me, a sphinx, someone indescribably self-contradictory and obscure."

Zola decided that Cézanne must be "lacking in character; you dread failure of any kind, in thought as well as in action; your main principle is to let things take their course and to leave yourself at the mercy of time and chance." He ended with an exhortation: "One thing or the other, really be a lawyer, or else really be an artist, but do not remain a creature without a name, wearing a toga dirtied by paint."

The letter accurately sketched one side of Cézanne's nature, though it was by no means a reflection of the whole of his nature. But it did not jolt Cézanne into action as Zola had hoped it would. Louis-Auguste, in a spirit of compromise, allowed his son to fit out a studio at the Jas de Bouffan. When Cézanne was not struggling with the law, he painted there and at the drawing academy, where his teacher was a decidedly conventional local painter named Joseph Gibert.

Among the very few works by Cézanne surviving from this period—

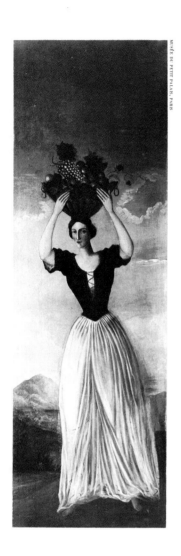

When Cézanne was about 20 he painted four panels with figures personifying the four seasons. One of them, seen above, shows Autumn as an idealized peasant woman bearing a harvest basket on her head. Cézanne painted these pictures in panels on the walls of the salon (right) at Jas de Bouffan, his family's country home. In a burst of youthful irreverence he signed the pictures "Ingres" and dated one of them 1811 to support the attribution. The smaller picture at the center of the display is a portrait of his father reading a newspaper, done at a later time.

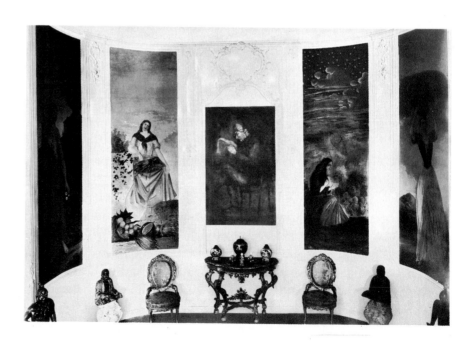

from about the fall of 1858 until the spring of 1861—are *Children with Rabbit*, after an engraving of Prud'hon's painting of that name; studies after the Dubufe and Frillié hanging in the Musée Granet; and a series of four panels representing the seasons that Cézanne painted on walls of the salon at the Jas de Bouffan.

The copy of Frillié's *Kiss of the Muse* that Cézanne made became his mother's favorite painting. Unlike her husband, she seems to have supported her son's artistic aspirations from the beginning, although she apparently felt no affinity for painting. Very little is known of Madame Cézanne beyond the fact that she was almost without education. She was illiterate at the time of her marriage, and even in middle age could sign her name only with difficulty. But she took her son's *Kiss* with her whenever the family moved from town to country.

Suddenly, in the spring of 1861, Louis-Auguste finally yielded to the entreaties of his wife and son and agreed to let Paul drop his law studies and go to Paris to paint. In April Cézanne journeyed to the capital and moved into a furnished room not far from Zola. He started attending the Atelier Suisse, a studio that provided a model but no instruction, to prepare himself for the entrance examination for the École des Beaux-Arts, the most influential art school in France.

Fellow students at the Atelier Suisse remembered Cézanne's heavy Provençal accent, his rudeness of manner and his total absorption in his work. He became a kind of class joke, and was known as "*l'écorché*" —the man without any skin—because of his extreme sensitivity to criticism. Claude Monet, a year younger than Cézanne, had arrived in Paris from Le Havre two years before him and worked occasionally at the Atelier Suisse. Years later, Monet recalled one of Cézanne's peculiarities that had attracted attention at the Atelier: he always put a black hat and a white handkerchief beside the model, said Monet, to remind himself of the two extremes between which he must establish his tonal values.

At 22 Cézanne was thin, stoop-shouldered and almost six feet tall. The earliest existing photograph of him dates from this period. It shows a darkly handsome young man, perhaps more southern Italian in appearance than French. From this photograph (*page 22*) Cézanne painted a self-portrait (*page 9*) that suggests his feelings about himself at the time. In the painting, he lengthened his chin, accentuated his cheekbones and eyebrows and gave his eyes an almost paranoid fixity. The effect was one of brooding menace.

During these early days in Paris, Cézanne visited the annual Salon of the all-powerful Académie des Beaux-Arts and expressed enthusiasm for the popular academic paintings displayed there—works much like those he had admired in Aix. But his tastes rapidly changed as he became exposed to the ideas of the painters at the Atelier Suisse. One of them, Achille Emperaire, was a native of Aix who apparently influenced Cézanne strongly in his rejection of the academy style. A hunch-backed, dwarfish man 10 years older than Cézanne, Emperaire painted a great number of nudes of almost no distinction. He admired Tintoretto and Veronese, however, and he took Cézanne to the Louvre to see the

works of these painters and those of Rubens, Titian and Giorgione. The apprenticeship to the old masters that began under Emperaire's influence never really ended for Cézanne. All his life he made a practice of returning periodically to the museum to study and sketch from the Venetians, Rubens, Michelangelo and others. "The Louvre," he wrote late in life, "is the book from which we learn to read."

Zola saw less of Cézanne than he had hoped he would. He soon became aware that Cézanne's first experience of Paris was not a success. Before a month had elapsed Cézanne talked dejectedly of returning to Aix and going into his father's bank. "I thought that by leaving Aix I should leave behind the boredom that pursued me," he wrote to a friend. "Actually, I have done nothing but change my abode, and the boredom has followed me."

There were probably many reasons for Cézanne's disenchantment, and one was undoubtedly simple homesickness. But more important was his discouragement over his work. His was not a precocious talent, and he must soon have become acutely aware that many of the painters at the Atelier Suisse were more knowledgeable about art and more advanced technically than he was. Cézanne himself was a painter to whom technique did not come easily. Throughout his life and later he was to be criticized for technical ineptitude, a complaint prompted by the distortions in his work.

The problem is complicated by the fact that there are two kinds of distortion. First, there are those found in certain of the early paintings —*The Orgy*, for example, or the first *Modern Olympia*. These distortions result from Cézanne's inability at this stage of his career to transfer to canvas the violent and complex images of his imagination. Then there are the distortions, the most important ones, that occur in his mature paintings. These were the logical consequence of Cézanne's conception of what a picture should be. They may have been involuntary or they may have been deliberate, but they were not the result of awkwardness; they reflect Cézanne's artistic vision.

Fortunately, some of the life sketches Cézanne did in his student days at the Atelier Suisse have been preserved, and these give some idea of his ability at the time. The drawings indicate that, although he was not a particularly gifted student, he could have developed into a perfectly competent academic painter had he wished to. He knew how to define forms through outline and how to achieve tonal gradations with a sharpened pencil. He also had an adequate understanding of anatomy.

In 1861, however, he was considerably depressed over his progress as an artist. His unhappy frame of mind affected his relationship with Zola. Zola had hoped that he and Cézanne would go on weekend rambles on the outskirts of Paris, much as they had done when they were schoolmates in Aix. But somehow their planned expeditions rarely worked out. Cézanne kept more and more to himself, disappeared for days at a time and at one point moodily left Paris, without informing Zola, to sketch in the town of Marcoussis on the Seine. Conversation with Cézanne, Zola wrote to Baille, had become extremely difficult: "If he advances an inconsistent opinion and you dispute it, he flies into a

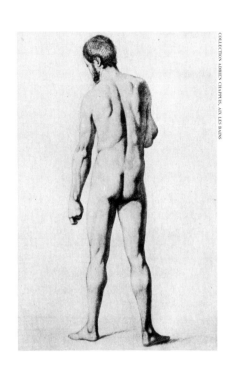

This academic study of a nude was drawn by the 23-year-old Cézanne from a live model at an art school in Aix. Although Cézanne's father opposed his son's artistic aspirations, he probably permitted him to enroll because a modest competence in music and art were considered necessary in a proper gentleman's education. The drawing above shows that Cézanne assimilated the techniques taught in art schools of the time.

rage . . . screams that you know nothing about the subject and jumps to something else." As this suggests, Zola failed in his efforts to counsel and encourage Cézanne. Trying to prove something to Cézanne, he complained, was like "trying to persuade the towers of Notre Dame to dance a quadrille."

One afternoon Zola stopped by Cézanne's lodging and found him with his trunk already packed, preparing to leave. To delay him, Zola, whom Cézanne had already painted a number of times, said that he would like to sit for another portrait. Cézanne agreed, but a few days later he furiously destroyed the partially completed work and again prepared to leave. All that remains of Cézanne's portraits of Zola at this period is an unfinished profile sketch.

Although Zola managed to prevent Cézanne's departure for a while, Cézanne returned to Aix in the fall, after five months in Paris. Zola saw him go with mixed feelings. He did not at once resume his correspondence with Cézanne; it was Cézanne who wrote first, after a lapse of several months. When Zola finally replied, it was to acknowledge that "Paris had done our friendship no good." Privately, he expressed an opinion that he was to hold for the rest of his life and that was finally to destroy his friendship with Cézanne: "Paul may have the genius of a great painter, but he will never have the genius to become one. The least obstacle makes him despair."

Cézanne remained in Aix a little more than a year. In accordance with his father's wishes, he entered the family bank as a clerk. He detested the business world, however, and enrolled again at the local drawing academy. In a ledger of the bank he scrawled two lines of wry verse: "My father the banker does not see without fear/ Behind his desk a painter appear."

What was appearing behind the desk Louis-Auguste was not at all sure, but he knew that it was not a banker. Reluctantly, he abandoned the idea of making his son his business heir and gave him permission to return to Paris.

Cézanne would perhaps not have had the courage to attempt Paris again if it had not been for Zola, who was now working as a clerk at Hachette's bookshop. In the summer of 1862 Zola spent his vacation in Aix working on his first novel, *La Confession de Claude*. The example of artistic productivity he set may have spurred Cézanne's own ambitions. In any event, in November 1862, shortly after Zola returned to Paris, Cézanne followed, provided with a small allowance sufficient to permit him to paint without worrying about earning his living.

Upon his return, he went back to the Atelier Suisse. But at the insistence of his father, he also applied for admission to the École des Beaux-Arts. To judge from the very few paintings that survive from this stage of Cézanne's career, including a portrait of his father and a self-portrait, the examiners at the school were quite right when they noted that Cézanne painted "riotously." They rejected his application, but Cézanne was undismayed. By this time he had lost his respect for academic painting, and he continued to work at the Atelier Suisse.

He was 23, and his career as a painter was about to begin.

As Cézanne continued his study of the human figure, he began to abandon strict realism. The drawing above, probably made while he was enrolled at the Atelier Suisse in Paris in the early 1860s, is a highly detailed description of the complexities of musculature. Below, in a drawing of a bather made many years later, Cézanne defines the figure but employs a freer, looser line, a characteristic of his mature style.

A Tormented Beginning

The visionary genius of Paul Cézanne was nurtured in a childhood of emotional tension. He was the only son of an overbearing father *(right)*, and he grew up in the quiet, tree-shaded town of Aix-en-Provence, an old provincial capital of southern France some 15 miles inland from Marseilles. His father, a self-made financier, was determined to groom young Paul for a position in the family bank at Aix. He sent him to a proper boarding school for young gentlemen and then on to the local university where he was enrolled in law courses.

But Cézanne was torn by passions that warred against the restraints of a provincial business career. Alternately plagued by fits of anger and depression, his imagination fired by morbid fantasies of violence and eroticism, he sought expression for his troubled feelings in painting. At the age of 22, he finally cajoled his reluctant father into letting him give up the law and go to Paris to study art.

The young painter's early efforts brought him little personal satisfaction and no acclaim. His work was ridiculed so much both by the public and the critics that he became embittered; once he even referred to painting as "a dog's profession." His initial bright enthusiasm turned to frustration and self-doubt—"The sky of the future is very dark for me," he lamented. Yet he was driven to continue painting, and as he struggled to express his inner turbulence, he slowly learned to discipline his powerful talent.

"Mocking, republican, bourgeois, cold, meticulous, stingy" was how the novelist Émile Zola, Cézanne's boyhood friend, described the artist's father. But Cézanne portrayed the old man with quiet dignity seated in the family living room at Aix. On the wall above the armchair (which also appears as a prop in the paintings on page 26 and 28) is one of Cézanne's earliest still lifes.

Portrait of Louis-Auguste Cézanne, c. 1866

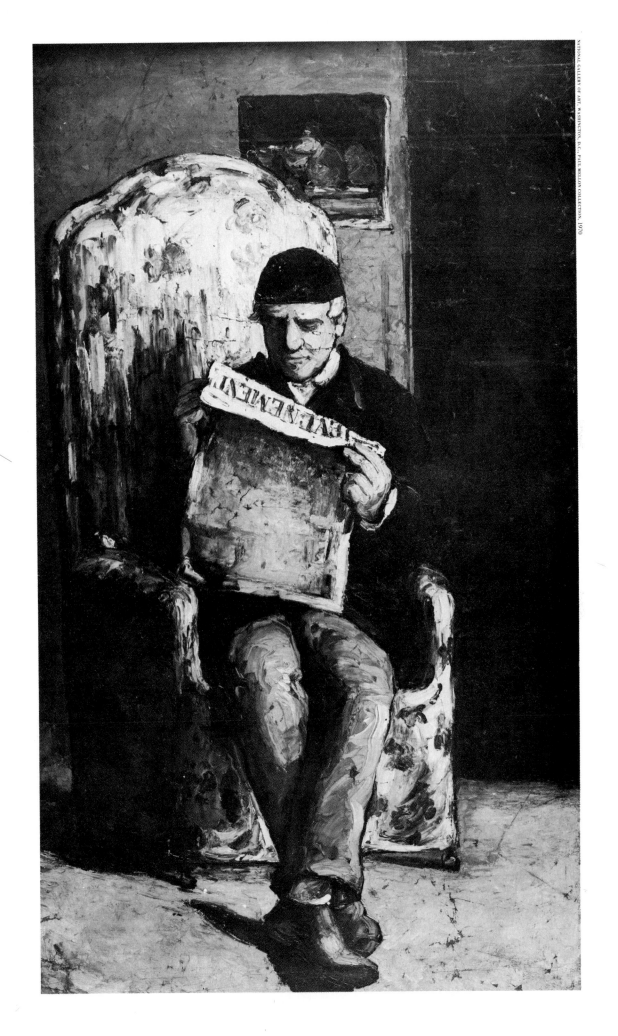

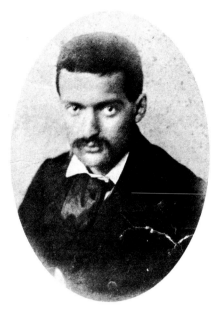

Paul Cézanne at 22

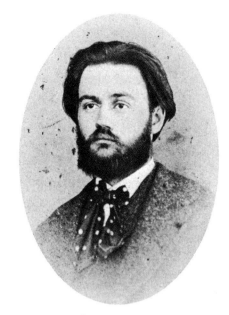

Émile Zola at 25

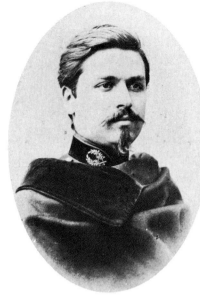

Baptistin Baille in his early twenties

One source of conflict between Cézanne and his father grew out of a boyhood friendship with Émile Zola. They met at boarding school in Aix, when Cézanne was 13 years old. The youths shared a fervent interest in literature and art, and an acute dissatisfaction with the small-town atmosphere of mid-19th Century Aix. Together with another lad, Baptistin Baille—who later became director of an optical instrument company—they developed such a close friendship that their schoolmates called them "the inseparables." They hiked through the countryside with volumes of poetry tucked under their arms, swam in a river near Aix, and wrote romantic verses. "What we were seeking was richness of heart and spirit," Zola wrote later.

The friends were separated when Zola moved to Paris in 1858, and Baille followed a few years later to go to engineering school. (He wears the school uniform in the picture above.) But the three maintained their intimacy through an intense correspondence. Cézanne wrote letters describing his emotional troubles; Zola replied by urging him to leave home—his father's newly purchased mansion and 37 acres of tree-shaded park near Aix *(right)*—and come to Paris. This advice infuriated Cézanne's father, who blamed Zola for the "unhealthy ideas" that fanned his son's desire to become a painter, but in the end Cézanne won his way.

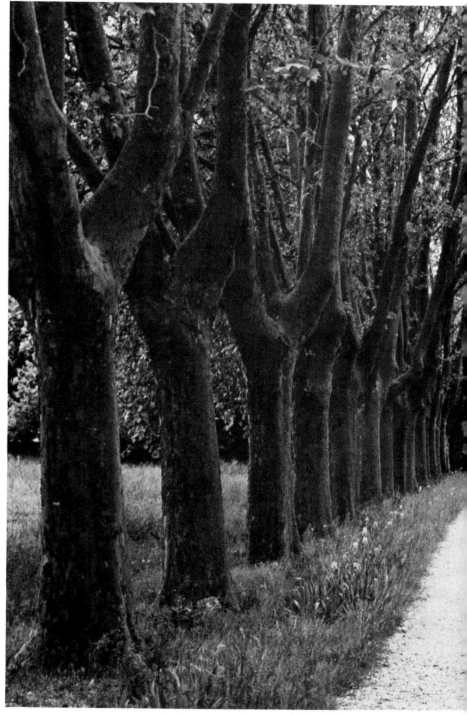

The Jas de Bouffan

22

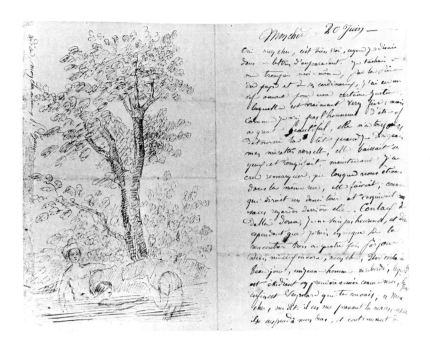

Cézanne's letters to Zola tell of lofty dreams, deep despair and unrequited love. This one, written in 1859 and embellished with a nostalgic drawing of the "inseparables" swimming in a river near Aix, describes his hopeless infatuation with a girl he hardly knows:

"I felt a passionate love for a certain Justine, who is really very fine; but since I have not the honor to be . . . beautiful, she always turned her head away from me . . . and now I, who am lazy, am happy only when I am drunk; I can hardly go on, I am an inert body, good for nothing."

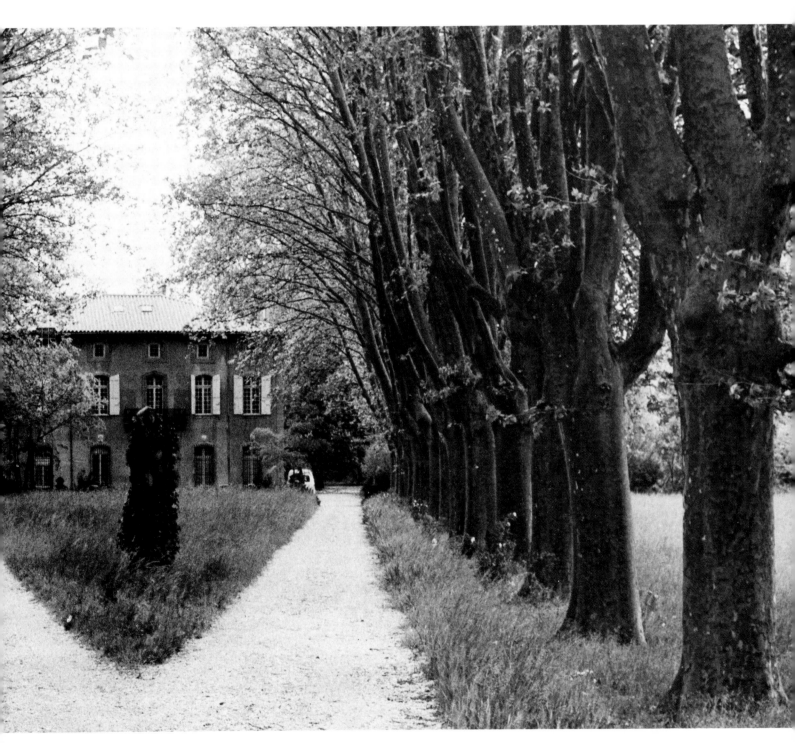

When Cézanne got to Paris in the spring of 1861, he contented himself for a while drawing in the precise Classical style favored by the academic artists of the day. Such bland exercises could not long satisfy his searching, troubled spirit, and he soon began to paint wildly imaginative canvases filled with scenes of violence, sexuality and death. A sketch of a corpse *(below)*, for a later painting called *The Autopsy*, reveals his morbid feelings with bold, heavily penciled modeling that emphasizes the body's awkward position in rigor mortis. In the weird scene called *The Temptation of St. Anthony (right, top)*, Cézanne has slapped paint on his canvas freely and vigorously, ruthlessly eliminating traditional details, exaggerating the voluptuous contours of the nude temptresses, and consigning St. Anthony to a far corner. The same loose drawing style, dark colors and sharply contrasting highlights pervade *The Murder (right, bottom)* in which a man and his female accomplice bend over their victim beneath a lowering sky. Cézanne applied his paints with such emotional abandon that, according to a childhood acquaintance, "It seemed as if he wished to avenge himself for some secret injury."

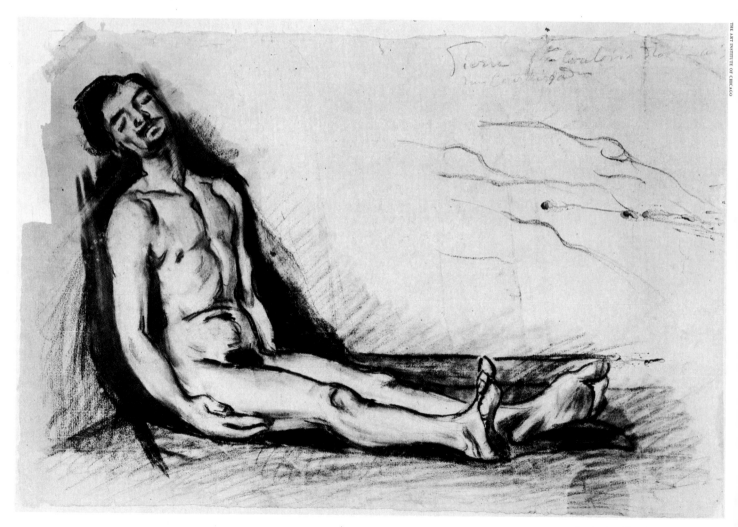

Study for *The Autopsy*, 1867-1869

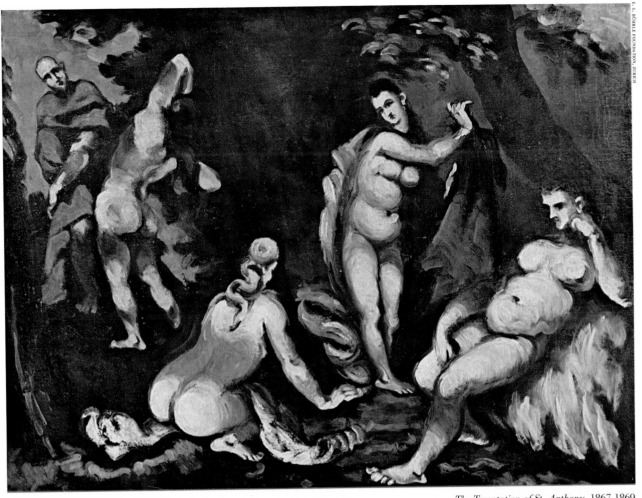

The Temptation of St. Anthony, 1867-1869

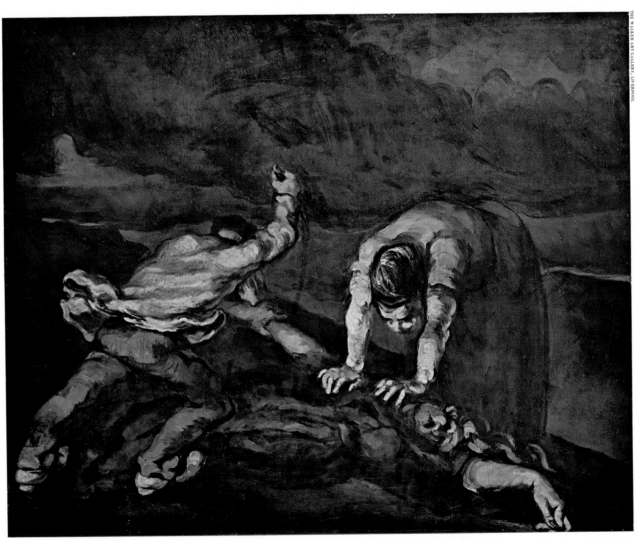

The Murder, 1867-1870

Not all Cézanne's early paintings dwelt on themes of violence and horror. In some of them, conventional subjects calmly treated gave proof of his efforts to control his frenzied imagination. Among the most successful of these was a series of portraits executed during his frequent visits to Aix.

Girl at the Piano (below) shows a tranquil domestic scene in the living room of the Cézanne home. With its quiet figures carefully placed against the intricate patterns of the wallpaper, striped rug and flowered upholstery, the picture speaks of Cézanne's growing interest in balanced, reasoned composition. The figures may be Cézanne's

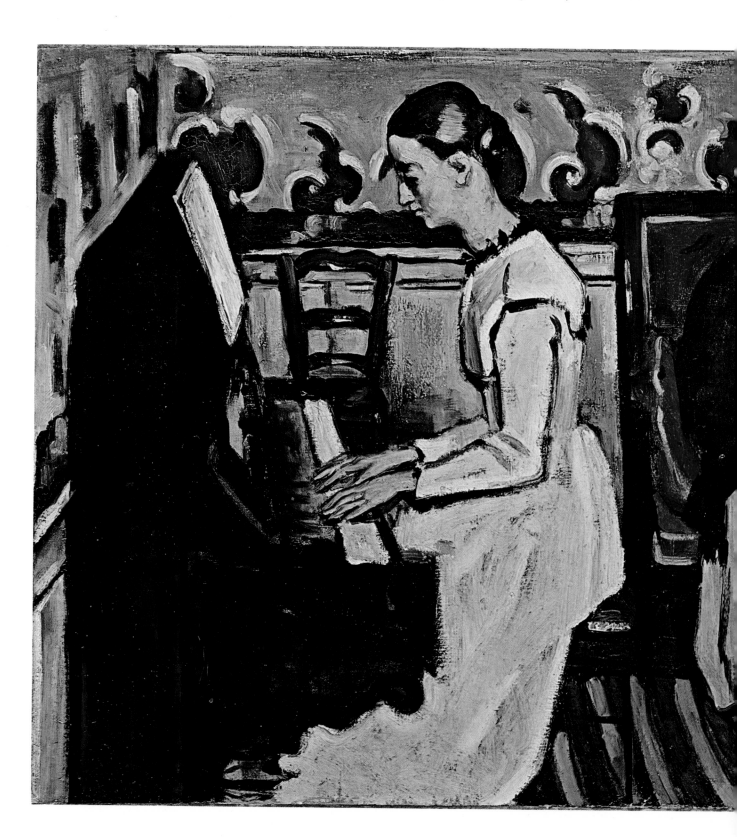

mother and sister, Marie, who encouraged him to paint, but almost never served as models.

A far more frequent subject for Cézanne was his Uncle Dominique, who patiently sat for the young artist in a wide variety of costumes and poses. Molding Dominique's strong features with the broad and vigorous strokes of a palette knife, Cézanne has used robust outlines and vivid color contrasts to give his figure a monumental gravity. The sittings themselves were apparently much less serious, however, for one observer reported that an artist friend of Cézanne's often stood by, lampooning the emerging portrait with "terrible jokes."

Girl at the Piano, c. 1866

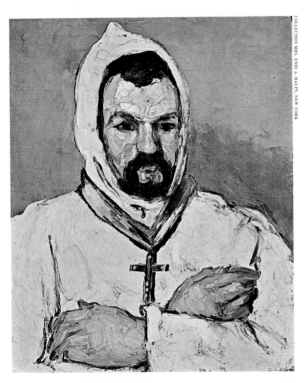

Uncle Dominique as a Monk, 1865-1867

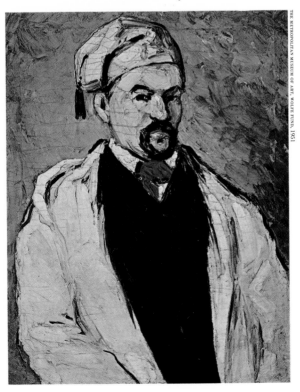

Uncle Dominique, 1865-1867

27

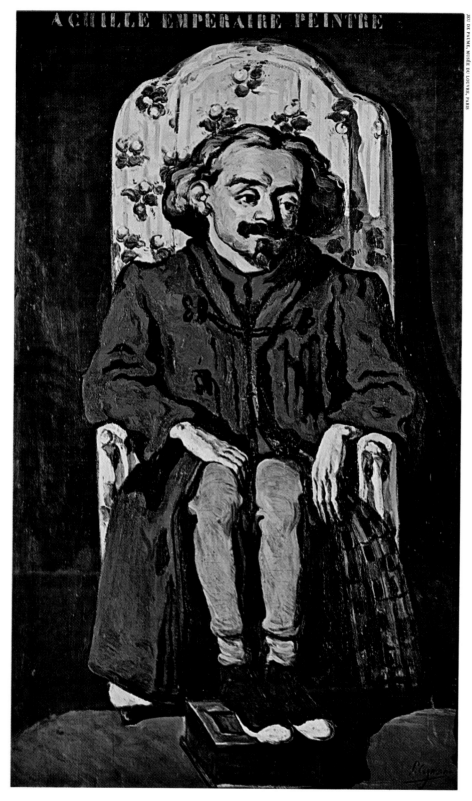

Portrait of the Artist's Friend, the Painter Achille Emperaire, c. 1868

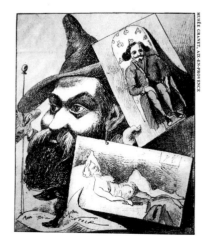

Cézanne longed for recognition. Each year he submitted canvases to the Salon, the exhibition of new paintings sponsored by the official French Academy of Fine Arts, which served as the supreme arbiter of popular taste. Each year his paintings were summarily rejected.

The reasons are not hard to find. The Salon judges preferred historical or literary subjects, depicted naturalistically. The great success at the 1870 Salon was *Salomé (above, right)*, by Henri Regnault, who showed

Henri Regnault: *Salomé*, 1870

mastery of texture and form, but little awareness of the psychological implications of his subject—the *femme fatale* who, urged on by her mother, caused John the Baptist to be beheaded. Cézanne's major entry in that same Salon was a powerfully wrought portrait *(above, left)* that has none of the grace, charm and finish of *Salomé*. Its subject was Achille Emperaire—whose name and occupation, "Painter," Cézanne carefully lettered at the top of his more-than-six-foot-high canvas. Not only is Cézanne's

portrait of this dwarf a good likeness, it has a great primitive strength that reveals a deep, almost cruel awareness of his deformed friend's unhappy lot. With it, Cézanne also submitted a picture of an angular reclining nude: the two works so shocked the art world with their bold departures from convention that the artist was caricatured in a Paris newspaper *(left)* and ridiculed as the master of all those who paint with "a knife, a brush, a broom, or any other instrument."

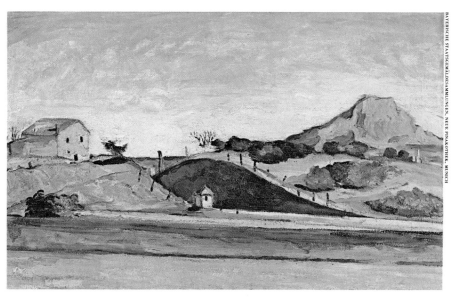

The Railway Cutting, 1869-1871

Derided by critics and scorned by the public, Cézanne took out his frustrations in hard work. He closeted himself in his studio for weeks on end, turning out canvas after canvas with unremitting energy. "I have never finished," he said, "never, never." Gradually he began to develop the unique personal style that would illuminate the great landscapes and still lifes of his later years.

A new stability and control began to govern Cézanne's work. As though seeking to tame his unruly temperament, the maturing painter began to arrange the elements in his canvases methodically and with precision. In *The Railway Cutting (above)*, the first of many pictures Cézanne was to make of Mont Sainte-Victoire near Aix, he carefully balances the house at the left with the stark, rugged shape of the mountain at the right. The various objects in *The Black Clock (right)* are fitted together as securely as bricks in a wall. Cézanne sets up a rigid framework of vertical and horizontal lines —the rectangular edge of the clock and the mirror behind it, the tall glass vase, the lip of the shell and the rim of the chocolate cup, all coordinated with the rectangular pattern formed by the folds of the tablecloth, itself as solid in appearance as a piece of monumental architecture. In reaching toward maturity as a painter, Cézanne had begun, wrote a friend, "to regulate his temperament and to impose upon it the control of pure science."

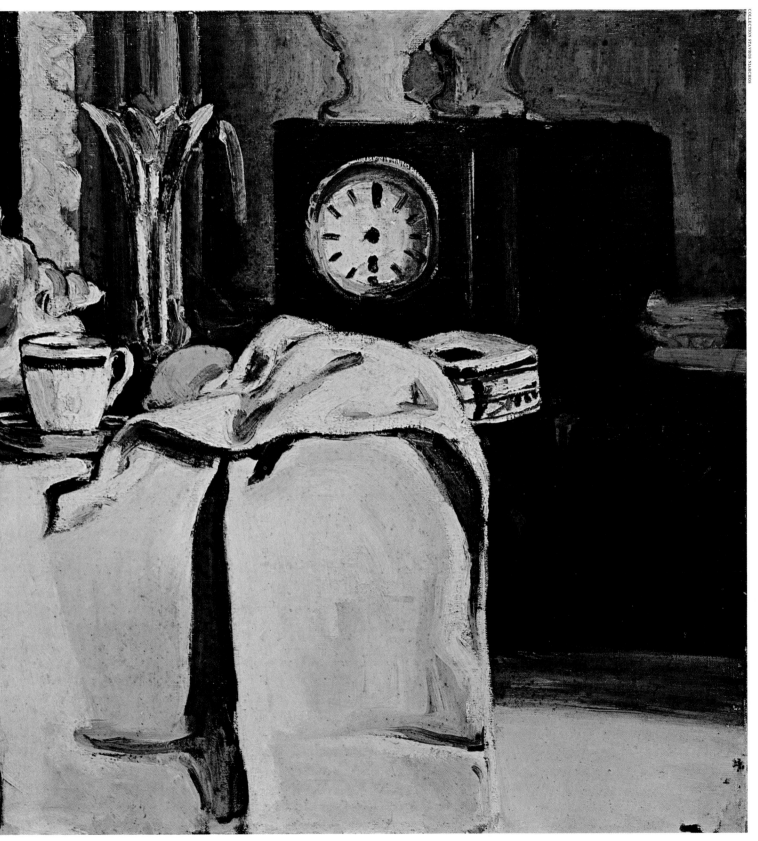

The Black Clock, 1869-1871

31

II

A Culture in Ferment

In their eagerness to acclaim Cézanne as a liberator and a revolutionary, many admirers have overlooked the fact that he was also inescapably a man of his own age. It is true that he was by inclination isolated from the public issues of the day, but his art was not isolated. In fact, the power with which Cézanne has spoken to the 20th Century is due partially to the sensitivity with which he responded, as a painter, to the currents of change that were at work in his own place and time —currents that radically altered the political, economic and social character of the Western world. To grasp the nature of his personal and artistic eccentricity, we must briefly examine some of the disturbances that troubled mid-19th Century France.

In the half-century following the French Revolution of 1789, France had six governments, all but one of which were overthrown by force; the historian André Maurois likened France in this period to "a plucked elastic cord that vibrates from right to left, unable to come to rest." Two interrelated power struggles raged. In the beginning the issue was whether the bourgeoisie would retain the power they had won in the Revolution or whether power would revert to the aristocracy. The restoration of the Bourbon monarchy in 1815 gave the aristocracy a brief advantage, but ultimately the bourgeois victory was complete. By 1830, when the revolutionary sympathizer Louis-Philippe became "Citizen King," France's middle class had taken firm control.

But while that class struggle was being decided, another was brewing. The political ascent of the bourgeoisie was, in part at least, a result of the industrial revolution. While it enriched and enlarged the middle class, it also created an urban proletariat of factory workers, who lived mostly in conditions of extreme poverty. To many liberal thinkers this situation was unendurable, and they looked forward to a new France ruled by the working classes. The writer Gustave Flaubert was expressing more than a personal animus when he wrote that "hate of the bourgeois is the beginning of wisdom."

By 1848 the class conflict in France no longer engaged aristocrats and bourgeoisie but bourgeoisie and workers. In February of that year

the resentments and the yearnings of the proletariat found violent expression in several days of mob rioting in Paris—known as the "Battle of the Barricades"—that toppled Louis-Philippe's government and brought in the Second Republic.

At the outset, the new regime advanced the proletarian cause in several ways, most importantly by proclaiming universal male suffrage for the first time in France's history. For a short period it seemed that the social revolution Karl Marx had recently begun to preach might actually occur.

But in 1848 Prince Louis Napoleon Bonaparte, nephew of the great Emperor whose rule had ended at Waterloo in 1815, was elected President of the Republic, with the strong backing of the banking interests. Shortly thereafter the government took steps to inhibit freedom of the press and of assembly and by means of a new electoral law disenfranchised three million new voters, most of them workingmen. In December 1851, the President seized dictatorial powers and a year later was proclaimed Emperor Napoleon III.

This curious and contradictory man had a genuine feeling for the workers, and in some respects his social ideas were in advance of his day; he even restored the vote to the proletariat. But he was convinced that the stability France so desperately needed could be achieved only by an authoritarian regime. "Though my principles are Republican," he wrote, "I think monarchy best suited to France."

The new Emperor launched France into a period marked by industrial expansion and imperialistic ventures. These ventures started well, with the Franco-British victory over Russia in the Crimean War in 1856 and the French victories at Magenta and Solferino in 1859, which drove the Austrians from Italy. But imperialism ended disastrously in 1870 with the total collapse of the French armies after one month of war against Kaiser Wilhelm's Prussian forces.

Nevertheless, under the Second Empire France grew rich. The government greatly accelerated railway construction, fostered industrial concentration, supported the organization of transatlantic steamship companies, drained marshes, built bridges and roads and ports. At Louis Napoleon's personal direction, Baron Georges Eugène Haussmann rebuilt Paris around a grid of broad boulevards, making it the most beautiful city in Europe and essentially the city it is today.

Life in the capital had never been gayer or more brilliant. The theater was enjoying a rebirth, and Sarah Bernhardt was launched on her elegant career; the works of Gounod held the stage in the new opera house, and the melting melodies of Offenbach filled the music halls. The affairs of the capital and the empire were endlessly discussed in the columns of dozens of newspapers and journals and in the red plush and gilt cafés that had opened along Haussmann's boulevards.

But beneath all this glitter and material prosperity a profoundly skeptical philosophy was growing. Two generations had come to maturity since 1789, and neither had known anything approaching political stability. The revolution of 1848 appeared to have had no lasting consequences at all. The bourgeoisie, as before, were becoming richer

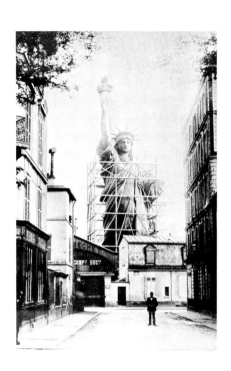

Swathed in scaffolding and towering above the narrow Paris streets, the Statue of Liberty nears completion in the outdoor studio of sculptor Frédéric Auguste Bartholdi, who worked on the 151-foot figure for 10 years. Commissioned by a sympathetic group of French citizens as a gesture of friendship to the United States, the statue, whose proper title is "Liberty Enlightening the World," was taken apart and shipped to New York. There it was erected on an island in the harbor and formally dedicated in 1886.

and the proletariat poorer; restrictions on freedom of expression were as severe as ever; the corruption of the regime and financial scandals involving the great public works programs were plain to see. "The country is a vast public and private Casino," one historian wryly noted in 1863. Belief in the perfectibility of man, which had been nourished by the fall of the old monarchy, was now not so easy to sustain; the mood of society had become negative rather than positive.

It was in this climate of uncertainty and change that Cézanne and the young Impressionists launched their careers. They did so at a time when French painting was more divided in its goals and expressions than it had ever been. The Revolution had altered French art as profoundly as it had other aspects of society, and had so broken up the artistic traditions that the painters of the 19th Century could find no esthetic language to agree upon. The poet Charles Baudelaire, who was also an art critic—and one of the very few Cézanne admired— succinctly summed up the problem in 1846: "We lack a school," he wrote, "that is to say, a faith."

The painters were, in fact, not so much lacking any faith as divided by several conflicting faiths. The first was founded shortly before the Revolution, when rococo elegance, which had prevailed throughout most of the 18th Century in the art of men like Antoine Watteau and François Boucher, gave way to a new classicism. The founder of this "Neo-Classicism," as it was later to be called, was Jacques-Louis David, who was deeply committed to the Revolution and whose works, painted with an almost sculptural realism, were political commentaries on his time.

David's most famous disciple in the 19th Century was Jean-Auguste-Dominique Ingres, who dominated French art during the 1840s and 1850s. As Ingres and his followers understood classicism, it meant the portrayal of historical and mythical scenes in strict conformity with rules established by the Renaissance masters. The Neo-Classic painters turned to the past to learn how to portray what Ingres called "the perfect type of the human figure," the realistic folds of drapery, the balanced "classic" gesture. Although they liked to think of themselves as heirs to the humanistic spirit of Greece and Rome, they seemed more interested in classical formulas for painting than in the classical values of individuality and naturalness; their classicism was usually more a matter of form than substance.

The Neo-Classic painters occasionally made scenes from antiquity stand as parables for affairs in contemporary life, but they rarely painted contemporary life directly. "We prefer," wrote the critic Paul de Saint-Victor, "the sacred groves, where the fauns make their way, to the forest in which the woodcutters are working; the Greek spring in which nymphs are bathing to the Flemish pond in which ducks are paddling; the half-naked shepherd . . . to the peasant, pipe in mouth."

Neo-Classic painting relied heavily on line—at which Ingres was a true master—rather than color. In a famous dictum Ingres insisted that "even the smoke must be expressed by line"; color, in his view, merely added "adornment to painting."

The shining star of the French theater toward the end of the 19th Century was Sarah Bernhardt, who made her stage debut in Paris in 1862, a year after Cézanne first visited there as a young provincial. The "Divine Sarah" was a talented comedienne and monologist as well as a great dramatic actress. She had a number of celebrated love affairs; and also somehow found time to dabble in sculpture and poetry. Shown here, at 36, she wears a crystal-beaded dress of her own design.

Finally, the Neo-Classic painters cultivated a slavishly imitative style that one critic as early as 1848 had denounced as "the precise imitation of irrelevant detail." The public wanted optical illusion—flowers they could almost smell, fruit they could almost taste—and in the canvases of the Neo-Classic painters they found just that.

Although this view dominated the art of the early 19th Century, it was increasingly challenged from many sides. During the second quarter of the century a romantic reaction set in that shifted the sphere of art from society to the individual, insisting that the form created was less important than the feelings and personality of the man who created it. The French painter most completely imbued with this rebellious romantic spirit was Eugène Delacroix. As heir to the great masters of color—Titian, Veronese, Tintoretto, Rubens—Delacroix stressed the importance of color over line, thus putting himself in direct opposition to Ingres. He indicated his opinion of Ingres' commitment to line by saying, "His art is the complete expression of an incomplete intelligence."

Because Delacroix painted in his own way, contrary to conventional preachings, he was, for Cézanne's generation, a symbol of freedom in art. For Cézanne personally he had twofold importance: first, he served as a link to the master colorists of the past and second, he provided what Cézanne called "moral support"—that is, he confirmed Cézanne in his belief that the business of painting was the expression of individuality.

Despite Delacroix's defiance of the Neo-Classic style, he still used in a great many of his paintings the historical, mythical and allegorical themes that had guided the mainstream of European art for generations. As the 19th Century progressed it became evident that these themes would no longer do. The traditional style of history painting seemed to have very little to say to a century shaken by industrial and political revolutions. The critical problem for the art of the time was to find a subject matter that had meaning for the contemporary world.

The most direct answer to this need was offered by the movement known as Realism. The Realists assumed that any subject matter could be treated artistically and that one subject was not inherently more beautiful or more significant than another; by preference they restricted themselves mostly to contemporary themes. The acknowledged founder and leader of the movement was Gustave Courbet, who was easily the most discussed and the most controversial figure in French art in the decade of the 1850s. He seemed to speak for the rebellious temper of all younger painters who mocked what they called "the art of the academies." His declaration of artistic independence was famous: "I, too," he proclaimed, "am a government."

Courbet rejected historical and religious themes and urged artists to paint their own people and their own time—to "bring art into contact with disreputable people." The "disreputable people" in his own canvases were frequently peasants and his portrayal of them delivered a sharp indictment of the existing society.

Such a radical concept of the function of art was frightening to an

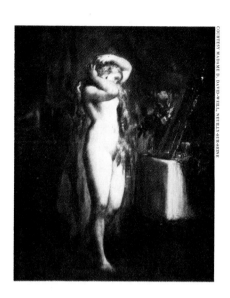

Among earlier painters, Cézanne reserved his greatest admiration for Delacroix. Both as a young artist struggling to find his own way and in his artistic maturity, Cézanne made many copies and adaptations of Delacroix's works. In copying Delacroix's *Le Lever (above)*, Cézanne added the figure of a servant and imposed his own stylistic touch with broad strokes.

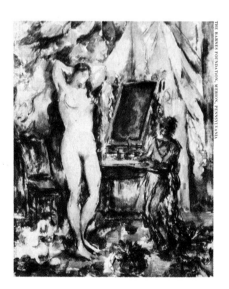

established order anxious to retain the political and economic power it had almost lost in the revolution of 1848. Count Nieuwerkerke, the Imperial Superintendent of Fine Arts, was expressing more than a personal distaste when he said of the work of the Realist school: "This is the painting of democrats, of those who don't change their linen. This art displeases me and disgusts me."

It was not long before an even more unsettling painter came to prominence. He was Édouard Manet, who was interested in a painting for its own sake rather than as an object lesson or an analytical observation. The great importance of Manet, who was linked for a time with the Realists and who would later be linked with the Impressionists, is that he completed the break with history painting that had been dramatized by Courbet. A useful distinction has sometimes been made between Courbet as an "objective" realist and Manet as a "subjective" one: Courbet was interested in the object as object, while Manet was chiefly interested in his own appreciation of the object. In this approach, which stripped subject matter of any narrative or connotative message, Manet can be said to be the first painter of the 19th Century to escape completely from the past. By the 1860s he had replaced Courbet as the leader of all that was modern and experimental in art.

In 1861, then, when Cézanne first went to Paris to study art, the field of painting in France had been agitated for some years by the three powerful and conflicting movements of Neo-Classicism, Romanticism and Realism. The situation was even further complicated by the fact that art was being patronized to an unprecedented degree by the bourgeoisie.

The new patrons valued works of art as symbols of financial success, but they were almost totally uninformed about art, and hostile to anything they failed to understand. Their taste was for vast historical canvases depicting scenes of terror, carnage, torture and violent death (one elaborate title, for example, was *Woman Tied to the Tree from Which Her Husband Had Been Hanged by Order of the Bastard of Vanves, Governor of Meaux in the XVth Century, Devoured by Wolves*); or for confectionary nudes or saccharine scenes of family life called *First Caresses, Grandmother's Friends* or *The Sugar-plums of the Baptism.*

In these preferences, the bourgeois public was merely following the lead of the immensely powerful and rigidly conservative artistic Establishment of the day. The base of power was the Académie des Beaux Arts, to which most of France's commercially successful painters belonged. They had almost all been trained in either the Neo-Classic or a watered-down Romantic style, and they ruled the public conventions of art with a firm grip. As Academy members they decided whose paintings should be purchased by the state, who should receive government commissions for mural decorations and who should be admitted to the Academy's official school, L'École des Beaux-Arts.

They also decided what paintings would be hung at the Academy's all-important Salon, the government-sponsored art exhibit that to a large degree shaped the public's taste. After its establishment in the 18th Century, the official Salon had for a long time exerted a good influence on French painting, stimulating interest in art and giving young

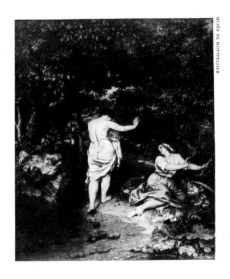

Cézanne's free copy of the Courbet nude bather shown above—he turned the female into a male—emphasizes the massive strength of the figure. The fragment below is all that remains of Cézanne's original, which was partly destroyed when being removed from the wall of the Jas de Bouffan on which it was painted.

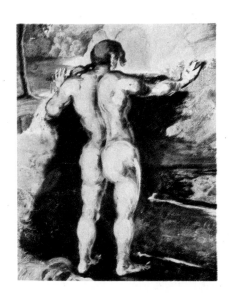

painters a chance to be seen. But it worked less and less well in the 19th Century, when the interests of painting and of the government began to diverge.

The Salon that Cézanne's generation knew had grown out of all reasonable proportions: between 1806 and 1848 the number of pictures exhibited had increased from 707 to 5,180. Furthermore, it had deteriorated into a mere showcase for the academic painters; the chief concern of the members of the Salon jury was to ensure that their own students were represented and to block the admission of paintings that departed from the formulas taught in the Academy. Originality was the unforgivable sin, and the art that did get displayed at the Salon was largely stereotyped and unrelated to intellectual currents of the day. It was, as the contemporary poet Fernand Desnoyers mockingly described it, a "Pandemonium of Greek temples, of lyres and Jew's harps, of Alhambras and tubercular oak-trees, of sonnets, odes, daggers and hamadryads in the moonlight."

To reject this officially sanctioned style—as the Realists did and as Cézanne and the Impressionists did later—was to invite not only abuse but real economic hardship. A painter who was not hung at the official Salon had very little hope of a successful career. The public, uncertain in its own taste, generally refused to buy canvases rejected by the Salon, and some purchasers even demanded and got refunds if the paintings they had bought were unexpectedly refused by the Salon jury.

The first overt sign of revolt against the Academy's tyranny came with the opening of the famous Salon des Refusés in May 1863, six months after Cézanne returned to Paris from Aix. This exhibition was decreed by Napoleon III as an answer to the growing agitation in artistic circles over the restrictive policies of the official Salon. All artists who had been refused by the Salon of 1863 were invited to show their works in the Palais de l'Industrie.

The Salon des Refusés caused a furor. Critics and public alike affirmed their allegiance to the Academy by unhesitatingly dismissing the controversial paintings as the work of incompetents or madmen. In general, the canvases were treated as jokes or worse. One that suffered special attack was Manet's *Luncheon on the Grass*. That painting's theme—a nude woman seated in a landscape with two clothed men—shocked bourgeois Paris and drew angry rebukes from the critics. "The nude when painted by vulgar men," wrote one, "is inevitably indecent."

Cézanne also exhibited in the Refusés, but the titles, number and nature of his works shown there are not known now, and apparently attracted little attention then. The exhibit did serve, however, to increase Cézanne's admiration for the work of Manet, and to acquaint him with his anti-Establishment contemporaries and their works. For these young painters, the resounding public failure of the exhibit had a salutary effect; it drew them together and strengthened their revolutionary convictions.

A great many of these rebellious artists frequented the Café Guerbois in the quarter of Paris known as Batignolles, a name that was soon applied to them. It was Manet who made the Café Guerbois popular with

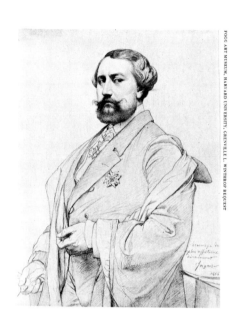

It was to the icily aristocratic Comte de Nieuwerkerke (shown here in an elegant drawing by Ingres) that Cézanne wrote two letters—the first polite, the second angry—protesting his exclusion from the annual Salon in 1866. As France's Superintendent of Fine Arts, the count could presumably have interceded for Cézanne, but he evidently did not do so, nor is there any record of his having answered either of Cézanne's letters. It was 1882 before Cézanne had a picture accepted at the Salon.

the young artists and Manet also who functioned as the intellectual leader of the Batignolles group that gathered there in the afternoons.

The roster of artists in attendance at the café reads like a roll call of the Impressionist movement. Among them was Camille Pissarro, who was two years older than Manet but who had not started painting seriously until he was in his twenties; Pissarro was from the island of St. Thomas in the Danish West Indies. He was often accompanied to the Café Guerbois by Claude Monet, who was back in Paris painting after completing two years of military service with the French army in Algiers. Somewhat younger were Armand Guillaumin, who supported himself digging ditches three nights a week for the Department of Bridges and Highways; Frédéric Bazille, scion of a family of rich winegrowers, who was painting while preparing to be a doctor; Pierre-Auguste Renoir, a tailor's son who was studying at the École des Beaux-Arts; and Alfred Sisley, son of a wealthy British silk importer in Paris, who had rejected a post in the family business to follow a painting career. Manet's authority over the group was often challenged by Edgar Degas, a witty and irreverent young aristocrat whose early exposure to the Louvre and the finest private collections of Paris equipped him with perhaps the surest artistic taste of any of his contemporaries.

Cézanne did not fit easily into this convivial society. Many years later Monet recalled him at this period as being negligent in his dress —in winter he wore a battered black felt hat and a shapeless overcoat streaked green with age—vulgar in his language and withdrawn and suspicious in his manner. When he met the others at the Guerbois he would ostentatiously pull up his sagging trousers and shake hands all around, omitting only Manet, whose elegant dress and mannerisms annoyed him. "I do not shake your hand, Monsieur Manet," he would say in the exaggeratedly nasalized Provençal accent he sometimes affected; "I have not washed for a week." If Cézanne decided to remain at the café, Monet recalled, he would sit broodingly apart from the others, taking no apparent notice of the conversation until somebody expressed an opinion with which he disagreed. He would then leap to his feet and stride off without saying a word. To an artist friend not in the group, he later said of the habitués of the Guerbois: "They're a lot of bastards; they dress as smartly as solicitors!"

Cézanne himself at this time, though only in his late twenties, looked almost like a middle-aged man. The existing photographs of him show that he aged very rapidly in appearance after about 1870, partly because of encroaching baldness. Monet and most of the others attributed his social eccentricity to a desire to shock. But Zola, remembering their youth together, saw in it "the cold rage of a tender and exquisite soul who doubts himself and dreams of being dirty." In his depressed moods, Cézanne often withdrew to his studio, shutting the door on everyone. Periodically during his early years in Paris he disappeared in this way for weeks at a time.

He worked steadily and with great concentration. His mornings were spent sketching from the nude at the Atelier Suisse, his afternoons working either at the Louvre or in his studio—where he lived, accord-

ing to Zola's recollections, amid a litter of old paint tubes, discarded canvases and dirty plates and saucepans. In the evenings from 7 to 10, he sketched again at the Atelier Suisse. For a time he joined a group of friends, mostly from Aix, who met Thursday evenings at Zola's apartment to discuss poetry and painting; intermittently, he saw something of Monet, Renoir and Pissarro, the three painters among his contemporaries with whom he felt most at ease.

Cézanne was eager for fame and painted furiously to achieve it. But he also seemed compulsively to reject it. He once called the Academy's Salon judges "idiots, bastards and eunuchs," and he told Pissarro that he wanted to "make the Institute blush with rage and despair." He set about this by giving his canvases scandalous titles, such as *Woman with Flea*, and submitting them on the last hour of the last day, occasionally trundling them up to the door in a handcart. Impelled by these mixed motives, Cézanne submitted paintings to the Salon every year from 1865 through 1870, and every year, not surprisingly, his canvases were rejected. His work, it was said by one jury member in 1866, looked "as if it had been painted with a pistol."

The other painters of the Batignolles group had scarcely better luck with the jury, despite their efforts to get recognition, and despite the flamboyant literary efforts of Zola on their behalf. Zola was then working for the newspaper *L'Événement*, and he received a special assignment to review the Salon of 1866. In an opening notice he declared his intention of exposing the Salon jury: "I shall no doubt annoy many people, as I am quite resolved to speak awkward and terrible truths, but I shall experience an inner satisfaction in getting off my chest all accumulated rage."

He did, indeed, annoy many people, and so many indignant letters poured in—"Improve your criticism a little by putting it in hands that have been washed," read one—that *L'Événement* was forced to drop Zola's series after only eight of the planned 18 articles had appeared. He immediately reprinted his articles, however, in a pamphlet titled *Mon Salon*, with a dedication to Cézanne.

Zola was passionately interested in the young painters' cause, but his approach was essentially journalistic rather than esthetic. It is likely that the person who benefited most from his controversial campaign was Zola himself: his art criticism brought him his first measure of fame, or at least of notoriety.

Zola understood very little of what the painters were trying to achieve artistically, and he was especially puzzled and disappointed by Cézanne's art. He never praised Cézanne in the *L'Événement* articles, and in his wordy dedication of *Mon Salon* to Cézanne, Zola speaks not once of the artist's work but only of their long friendship.

Zola's lack of appreciation is not surprising, however. Cézanne's art baffled many people, including many painters far better equipped technically to evaluate it than Zola was. In fact, no one recognized Cézanne's genius at this time, and once again Paris, where success was so hard to find, began to depress him. He took to returning to Provence at intervals, thus establishing a pattern of living that he was to follow

until the last years of his life: part of the year in Paris or environs, part in the south, where he usually lived with his family at the Jas de Bouffan.

In his studio there Cézanne painted portraits of a few friends and members of his family—particularly his father and his uncle Dominique Aubert, brother of Madame Cézanne and a bailiff in Aix. Perhaps because she was too shy to pose, he never painted a formal portrait of his mother, although she has been tentatively identified as the model in one drawing and one painting *(pages 26-27)*.

Knowing what we do of Cézanne's personality, it is not surprising to find in his letters and in the reports of his friends that his painting was not a joy to him but a compulsion. He experienced none of the unaffected happiness that Renoir found in his work, nor did he ever know the "kind of paradise" Matisse remembered being carried to when he first took up a brush. Every evening, Cézanne wrote to Zola, he felt "a black depression" coming over him, and he spoke again and again in his letters of "apathy" and "lethargy." In fact, nothing is stranger in the strange character of this immensely prolific man than the recurrent illusion that he had no serious interest in doing anything at all. "Life for me is beginning to be of a sepulchral monotony," he wrote one summer to a friend. "I paint to divert myself."

The diversion lasted for more than 40 years, and in the course of that long career his art underwent a transformation so profound that at times it is difficult to see in the young rebel from Provence any signs of the great painter he was to become. "In all the history of art," writes the critic René Huyghe, "there has seldom been a painter whose early style differed so greatly from that of his maturity."

Looking at Cézanne's career now, we can see that it evolved in four distinct stages, although it is not possible to determine precisely when one stage ended and another began. All through his life Cézanne returned to earlier forms and methods and juxtaposed chronologically different techniques within a single painting. Cézanne rarely signed or dated his paintings, and he labored over them for long periods, often abandoning them and returning to them many months later. The dates assigned to them by art historians are often only educated guesses. Nevertheless, his work can be said to have moved from a vividly emotional early stage into one in which the techniques and color theories of Impressionism had a strong effect; then came the development of a controlled, mature style that the critic Lionello Venturi has labeled "constructive"; finally came a period of synthesis during which his painting, incorporating elements of all the previous styles, became freer and more nearly abstract.

In the first stage, which lasted until the early 1870s, Cézanne was groping for a means to express his intense inner agitations. He was looking not only for a technique but for a subject matter, and the task was not an easy one. He might reject the "art of the academies" and with it the conventions of history painting, but he had a strong literary bias and a compulsion to commit to canvas the passionate fantasies of his adolescent poetry. Torn between old masters, new realists and

Over the years, Cézanne's active imagination took nourishment from many sources. One youthful work was an adaptation of the fashion print *(above)* which appeared in *L'Illustrateur des Dames*, a magazine that his sisters read. In his own version, Cézanne placed his sisters, Marie and Rose (wearing their own gowns), in the same poses as the women in the print, but added two of his friends in the background to add interest to the scene.

what he knew of the French romantic tradition, emotionally uneasy and technically unsure, he found his way slowly, haltingly and with many misgivings, as he was to do throughout his career.

"I am one of the intense ones," Cézanne once remarked to a friend, and his early group compositions amply demonstrate what he meant. While contemporaries like Pissarro and Monet were painting pastoral scenes in the countryside around Paris, Cézanne was painting erotic and often violent pictures *(pages 24-25)* that disturbed and puzzled his friends. Some of the dreams that were haunting him during this period are apparent from the titles he gave his canvases: *The Rape, The Orgy, The Strangled Woman, The Courtesans, The Murder, The Temptation of Saint Anthony, The Autopsy, The Abduction.*

Cézanne laid the paint on vehemently with a fully loaded brush in thick ridges and lumps, exaggerating lights and shadows, juxtaposing violently contrasting areas of color. He used black a great deal and also various dull browns and reds, which he liked to silhouette against lighter greens, blues and grayish whites. He favored swelling, undulant forms—clouds, trees, draperies, hills and haunches.

The results he achieved were full of shortcomings: his figures are sometimes awkwardly arranged and out of proportion, and space is unconvincingly defined. There is too much dependence on narrative and too little dependence on form. Yet it must be added that the pictures, full of conviction and bursting with physical energy, movingly reveal the intensity of the emotion that inspired them.

Cézanne apparently tried to sell some of these early paintings but with no success. A letter of January 1867, to Zola from Antony Valabrègue, a poet friend of Cézanne's, reveals that the artist sent an unidentified painting to a dealer in Marseilles at about that time: "There has been a great deal of fuss," wrote Valabrègue. "Crowds gathered in the street outside. They were astounded. People wanted to know who Paul was. From that point of view there has undoubtedly been a certain excitement and success due to curiosity. However, I think that if the picture had been exhibited any longer, in the end the window would have been broken and the canvas destroyed."

Looking now at Cézanne's violent and extravagant early group compositions, it is easy to understand why Roger Fry, in the 1920s, called him "the first wild man of modern art." But in fact, Cézanne at this time was struggling hard to overcome the "wild" temperament of his early years, to control it with a more objective discipline.

When Cézanne the observer succeeded in subordinating Cézanne the visionary, he showed a marked predilection for the straight line rather than the baroque curve and for an austere, almost architectural arrangement of form. In this vein is the remarkable series of portraits of his Uncle Dominique *(page 27)* painted between 1865 and 1867.

What is immediately striking about the portraits is the apparent discrepancy between the agitation expressed in the thickly pigmented surfaces and the impulse to stability and order evident in the starkly simple forms. And yet this discrepancy is a source of their strength. Working rapidly with a palette knife, Cézanne achieved in the best

of the series an effect, characteristic of his later work, of both containment and immense tension.

The same elements are present in the artist's audacious portrait of his hunchback friend, *Achille Emperaire (page 28)*, painted probably in 1868. Against the flowered upholstery of a high-backed armchair —it appears again in a portrait of his father *(page 21)*, and in *A Young Girl at the Piano (pages 26-27)*—Cézanne showed the figure of Emperaire seated full face, in an attitude of extreme simplicity. The rigid symmetry of the pose is relieved only by the position of the hands and by the slight turn of the head, which seems to dwarf the spindly body. For the forceful, vibrant use of color and for the architectural severity of the composition there was no precedent in Cézanne's time. Indeed, *Achille Emperaire*, which was rejected at the Salon of 1870— and which now hangs in the Louvre—made the work of most of Cézanne's contemporaries seem conventional by comparison.

Neither still life nor landscape yet preoccupied Cézanne as they would later, but he nevertheless produced distinguished examples of each in these early years. Without question the most accomplished still life of the early period is *The Black Clock (pages 30-31)*, which Cézanne gave to Zola. In its stability, its strong delineation of forms, its rhythmic repetitions, this picture gives evidence of a new deliberation in Cézanne's method. The objects in it have been carefully selected and their composition carefully balanced, although the thickness of the paint, the disarrangement of the napkin, the odd, spiky shapes of vase and shell still suggest the vehement personality of the artist.

In a landscape called *The Railway Cutting (page 30)*, Cézanne demonstrated strikingly the measure of his success in bringing his temperament under control on canvas. In *The Railway Cutting*, impetuosity and abandon have been partly replaced by reflection, calculation and restraint. The view is from the garden of the Jas de Bouffan: the garden wall extends like a bar across the entire picture; in the middle distance are the railroad tracks and in the far distance, Mont Sainte-Victoire. Cézanne has greatly simplified the scene, stressing its horizontal rhythms of foreground, wall and horizon, balancing a few large forms against one another, muting his lighting effects to give an evenness of color to the entire canvas. The peculiar sense of desolation that seems suggested by the scene is as much a function of Cézanne's technique —the muffled color, the isolation of forms in space—as it is of the things depicted. In this respect, the picture is a prefiguration of the great landscapes to come.

Not all the canvases Cézanne painted at this time showed such progress. They varied greatly in quality, style and degree of indebtedness to other painters. Yet all of them conveyed a sense of what Renoir, many years later, called Cézanne's "crude and admirable" power.

And in such works as *The Railway Cutting* and *The Black Clock*, he showed that he had finally come to terms with this turbulent creative force to fashion the beginnings of an artistic language of his own. In his painting—and coincidentally in his personal life—he was about to take a new course.

A Time of Turbulence

France in Cézanne's time was in a state of turmoil that extended into every sphere of life. Politically the nation shifted dramatically from republic to dictatorship and back to republic. In 1851, the elected President of the Second Republic, Louis Napoleon, assumed the title of Emperor. In many ways he was an enlightened ruler and his reign was prosperous. He built up an extensive railroad system; he had Paris redesigned with broad boulevards and spacious plazas, and he arranged international expositions to display the remarkable achievements in science and engineering. The artistic world flourished, too, under the leadership of such creative personalities as the composers Offenbach and Gounod, the novelists Flaubert, Merimée and George Sand and painters Delacroix, Ingres, Daumier, Courbet and the revolutionary Manet.

But Louis Napoleon's reign came to a disastrous end in 1870 when he declared war on Prussia and was humiliated by a swift defeat. A period of near anarchy followed. When peace was restored, the new Republican government was forced to contend with political instability and shattering scandals abroad and at home.

Though Cézanne lived in this world, he was never a part of it. Staying mostly in the provinces, he seemed to have remained largely untouched by the events around him. Still he was not unaware of what was happening; he once said, "I do not understand the world. That is why I have withdrawn from it."

Helmeted and holding a sword, a symbolic figure of France stands guard over fallen soldiers in a contemporary painting of the Franco-Prussian War by Ernest Meissonier. Like a number of other French artists, Meissonier saw active service in the army.

Ernest Meissonier, *The Siege of Paris*, 1884

Louis Napoleon lost both the war and his crown.

Otto von Bismarck led the victorious Prussians.

A magazine illustration printed during the siege of Paris shows a butcher shop in the city offering its customers "Meat, canine and feline," and "rats."

In the summer of 1870 Emperor Louis Napoleon, fearful of Prussia's increasing power under Bismarck's leadership, declared war. Cézanne hid in Aix to avoid being drafted, but most Frenchmen eagerly welcomed the war: the streets of Paris rang with cries of "Vive la guerre." However, the French were ill prepared, and in little more than a month Louis Napoleon was defeated in combat and forced to surrender at Sedan. When the disastrous news reached Paris a mob of citizens stormed into the Chamber of Deputies, installed a new government, the Third Republic, and decided that they could hold Paris against the Prussian army. They did. But five months of Prussian siege of the city *(below)* starved the people into eating dogs and rats to keep alive *(below, left)*. In the end the exhausted French accepted Bismarck's peace terms. Though humiliated, the nation quickly regained its former prosperity.

A French soldier raises the flag of surrender at Sedan.

During the siege of Paris 236,000 Prussian soldiers shelled the city. But French civilians and soldiers made Paris a fortress and kept the enemy out.

48

A symbol of France's postwar prosperity, the lacy 984-foot-high Eiffel Tower stood guard over the Paris Exposition of 1889 *(left, below)*. It was built by Alexandre Gustave Eiffel *(on lower steps at right)*, an engineer who pioneered the use of iron for bridge-building and was later to make important contributions to the new science of aerodynamics. It took four years of planning and two more years of construction for the tower to rise to its full glory *(left)*. For the finished spire, Eiffel apparently had the same fondness as he did for his own children—he lived and worked for many years in an apartment that he built at its summit.

Although such expositions concentrated on technology, they also displayed achievements in the fine arts. The fair of 1889 exhibited a canvas by Cézanne, *The House of the Hanged Man (page 66)*. But it was shown only at the insistence of the artist's patron Victor Chocquet, who refused to exhibit some valuable furniture unless his friend's painting was hung. It was placed, however, so near to the top of the gallery that it was almost impossible to see, and as far as is known, Cézanne himself never took the trouble to go and look at it.

A cartoon mocks Zola's concern with minute detail.

The leading literary figure in Cézanne's world was his boyhood friend, Émile Zola. In one of those curious coincidences of history, these two men from the same small town caused the greatest artistic furor of their age, although for years they both struggled in obscurity. Zola was the first to achieve recognition. Like Cézanne, he had been condemned for seeking a new method of expression, which he found in naturalism, a down-to-earth treatment of life that omitted no sordid detail and blinked at few aberrations of human character. The public, and particularly the press, reacted with shock and horror to Zola's writings. *L'Assommoir*, his first popular novel, was the story of the degeneration of a washerwoman, and the press cried, "A calumny on France . . . a mass of filth that should be

Before he became famous and fat, Zola posed for this photograph with his publisher and illustrator.

handled with forceps. . . . Literary gutter cleaner." Newspapers published cartoons like the one at left ridiculing his naturalistic style. "It was no longer a criticism," Zola recalled, "it was a massacre." Yet the book sold 100,000 copies in a few months. A sequel, *Nana*, the story of a prostitute, drew even greater abuse but it was a huge financial success. With its proceeds Zola lavishly decorated the country home he had bought at Médan. There he enjoyed entertaining his literary and artistic friends. Cézanne was a frequent visitor until 1885, when he stopped coming altogether, declaring that Zola's "bourgeois" life disgusted him. The two men never saw one another after July of that year—within nine months they also ceased to correspond.

Nana was seen as a goddess in a slop bowl.

At Médan Zola works at the huge carved wooden desk that Cézanne thought made him look like a pompous minister of state.

Shown here before his trial, Dreyfus was a model officer.

On December 22, 1894, an event occurred that would cause all the smoldering antagonisms in turn-of-the-century France to erupt, dividing the nation into two warring camps. Captain Alfred Dreyfus, the only Jewish officer on the French General Staff, was accused of selling military secrets to the Germans. Although the evidence against him was ridiculously flimsy and contrived, he was sentenced to life imprisonment on Devil's Island. Four years later Dreyfus' friends and family produced evidence that a Major Esterhazy was the traitor. Under this pressure and anxious to refute charges of anti-Semitism, the corrupt General Staff agreed to try him, but to save face they assured Esterhazy that he would be acquitted. Dreyfus remained on Devil's Island. France's liberal intellectuals were enraged: Zola published a vitriolic 20-page letter, "J'Accuse" (right), to the President of France asserting Dreyfus' innocence and naming the guilty parties. The whole nation was aroused. The issue had gone far beyond the question of Dreyfus' innocence, and had taken on religious, military and political overtones. Many artists sided firmly with Dreyfus, but Cézanne, living in Provence, allied himself with the provincial anti-Dreyfus conservatives. The affair was finally settled in 1906, when Dreyfus was completely exonerated.

Stiff-backed, Dreyfus stands in the dock at his first trial. The evidence against him consisted mainly of confusing reports from handwriting analysts.

A cartoon shows Zola pricking the Army with his pen.

Zola's letter to the President of France was published in the liberal Paris paper, *L'Aurore*.

Dreyfus—aged and whitehaired—returns triumphantly to Paris after his release from imprisonment.

III

The Belated Apprenticeship

In 1869, during one of his periodic stays in Paris, Cézanne took a mistress. The liaison was highly significant for Cézanne because it was the first time he had formed any kind of steady relationship with a woman, and because it was to last the rest of his life.

The young woman's name was Marie-Hortense Fiquet, and she was 19 years old, 11 years younger than Cézanne. She was born in the small town of Saligneil in eastern France but had moved to Paris with her family when still a child. Her father in 1869 was modestly employed in a bank, and Hortense earned her own living by sewing the bindings of handmade books. It has been said that she supplemented her income by doing occasional modeling, but this may be a legend invented to explain how she met the artist. Almost nothing else factual is known of Hortense at the time she began living with Cézanne.

Cézanne made more than 40 pictures of Hortense over the years (*pages 104-105*), but since he seldom attempted an exact likeness in his portraits, they do not provide us with a clear image of her. From them, however, it may be fairly judged that she was not a beauty. She had dark hair and eyes, a rather rectangular face and a strong jaw. The jaw is particularly evident in the two existing photographs that were made of her many years later.

No correspondence between Hortense and Cézanne survives, so we must rely for our knowledge of her character on the reports and letters of the artist's friends. Generally they adopted a derisive tone toward her. She was apparently gregarious where Cézanne was withdrawn, conventionally "bourgeois" where he was strenuously eccentric. She had no interest in the two things that absorbed Cézanne—literature and painting. When she ventured an opinion on art in the presence of others, Cézanne quickly silenced her by insisting that she was "only talking nonsense." He was later to describe her as being interested in "nothing but Switzerland and lemonade," and his friends called her *La Boule*—"The Ball"—possibly because they felt that she was an intolerable burden to Cézanne and a fetter on his freedom. Cézanne evidently shared this sentiment, for he spent a great deal of his life

Seated in the garden of his friend Camille Pissarro, who stands at right, Cézanne, paunchy and prematurely bald, looks far older than his 38 years in this photograph taken in 1877. The patient and sympathetic Pissarro was among the first to recognize Cézanne's genius. He once advised his son Lucien (standing between two unidentified men), "If you want to learn to paint, look at Cézanne."

separated from Hortense even after he finally married her in 1886.

What remains tantalizingly unexplained is the emotional tie that preserved this curious relationship for nearly 40 years. Three years after they met, their only child was born—a son, Paul, who was both recognized and registered by Cézanne. The arrival of this child undoubtedly helped keep them together and so, one assumes, did Cézanne's customary inertia. Cézanne's friends apparently believed that the source of Hortense's devotion was the prospect of Cézanne's future inheritance. And yet we must assume some measure of real affection, at least on Cézanne's side, for in his late correspondence with his son he asks after Hortense with interest and, when she was in poor health, with apparent concern. Whatever the tie that linked him to her, he was involved with her until the end of his life.

In July 1870, the French government declared war on Prussia and threw France into a turmoil of preparation. To escape the bustle and avoid the possibility of his being called up into the army, Cézanne and Hortense left Paris for the town of L'Estaque, a Mediterranean fishing port that was also an important center for the tile industry because of its abundant natural deposits of fine white clay. Aix was only 15 miles inland, and Cézanne's mother apparently owned a small vacation house in L'Estaque. It is natural that Cézanne would take refuge there.

Cézanne's reluctance to serve in the army, while completely in character with his idiosyncratic detachment from the events of his day, was nevertheless shared by many other Frenchmen in that chaotic summer of 1870. The war was popular in some quarters but not in others, and the country was disastrously ill prepared. The army lacked uniforms, ammunition and adequate stores of food; the general staff was without maps of the frontier; soldiers were assigned to units that did not exist.

Under the circumstances, Cézanne or anyone else who wished to avoid conscription could do so without much difficulty. The police did visit the Jas de Bouffan once with the intent of arresting Cézanne for not responding to the general mobilization call. His mother, while inviting them to search the premises, assured them that her son had left several days earlier and that she would notify them as soon as she knew where he had gone. The search for him, if there was one, was apparently not very thorough, for he lived out the rest of the war at L'Estaque undisturbed by the police.

He was caused considerable anxiety by his father, however, from whom he was concealing his liaison with Hortense. As Louis-Auguste grew older he became increasingly obsessed with the idea that his fortune was threatened by thieves; he would inevitably include in this category any adventuress with whom his only son became involved. Cézanne apparently feared that if the liaison were discovered his allowance would be reduced or cut off—a fear that was to prove quite justified when the secret finally came out eight years later.

Shortly before leaving Paris for L'Estaque, Cézanne had served as a witness at the wedding in May 1870 of Zola to Alexandrine Meley. She was a former salesgirl in a Paris flower shop who had been Zola's mistress for five or six years. Zola by this time was well launched on

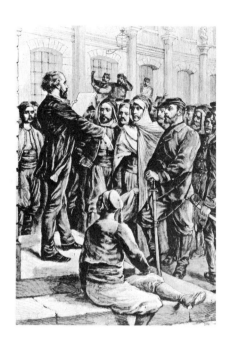

Like Cézanne, who avoided conscription in the army, many other Frenchmen were opposed to or apathetic about their country's involvement in the Franco-Prussian War. But after Napoleon III's disastrous defeat and the assumption of power by a new Republican government, men like Léon Gambetta, the Minister of the Interior and War, attempted to arouse a fresh martial spirit. In the engraving above, Gambetta is shown talking to his troops, among whom are the exotically costumed Zouaves. Despite Gambetta's efforts, however, France was forced to capitulate to the Prussians.

a literary career, although he was not yet famous. In 1866, with characteristic energy, he had written two melodramatic potboilers designed to bring him, as he admitted, the "two things I need above all else—publicity and money." These early efforts brought him neither, but his next two novels, *Thérèse Raquin* and *Madeleine Férat*, published in 1868, at least stirred a certain interest, either indignant or prurient, because of their frank exploration of the causes and consequences of two adulterous love affairs.

In 1869 he began work on a long series of novels—he originally planned 10, but the series grew to 20—telling the "natural and social" history of a family under the Second Empire. Zola called the fictitious family, and the series, *Les Rougon-Macquart*, and he worked on it for the next 24 years. In it Zola described Aix, under the name of Plassans, and many of his old friends also appeared thinly disguised, including, of course, Cézanne.

The introductory novel of the series, entitled *La Fortune des Rougon*, was completed in 1869 and began to be serialized in the newspaper *La Siècle* in the summer of 1870, only to be interrupted by the outbreak of war. Zola, as the sole son and support of a widow, was exempt from military service; but as the Prussian armies threatened Paris, he feared for the safety of his wife and took her to Marseilles, where for a time he fitfully published an unsuccessful newspaper.

Five miles away, in L'Estaque, Cézanne was becoming more and more absorbed in the drama of colors and forms along the rocky coast and in the arid hills behind the town. Zola included in his notes for his later novel *L'Oeuvre* an exact description of L'Estaque and environs as they looked at the time:

"A village just outside of Marseilles, in the center of an alley of rocks that close the bay. . . . The arms of rock stretch out on either side of the gulf . . . and the sea is but a vast basin, a lake of brilliant blue when the weather is fine. The coastline . . . is bordered with factories that sometimes let out high plumes of smoke. The village, its back against the mountains, is traversed by roads which disappear in the midst of a chaos of jagged rocks. . . . Nothing equals the wild majesty of these gorges hollowed out between the hills, narrow paths twisting at the bottom of an abyss, arid slopes covered with pines and with walls the color of rust and blood. High up, above the black border of the pines, is placed the endless band of the blue silk of the sky."

Cézanne was to treat this challenging landscape in many different ways during his life, but in his first artistic exposure to it in 1870 he was particularly concerned with a problem that was much on his mind at the time—namely, how to be faithful to both nature and his feelings. He wanted to paint what he saw, but he also wanted to paint what he felt about the things he saw. He still wavered at this period between impetuosity and restraint, and what he badly needed was a method of rendering nature faithfully but feelingly.

It was natural that in his search for a method Cézanne would turn to his old friends in the Batignolles group. The whole group had become intrigued with the problem of how to portray nature accurately. Most

Édouard Manet

Although Cézanne knew the painters
Manet *(above)* and Degas *(below)*, he was
ill at ease in the presence of these elegant,
witty and sophisticated men. He once
grumbled that Degas lacked "guts" in his
painting, and said that Manet "belches
tone, but lacks harmony." Nonetheless, he
so admired the latter's *Olympia*, that he
said, "Our Renaissance dates from it."

Edgar Degas

of them had grown increasingly to feel that painting had become so
hobbled by convention that artists had lost the simple ability to see.
The trouble was that for generations artists had painted landscapes in
the studio, using sketches they had made in the open. Cézanne's re-
bellious contemporaries advocated a quite different technique—that of
plein air painting, or painting out-of-doors. The artist Eugène Boudin
had begun painting out-of-doors as early as 1850, but the technique
was still considered highly radical when Pissarro and Monet began to
practice it in the mid-1860s.

"I remember," wrote Pissarro many years later, "that though I was
full of ardor, I did not have the slightest idea, even at the age of 40, of
the profound aspect of the movement that we pursued instinctively.
It was in the air."

The movement, of course, was to become Impressionism, and it would
not be many years before the term would stand in the minds of the
public and most critics for all the dangerous, revolutionary, anti-
academic currents in contemporary art—for any painting, in fact, with
which they disagreed.

The Impressionists believed that there were no essential and un-
changing forms in nature—there were only passing impressions of form,
subject to continual modification by changing atmospheric and light
conditions. It was the artist's task to capture these impressions. "One
does not paint a landscape, a seascape, a figure," said Manet. "One
paints an impression of an hour of the day."

Accordingly, the Impressionists moved their easels outside, and be-
gan recording nature's moods. Monet, Sisley and Pissarro painted many
winter scenes in the countryside around Paris, trying to capture the
subtle play of color on snow. Equally fascinated with the effects of
light on water, Pissarro painted the Marne at Chennevières while Monet
and Sisley, with Renoir and Manet, painted the Seine at Argenteuil—Mo-
net in a specially fitted houseboat. Bazille, Renoir and Monet became
absorbed in the dappled effects of sunlight shining through foliage onto
tablecloths, summer dresses, rocks, grass, faces, nude bodies.

When the Impressionists took their canvases outside they took with
them palettes full of bright, pure colors that lent a new shimmer and
radiance to their works. They used unmixed pigments which they laid
on in short, vivid strokes to convey something of the multiplicity of
color and light effects in nature. This technique—often referred to as a
"broken-color" technique—led to a blurring of outlines, so that forms
seemed to be partly dissolved. Dissolution of form became particularly
noticeable in the paintings of Monet *(page 65)*, even though in Le
Havre, where he was brought up, he had enjoyed a reputation as a car-
icaturist, with all the talent for line that caricature requires.

Although the Impressionists were derided for many years, the ef-
fects of their technical innovations were felt, if not acknowledged, rath-
er quickly. As early as 1876, a contemporary critic noted that works in
the official Salon were becoming lighter and brighter, showing the influ-
ence of the vivid Impressionist palette. It was, the American collector
Duncan Phillips observed many years later, as if the Impressionists had

opened a window on 19th Century art, letting the air and daylight in.

With the light came new subject matter: boating parties, picnics, dances, the world of the theater and the world of sport, girls in spangled dresses, bathers in candy stripes and bathers in the nude, bridges and railway stations, leafy river banks, the streets of Paris aflutter with flags. It was, on the whole, the vision of the 19th Century middle-class city dweller, who saw the world around him as a constant diversion. Manet found much of his inspiration in the diversions of polite society, at the Folies-Bergères, in the Tuileries gardens; Degas found it at the race track or ballet, Renoir in the faces and forms of Parisian women, whom he painted with such verve that the novelist Marcel Proust observed that one no longer saw women on the streets of Paris, one saw Renoirs.

In the fall of 1871, however, when Cézanne returned to Paris after his self-imposed exile in L'Estaque, Impressionism was still only "in the air." Its proponents, then known vaguely as the Batignolles group, were just beginning to reassemble after having been scattered by the war. Pissarro and Monet had taken refuge in London. Renoir was called up and spent his military service training cavalry mounts in the Pyrenees. Manet and Degas remained in Paris, both serving in the artillery. Only one of the Batignolles group failed to survive the war. Frédéric Bazille enlisted in the third regiment of Zouaves, celebrated for the unusually difficult and dangerous nature of their missions, and was killed in action on November 28, 1870.

Among all the Batignolles painters, Camille Pissarro was the one whom Cézanne felt he could most trust to help him in his search for guidance in the painting of landscape. Not only was Pissarro older by nine years and more experienced, but he apparently was also a born teacher and a remarkably sensitive and tolerant critic. He helped advance the careers of dozens of painters—including some, such as Gauguin, whose character he thoroughly disliked. Cézanne years later spoke of "the humble and colossal Pissarro" almost reverentially: "Pissarro was like a father to me . . . something like the good Lord."

It is clear that Cézanne needed someone to turn to at this time. In January 1872 the birth of his son Paul introduced a new complication into the artist's life. Since his father still did not know about Hortense, Cézanne obviously could not take the baby to Aix; but Paris, as usual, was getting on his nerves. He became so impatient and irritable that he alienated even the most loyal of his friends. "I have found him forsaken by everyone," wrote Achille Emperaire after an unhappy visit of a few weeks with Cézanne. "He no longer has a single intelligent or affectionate friend."

Pissarro was perhaps the one man who had the tolerance and patience to deal with Cézanne's prickly moods. So when he offered hospitality as well as help with his painting, Cézanne gratefully took Hortense and the child to join Pissarro in the town of Pontoise, in the green Oise valley. Here, and later in nearby Auvers, he served what Roger Fry has called "his first and only apprenticeship."

For a man to whom any kind of social intercourse was difficult, the tranquil atmosphere of Pontoise and its environs was ideal. Pontoise

Claude Monet

Cézanne's erratic behavior toward people extended even to his painter-friends Monet *(above)* and Renoir *(below)*, whom he alternately abused and praised. He described Renoir as having "vast talent" and yet said "I do not like his landscapes; they are woolly." On one occasion he denounced Monet as being "sly," but nevertheless esteemed him as "the greatest of us all."

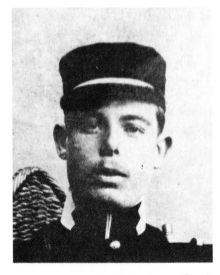

Pierre-Auguste Renoir

itself was a town of some size, surrounded by orchards, but Auvers, where Cézanne moved at the beginning of 1873, was still a village, its narrow streets unpaved, its stone cottages thatched. Stretched out along the Oise River and partially hidden by chestnut trees, it was protected in the rear by a gentle hill from the top of which one could see wheat fields rolling away to the horizon.

In these idyllic surroundings, Cézanne and Pissarro worked together, tramping around the countryside and painting directly from nature. For Pissarro, *plein air* painting was an article of faith, and he pursued it with a missionary zeal that seems almost visibly manifest in the ample, patriarchal beard we see in photographs of him taken at the time. The two artists—both in heavy boots and broad-brimmed straw hats—set up their easels in the roads and meadows around Pontoise, sometimes painting together and sometimes independently, but always trying to record accurately what they saw.

The most immediate effect of Cézanne's stay in Auvers and Pontoise was to confirm him in his inclination toward landscapes and still lifes and away from visionary subjects. He continued throughout his life to paint occasional canvases based on his inner visions, but after the mid-1870s the scene before him became more and more important.

As the two artists worked together, Pissarro showed Cézanne that form could be achieved by color as well as by line; that it is important to record the reflections that colors cast on their surroundings; that a picture should not be attacked piecemeal but that all sections of it should be advanced at the same time. Pissarro clarified and lightened Cézanne's palette and urged him to do away with heavy earth colors. "We are perhaps all derived from Pissarro," Cézanne said years later. "Already in '65 he had eliminated black, bitumen, sienna and ochres."

In addition to introducing Cézanne to lighter, brighter colors, Pissarro also suggested to him the advantages of the Impressionist broken-color technique and short brushstroke. Cézanne adopted both of these with modifications. Although he returned occasionally to his early practice of laying on paint with a palette knife or in sweeping strokes with a broad brush, Cézanne at this time began to favor the short strokes that were to become almost a signature in his work. These brushstrokes at first were similar to the loose, free strokes of the Impressionists; however, Cézanne gradually developed the technique of using uniform, rectangular strokes arranged in a diagonally parallel direction (usually slanting from upper right to lower left) across the surface of the canvas. Eventually, he altered the direction of his brushstrokes, not only in different paintings but in different sections of the same painting. But he took care to see that in each section the strokes were similarly shaped and that they fell in strictly parallel directions. It is this continuity of brushstroke that gives Cézanne's canvases their woven, almost carpetlike character and also the sense of rhythmic movement of such works as *The Château at Médan (page 152)*.

Cézanne worked with Pissarro intermittently through 1872, 1873 and the first half of 1874. His will to learn was immense and his capacity for work apparently inexhaustible. At Pontoise and Auvers he

At a time when he was almost unrecognized, Cézanne found an ardent admirer in Dr. Paul-Ferdinand Gachet *(above)*. An enthusiastic amateur artist, the doctor was an eccentric who spent as much time making friends with avant-garde painters as he did in the practice of medicine. One of these friends, Pissarro, introduced him to Cézanne. Gachet also knew Courbet, Manet, Monet, Degas, Renoir and Van Gogh; the latter immortalized the doctor in several stunning and now famous portraits.

produced oils, watercolors, drawings, pastels, even etchings. Cézanne copied a painting of Pissarro's to get a better understanding of the older painter's technique and palette. He went out in the mornings and again in the afternoons, on bad days as well as good, gradually forging a new language to convey his art. One day he was discovered on the banks of the Oise by the established landscape painter Charles Daubigny. "I have just seen an extraordinary piece of work," Daubigny wrote to a friend. "It is by a young and unknown man, a certain Cézanne."

The question of whether Cézanne was or was not an Impressionist has been considerably debated, but it is not, finally, of great importance. It is clear that if Cézanne was ever what might be called a pure Impressionist—that is, in the line of Monet, Pissarro and Sisley—he did not long remain one. Because of the originality of his own artistic personality he soon transformed whatever he borrowed from the Impressionists just as he transformed whatever he took from the old masters.

In general, Cézanne's drawing was stronger than that of the Impressionists, his volumes weightier, his space better defined. Although he adopted the Impressionist broken-color technique, he used it in such a way that it worked to build forms rather than dissolve them, as frequently happened in Impressionist canvases. He could not understand the Impressionists' interest in the fugitive qualities of light, and he criticized them for not trying to penetrate beneath the surface of what they saw. Finally, he had no interest in the social world that so intrigued his friends—the boating parties, theater crowds, racetrack jockeys, iceskaters and promenaders in the Bois de Boulogne.

The painting that is sometimes called Cézanne's first "Impressionist" picture—the *House of the Hanged Man (page 66)*—was painted in Auvers in the autumn of 1872, and clearly demonstrates how Cézanne combined a characteristically Impressionist handling of color with his own sense of form and structure.

Pissarro recognized his protégé's independent approach. Cézanne, he insisted, had "a vision that is unique." In discussing their working relationship, Pissarro recalled that "we were always together, but each of us preserved the one thing that really mattered, his own sensation." How true this was can be seen by comparing Pissarro's *Orchard with Flowering Fruit Trees* with Cézanne's version of the same scene *(pages 68-69)*. Where Pissarro's picture has charm, Cézanne's has force, achieved partially by the reduction and abstraction of the motif to a few starkly opposed forms. It is obvious that Cézanne had begun to see surfaces and volumes in geometric terms; already he had become absorbed in internal rhythms and the balance of forms. In a sense, Cézanne was occupied all his life with the problem of how to use the broken color of Impressionism to build firm pictorial structures, and his constant struggle to bring the two principles together probably accounts for much of the feelings of probing and tension in his canvases.

During his stay in Auvers Cézanne met the patron, physician and spiritual counselor to two generations of French painters. This was the remarkable Dr. Paul-Ferdinand Gachet. An amateur painter and graphic artist, Gachet had moved in artistic and literary circles since

At the suggestion of Dr. Gachet, Cézanne briefly tried his hand at etching, producing the two shown here and three others. Below is a landscape of Auvers. Above is a portrait of his friend, the painter Armand Guillaumin. In the upper left-hand corner of the portrait Cézanne scratched a tiny image of a man on the gallows, an emblem that had nothing to do with Guillaumin but which Cézanne adopted temporarily as a kind of trademark. It made reference to his own landscape painting, *House of the Hanged Man (page 66)*.

his youth; he knew both Courbet and Victor Hugo, and he made a point of frequenting the cafés in Paris favored by writers and artists.

At the Café Guerbois he had become acquainted with the members of the Batignolles group, for whom he apparently felt an almost reverential respect. He was a free-thinker and a socialist, practiced homeopathic medicine, was deeply interested in phrenology and palmistry, and at the Café Guerbois was fond of arguing the merits of cremation and free love. Assuming that he would outlive all his contemporaries (he once contemplated writing a book titled *The Art of Living a Hundred Years*), he proposed performing an autopsy on Renoir as part of a study of artistic genius, an offer that Renoir gracefully but firmly declined.

By the time Cézanne moved to Auvers, Dr. Gachet was already something of a local legend, chiefly because of his habit of dyeing his hair yellow—he was popularly known in the neighborhood as "Dr. Saffron" —and of striding through town on sunny days carrying a white parasol. His three-story house contained—in addition to his wife, two children and a menagerie of cats, dogs, chickens, rabbits, ducks, pigeons, a peacock, a tortoise and a goat—various glass and pottery pieces that Cézanne never tired of arranging into still-life compositions.

The house was also filled with paintings Dr. Gachet had bought from his friends or accepted in payment for medical services. In 1873 he became the first purchaser of a Cézanne painting when he bought the artist's second version of *Modern Olympia (pages 66-67)*, which had been painted in the Gachet house. The doctor also persuaded a retired schoolmaster of Pontoise to buy a few of Cézanne's paintings, and he convinced the local grocer that he would be wise to accept some paintings from Cézanne in payment of his grocery bill.

In 1873 Pissarro also introduced Cézanne to a Parisian paint dealer named Julien Tanguy. Tanguy's artistic judgment was apparently excellent, and he made it a practice to accept paintings from artists he thought promising in exchange for canvases and tubes of paint. He thus acquired over the years many paintings by Pissarro, Cézanne, Guillaumin, Sisley, Van Gogh, Gauguin, Signac, Seurat and others.

Tanguy stacked all these paintings in a back room of his small establishment, but on the slightest provocation he would bring them out and show them to visitors. In the 1880s and early 1890s young painters flocked to his shop to see the Cézannes there, for they could be seen nowhere else in Paris. "One went to Tanguy's to look at his work as to a museum," Émile Bernard recalled. There can be no question that Tanguy not only saved many of Cézanne's paintings for posterity by persuading Cézanne not to destroy works he was unhappy with, but also helped lay the groundwork for his eventual influence and fame.

A third patron who was to play a major role in introducing Cézanne and the Impressionists to a reluctant public was Victor Chocquet *(pages 70-71)*, a customs official in Paris who collected paintings and antiques. He was not wealthy but he bought shrewdly, and owned a first-rate collection of contemporary paintings, including works by Manet, Renoir, Monet and Pissarro. The first time he saw any of Cézanne's work at Tanguy's shop he purchased a *Bathers* on the spot; at the time

of his death in 1890 his collection of Cézannes numbered more than 30.

In the spring of 1874, as Cézanne was getting ready to leave Pontoise and return to Aix, the Impressionists held the first group exhibition of their work in Paris. Fearing that Cézanne's paintings—unconventional in their handling and often extravagant in their themes—would merely antagonize a public already hostile to the whole Batignolles group, several of the exhibitors objected to including him. Pissarro, however, insisted that Cézanne could not be left out, and as a result three of his canvases were hung—the second *Modern Olympia*, an Auvers landscape and *The House of the Hanged Man*.

Apparently ignored at the Salon des Refusés of 1863, Cézanne now attracted public attention for the first time. Some visitors to the 1874 exhibition were amused, but most, as Cézanne's colleagues feared, were outraged. All of the exhibitors were badly reviewed, but none of them infuriated the critics as Cézanne did. Of the three Cézannes, the *Modern Olympia* caused the most comment; its erotic, hallucinatory theme and its bold, unbridled treatment of forms and colors prompted one critic to conclude that its creator was "a sort of madman who paints in delirium tremens." The critical reaction to Cézanne in 1874, in fact, set a pattern of almost hysterical disapproval that persisted to the end of his life and beyond. (He did achieve one qualified success at the Salon in 1882. The painter Antoine Guillemet had become a member of the official jury and as such was entitled to submit a work by one of his pupils. Claiming Cézanne as his pupil, he got an oil accepted under the title *Portrait of Monsieur L.A.* This work has since disappeared.)

In 1876 the Impressionists again held a group exhibition to which Cézanne, for unknown reasons, did not contribute. But he did exhibit with them in their third group show in 1877, submitting 16 works— three watercolors and 13 oils, including the *Bathers* bought by Chocquet and a *Portrait of Chocquet*.

Although he was again ridiculed, Cézanne this time found one articulate defender in the critic Georges Rivière, who with the aid of Renoir published a small journal for the duration of the show to defend and explain what the Impressionists were seeking. Of Cézanne, whom he had met but hardly knew, Rivière wrote: "M. Cézanne is a painter and a great painter. . . . His beautiful still lifes, so exact in the relationship of tones, have a solemn quality of truth. In all his paintings the artist produces emotion because he himself experiences a violent emotion which his craftsmanship transmits to the canvas."

Rivière's words were remarkably perceptive, but they did Cézanne little good, because nobody was listening. For a period of 20 years after the third Impressionist show, the artist's work went virtually unnoticed. Cézanne himself all but disappeared. While growing steadily more sure of himself as a painter, he was still upset by the public's rejection of his art, and he sank deeper and deeper into his self-imposed isolation both in Paris and Aix. Roger Fry has recorded that when he was an art student in the early 1890s he never even heard the name Cézanne. In fact many people, if they thought of him at all, thought that the "refined savage" of Aix, as Pissarro had called him, was dead.

The Impressionist Revolt

On April 15, 1874, a radical movement that had been gaining momentum since the 1860s and was later to be dubbed Impressionism burst upon the tradition-bound Paris art world like a thunderclap. Its debut was held, amid hoots of derision from the public and the critics, in a studio overlooking the Boulevard des Capucines. Thirty avant-garde painters, including Claude Monet, who painted the scene at the right, showed 165 works; among them were three by Cézanne.

Both Cézanne and the Impressionists were in revolt against the academic art of the Salon, and shunned historical and literary subjects. Many of these artists concentrated instead on scenes from contemporary life— families on picnics, boating on the Seine, the bustle of Paris streets and cafés. They painted landscapes directly from nature, rather than in the studio. They discarded the precise drawing and drab earth colors of the academies, substituting freely applied flicks of bright, pure pigments to re-create the shimmering effects of light as they varied with the season, the hour and the weather.

Under the Impressionists' influence, Cézanne's palette grew brighter, his brushstrokes shorter and more delicate. He began to avoid unnatural contrasts of dark and light, and he abandoned the somber modeling of his earlier works. But Cézanne's interest in form eventually drew him away from Impressionism and toward his own disciplined structural style.

The evanescent beauties of Paris in winter are caught in the delicate brushstrokes of this Monet painting, which was shown in the first Impressionist exhibit and is a view from the very studio where the show was held. In this characteristically Impressionist picture the emphasis is wholly on color and atmosphere; forms and outlines dissolve in misty light. This quality later drew mixed admiration and criticism from Cézanne, who once exclaimed, "Monet is nothing but an eye, but, God, what an eye!"

Claude Monet: *Boulevard des Capucines*, 1873

64

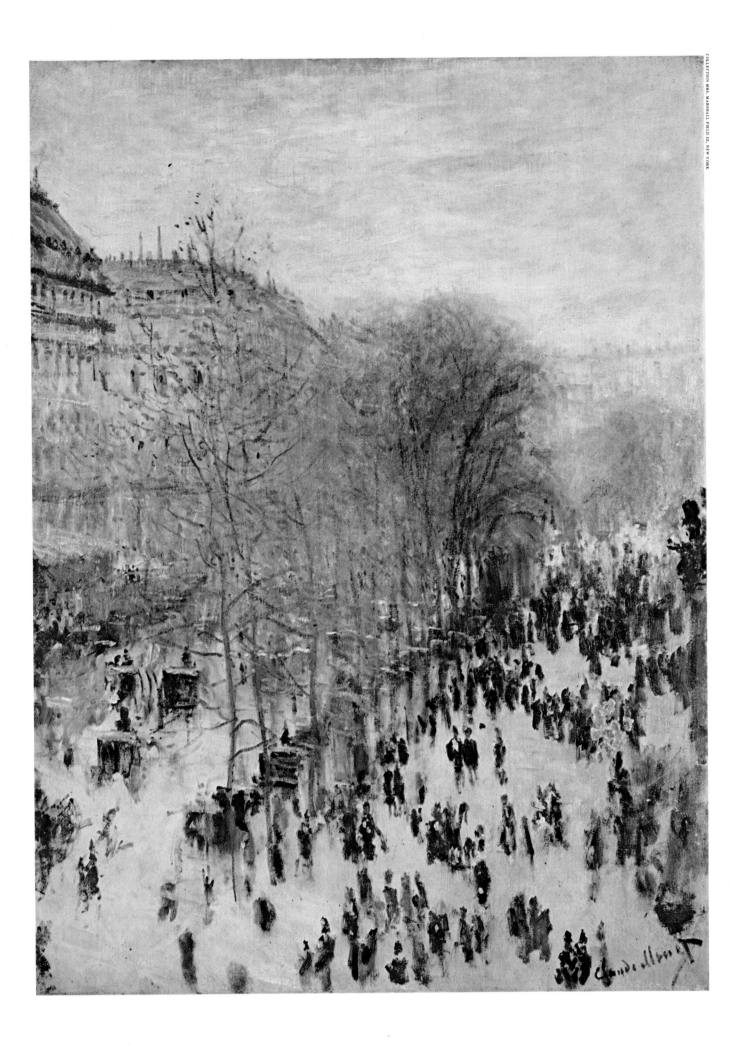

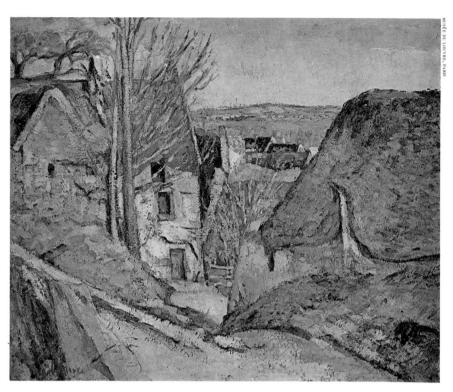

House of the Hanged Man, 1872-1873

No painting in the Impressionist exhibition received such critical abuse as Cézanne's *Modern Olympia (right)*. Its erotic subject, a voluptuous courtesan being unveiled before the lascivious gaze of a fashionably dressed *bon vivant*, outraged the public, which often expressed its indignation physically. The owner of the painting was warned that if it were not closely guarded it might "be returned to you torn to pieces." Its flamboyant figures and intense colors were compared by one critic to "the weird shapes generated by hashish, borrowed from a swarm of bawdy dreams." The picture recalls some of Cézanne's romantic works of the 1860s, but compared with the morbid tone of those paintings *Modern Olympia* abounds with healthy good humor. It was in fact a lighthearted satire on an earlier and more notorious *Olympia* by Édouard Manet.

In another painting *(above)* Cézanne came closer to true Impressionism. It was painted out-of-doors; the colors are fresh and natural, and they are applied in short, patchy strokes that evoke the dappled effect of warm autumn sunlight on the road, stucco walls and the thatched roof of the house. Though it was one of the few pictures in the entire exhibit that was sold, it too came in for critical abuse: one writer predicted that Cézanne's "too exclusive love of yellow" was certain to compromise his future as a painter.

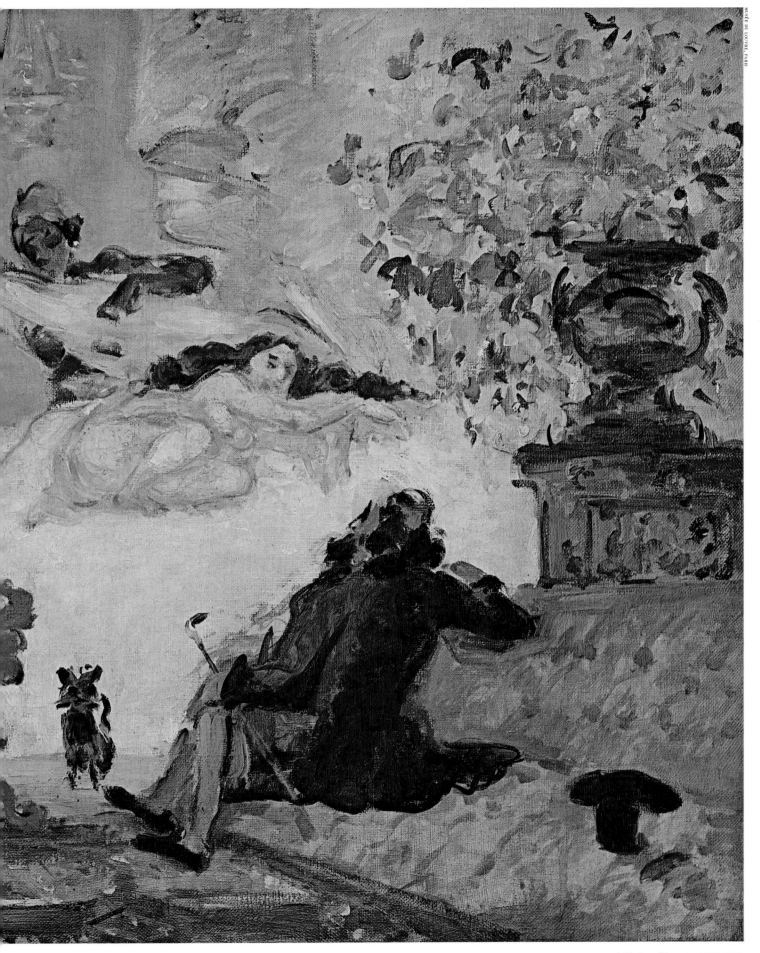

A Modern Olympia, 1872-1873

Drawing of Pissarro by Cézanne, 1873

Of all the Impressionists, Camille Pissarro *(left)* influenced Cézanne's work most profoundly, and it was during his visits to Pissarro's home in Pontoise that Cézanne began to paint from nature as the Impressionists did. There in the countryside, he and Pissarro often worked side by side, using much the same techniques. The two paintings compared below—Pissarro's at the left and Cézanne's on the right—eloquently demonstrate the similarities and differences in their interpretation of the same scene. In both paintings, touches of bright pigment rather than demarcated outlines suggest the shapes of tree trunks, blossoms and the shuttered windows of the houses. The variegated shadows

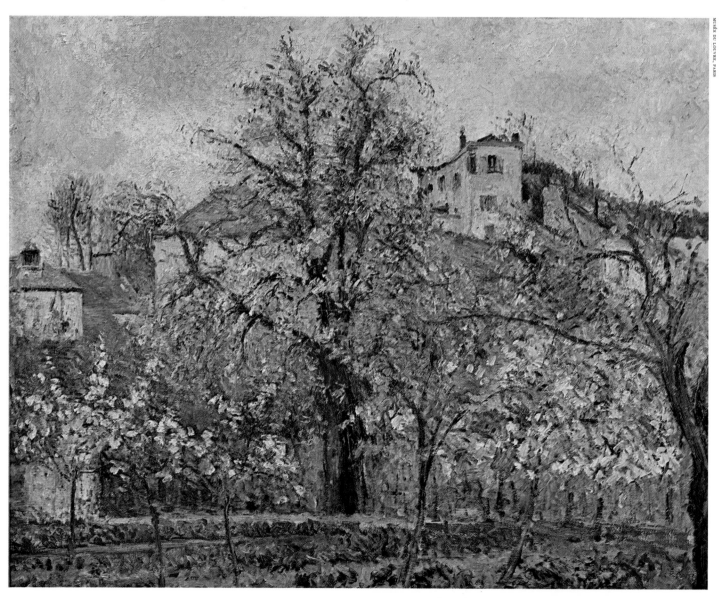

Camille Pissarro: *Orchard with Flowering Fruit Trees, Springtime, Pontoise,* 1877

on the roofs and walls of the houses are shown with tints of pure blue. An inescapable feeling of the outdoors pervades both works.

Yet Cézanne was obviously more interested in the architectural elements of the scene than Pissarro was. He has simplified and rearranged nature in order to concentrate on the buildings and the strong contours of the hills, imbuing his canvas with more solidity than the Pissarro work. Aside from Cézanne's greater concern with structure, there was quite possibly a purely practical reason for the difference between the two paintings: Cézanne worked so slowly that the blossoms may very well have fallen from the trees before he could complete his picture.

Drawing of Cézanne by Pissarro, 1874

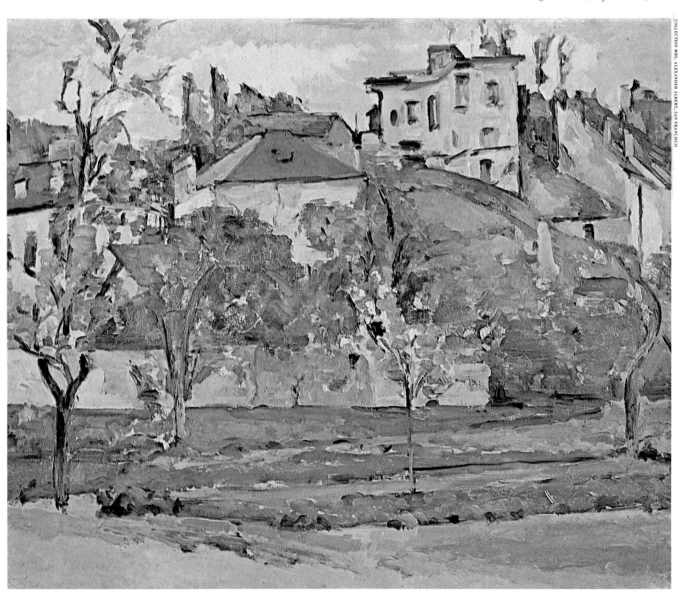

Orchard in Pontoise, 1877

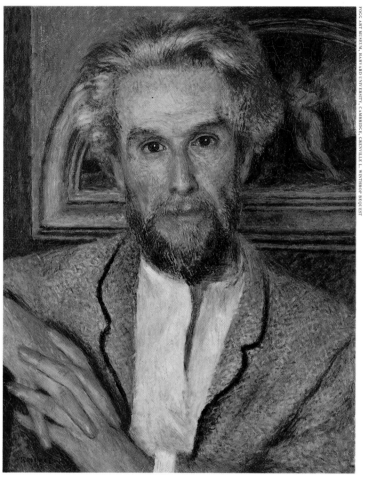

Pierre-Auguste Renoir: *Portrait of Victor Chocquet*, c. 1875

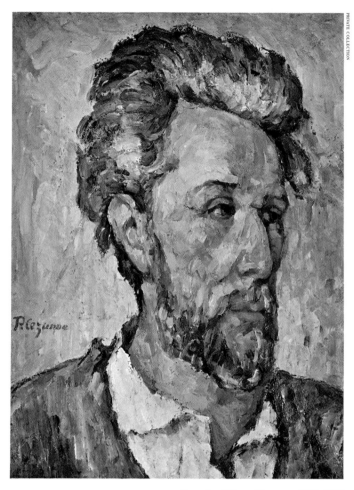

Portrait of Victor Chocquet, 1876-1877

The Impressionist movement affected Cézanne in practical as well as artistic matters, for it introduced him to his earliest patrons. One of the most enthusiastic of these was Victor Chocquet, a customs official who, though not rich, had gradually acquired a superb art collection. He was one of the few men of his day to see merit in the new artists and particularly in Cézanne, whom he came to think of as his own painter. He attended the Impressionist exhibition of 1877 daily, stoutly arguing the worth of his friends' work with abusive visitors. Ironically, the most vilified painting there was a Cézanne portrait of Chocquet himself, shown above at right.

Cézanne had met Chocquet through Renoir, whose portrait of the collector is above at the left. While both works sparkle with Impressionist effects, the Cézanne appears more forceful, its forms more solid. This concern for structure is more apparent in Cézanne's portrait of Chocquet seated *(right)*. The colors are still luminous, but now the strong horizontal lines of the picture frame and side table make a pattern with the verticals of the sitter's right leg and the chair back. The repeated whites in Chocquet's hair, shirt and socks, the reds in the rug and the wallpaper, and the yellow of the frames and chair all serve to unify the composition. In this way Cézanne was seeking to realize his aim to "make of Impressionism something solid and durable, like the art of the museums."

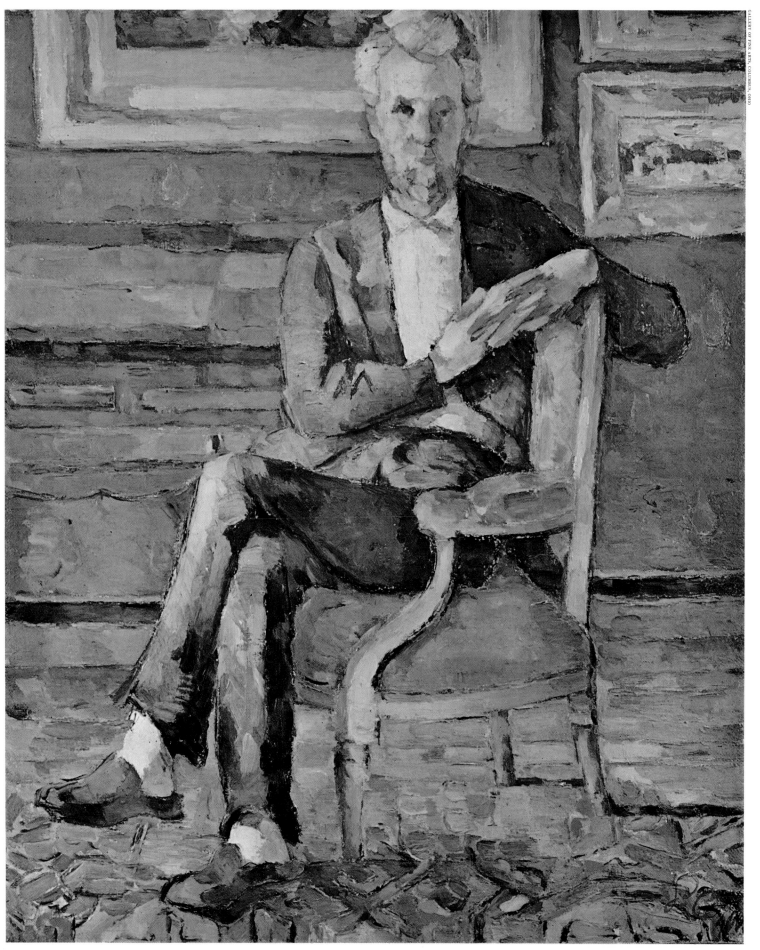

Portrait of Victor Chocquet, c. 1877

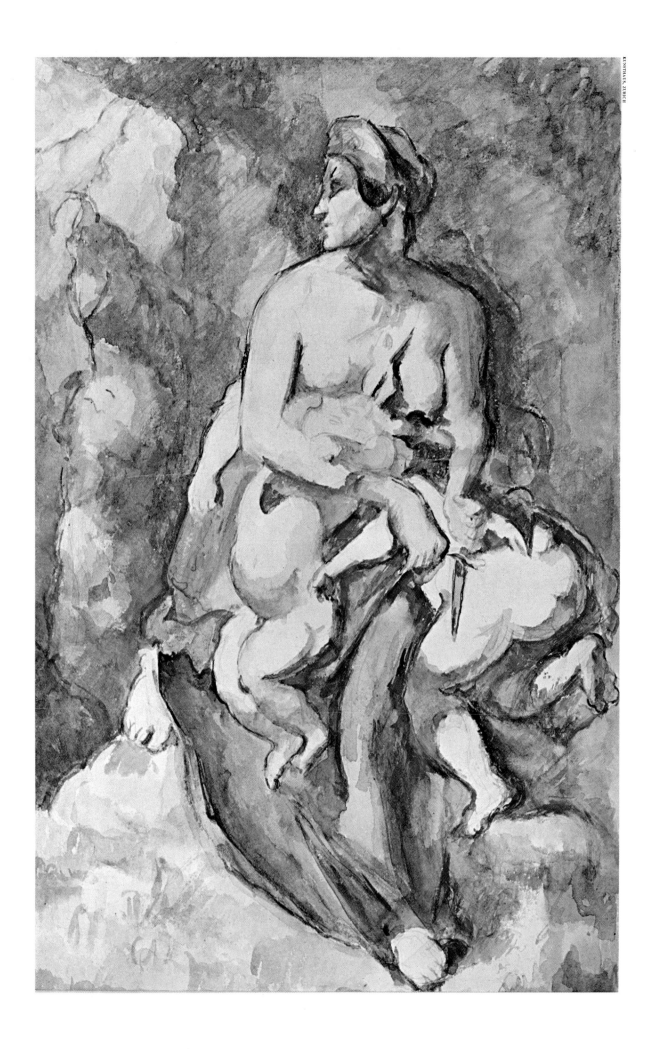

IV

The Master's Method

In his self-imposed exile, while almost nobody was looking, Cézanne became a great painter. We see this transformation taking place in his canvases, but of the man himself we have only fragmentary glimpses for a decade and more—from the late 1870s to the early 1890s.

All through these years Cézanne moved with a restless, fugitive persistence from one residence to another in Provence and in and around Paris. Thus we find him living in L'Estaque, Gardanne and Aix in the south; in Pontoise, Auvers, Chantilly, Fontainebleau, Issy, Melun, Médan, La Roche-Guyon, Villennes and Vernon around Paris; and at a half-dozen different addresses in the city itself. He rarely stayed at any one of these addresses for as long as a year at a time, but he returned to certain of them repeatedly.

His correspondence with Zola is the best guide to his activities during his late thirties and forties. It is in these letters, for instance, that we learn of a tragicomic crisis that occurred between Cézanne and his father at the beginning of 1878.

Following the disappointing reception of his works in the third Impressionist group show in May 1877, Cézanne had spent the summer and fall painting in the outskirts of Paris before returning—in December or January—to Provence. There he found himself in the ridiculous position of having to shuttle back and forth between Marseilles, where he installed Hortense and young Paul in a small apartment, and the Jas de Bouffan, where he lived in constant dread that his father would discover his young family.

The situation was given away quite inadvertently by Victor Chocquet, who was not aware of Louis-Auguste's habit of opening all his son's mail. In a letter to his friend, Chocquet made a reference to "Madame Cézanne" and "Little Paul." Cézanne reported the incident to Zola, writing that his father had "heard from various people that I have a child, and he is trying in every possible way to catch me off my guard. He wants to rid me of the encumbrance, he says." Infuriated by Cézanne's stubborn denial of a liaison in the face of the evidence, Louis-Auguste reacted as his son had feared he would, by cutting his

This striking watercolor of Medea, the tragic princess of Greek myth, shown with the two sons she has just murdered, was copied by Cézanne from an oil painting by Eugène Delacroix. Cézanne was strongly impressed by Delacroix's emotional themes and brilliant palette; he once remarked that Delacroix's sense of color was so masterful that, "We all paint differently because of him."

Medea (after Delacroix), 1879-82

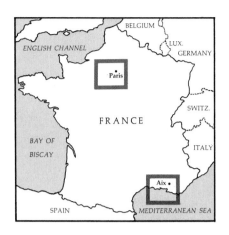

The ruled boxes on this map of France locate the areas around Paris and Aix where Cézanne painted virtually all of his landscapes. The detail maps below show the towns in the two vicinities where he worked most frequently. It was in the environs of Paris that Cézanne visited Zola (Médan), Pissarro (Pontoise) and Dr. Gachet (Auvers). Most of his traveling around Aix was on day trips, but he lived for a while in L'Estaque, and for more than a year in Gardanne.

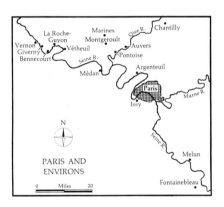

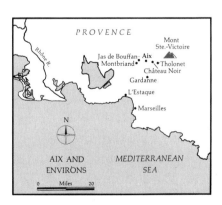

allowance in half—from 200 to 100 francs a month—arguing that this was sufficient for a single man.

Poor Cézanne added in the same letter to Zola that several days earlier he had "slipped away" to Marseilles to visit Hortense and the child, who had been ill, and had missed the train that would get him back to Aix in time for dinner. Rather than antagonize his father by an unannounced absence from the table, the greatest French painter of his generation—now a man of almost 40—had trudged the 18 miles from Marseilles to Aix. Even so, he was an hour late.

To support his family, Cézanne was now forced to borrow money from Zola. "My good family," he wrote Zola with elaborate irony, "which is very worthy, to be sure, is perhaps a bit tight-fisted to an unfortunate painter who has never been able to do anything; it is a light failing and doubtless easily excusable in the provinces." Finally, with the aid of his mother, he got the allowance restored. The further irony is that Cézanne was already legally in possession of his inheritance, made over to him by Louis-Auguste in 1870 to avoid inheritance taxes, but was too fearful of his father to touch it.

The contrast between Cézanne and Zola at this point in their careers could not have been more striking. Zola was not only very much in the public eye but by the late 1870s was well on his way to being the most popular novelist in France. He had published seven of the Rougon-Macquart saga, and the most recent one, L'Assommoir, had achieved one of those succès de scandale that the French particularly enjoy. The book's theme of the progressive deterioration of Zola's fictional family through disease and drink gave it an enormous vogue; by 1878 Zola was earning enough from his writing to buy, on the Seine near the town of Médan, a "modest rustic retreat," for which, as he wrote to Flaubert, "literature has paid."

Zola added two large wings to the original house, furnished it with an astounding clutter of china, pewter, brass, ivories, wood-carvings, armor, tapestries, ivory angels, busts of Venus, Sèvres porcelain vases and Japanese fans carved with erotic themes. Here he lived eight months of the year and lavishly entertained famous literary figures of the day —Flaubert, Turgenev, Daudet, Edmond de Goncourt, de Maupassant. Cézanne made an occasional appearance, although he did not mix with the other guests; he felt, he said dryly, as if he were visiting a ministry.

Cézanne's disenchantment with Zola's way of life and with his works becomes more apparent as their correspondence progresses. Cézanne himself was a great reader—he was familiar with the philosophical works of Kant and Schopenhauer; the writings of Chateaubriand, Hugo, Stendhal, Balzac; the dramas of Racine and Molière; and the poetry of Baudelaire, whose Fleurs du Mal he knew by heart. With this intellectual orientation, he apparently resented Zola's instinct for popularization; after reading Zola's Un Page d'Amour in 1878, for example, he assured his friend that the work would be a "great success," but added rather bluntly: "It is truly regrettable that works of art are not better appreciated and that it should be necessary, in order to attract the public, to paint things in a high key which is not altogether appropriate."

There were periods—the year 1887 was one—when the silence around Cézanne was nearly complete. ("Thank you," he wrote once to Zola from the Jas de Bouffan, "for not forgetting me in the remoteness in which I live.") During those years Cézanne probably painted something more than 300 canvases. Among them are most of the paintings from his brush that affected the early course of 20th Century art. The work of this period of Cézanne's life has been analyzed in many different ways and is susceptible to many interpretations. One of the simpler ways of approaching it is in terms of Cézanne's mature concept of a picture and his method of constructing one.

Cézanne's point of departure in painting was radically different from that of his contemporaries. He was not attracted to subjects by their topical interest, charm or erotic content, their inherent drama or possible social or allegorical significance. He looked at them only as visual images beneath which there was a substructure of meaning to be found. It was only through the revelation of this meaning that the artist was able to express his deepest emotions. And the two things—the revelation and the self-expression that went with it—constituted the artist's only reason for being. Cézanne was suspicious of painters who he believed were pursuing lesser goals, such as decoration, which he accused Gauguin of when he called him "just a maker of Chinese images," or self-expression without discipline, which Cézanne thought was the ruination of Van Gogh. (Émile Bernard described the only recorded meeting between Cézanne and Van Gogh. It was in Tanguy's shop; after inspecting Van Gogh's canvases, Cézanne is supposed to have said to him: "In all sincerity, you paint like a madman!")

The attitude Cézanne held toward Gauguin and Van Gogh suggests some of the difficulties of trying to apply labels in art. For want of a better word, the term "Post-Impressionist" has long been used to categorize the artists who reacted against Impressionism, with its purely visual emphasis, in favor of an art that was more deliberately constructed and more psychologically expressive. It is obvious from this definition that Cézanne was the first Post-Impressionist, and he has often been regarded as such. But Gauguin and Van Gogh are also spoken of as Post-Impressionists, as is Seurat—and Cézanne had serious reservations about all three. None of them, he felt, submitted to the hard discipline of finding the inner logic of nature in order to find the inner logic of themselves.

In fact, there was probably not a painter alive whose aims Cézanne wholly and unqualifiedly approved of. That he knew the work of the important painters of his time there can be little doubt, for he saw their canvases at Tanguy's. Even the painters who directly influenced him, such as Courbet and Delacroix, he admired for things other than their intentions. He distrusted Courbet's assertion that art should be social commentary, and Delacroix's that it should narrate literary themes. And, as we have seen, he distrusted almost from the beginning the Impressionist concern for the fleeting moment.

Several consequences followed from Cézanne's unique approach to art. One was that an inordinate amount of *looking* preceded the act of

painting. Cézanne had to *see* a motif first. That is not to say that he had to see the whole structure before he began to paint. In fact, it was impossible for him to do so. The process of painting itself, if it went well, was a continual revelation of the inner meaning of the scene. But the artist did have to find at least a starting point from which he could build. Lacking this, the scene had no significance for him—it became merely another one of those picturesque views that appeared, as he wrote to a friend, "in the albums of young lady tourists." This is what he meant when he wrote Zola from L'Estaque in 1883, "I have some beautiful viewpoints here, but they do not quite make motifs."

In discussing his work Cézanne complained that "the reading of the model and its realization are sometimes very slow in coming." This suggests that there were two distinct stages in the creation of a painting. The "reading," the effort to "get to the bottom of what you find in front of you" as Cézanne put it to a young artist friend, was followed by the "realization"—the formation of a painting out of whatever materials the reading had presented.

This last is important. The painting *must* be constructed out of components—the colors, forms, spatial relations—present in the model. Otherwise, it would be meaningless in terms of Cézanne's understanding of the function of art. "The painter ought to consecrate himself entirely to the study of nature," he once wrote, "and try to produce pictures that will be a teaching." If his pictures were to "be a teaching" about the significant forms and colors of the natural world, they must retain a recognizable identification with that world. They must remain, as Cézanne said many times, "faithful" to nature.

This concept of fidelity to nature has led to much confusion about Cézanne's work, for it is obvious that he did not simply reproduce what his eye saw. He was not interested in what he called "shallow imitation." Émile Bernard quoted him as saying: "We should not be content with strict reality. . . . The transposition that a painter makes with a personal vision gives to the representation of nature a new interest; he unfolds, as a painter, that which has not yet been said; he translates it into absolute terms of painting. That is to say, something other than reality."

To understand where Cézanne adhered to and where he departed from the real world, it is useful to think of his reading of the model as a kind of dismantling process. When the various components of the "strict reality" were, in a sense, spread before him, he could select those components most expressive of the meaning of the scene and unite them in a composition.

In short, the visible world was only a starting point for Cézanne— the source of the materials he needed to construct his picture. He felt no necessity for the individual objects to retain the precise identities, in terms of color or shape, they had in the real world. What was important to him was the relationship of those colors and forms in space; for him fidelity to nature was simply fidelity to these relationships. He expressed the double compulsion to be faithful to his model and to depart from it in one of his many letters to Bernard: "One cannot be too

scrupulous, too sincere, too submissive before nature . . ." he wrote, "but one ought to be more or less master of one's model."

The model might be part of the countryside near Aix in which were united, in various forms and shapes and at various depths, the characteristic colors of Provence—yellow ochre, orange, green, purple, blue. In building his motif from this model Cézanne would leave out a great deal, including colors he felt were not expressive of the country, and he might very well alter the specific characteristics of the objects that remained. He might put orange in the trunk of a tree, or give the blue sky some of the greens of the trees and vice versa, or move some objects forward in space and others backward, or use a single bush or perhaps a house to express a volume that in nature was expressed by a mass of trees. The completed picture, therefore, would not look precisely like the scene before Cézanne's eyes, but it would contain the essential components of that scene. It would, in Cézanne's view, be more meaningful than the original scene. And that is the secret of the landscapes that so remarkably catch the essence of Cézanne's country while eliminating most of its details. A visitor to Provence quickly becomes aware of this union of abstraction and reality in Cézanne, and photographs of the sites he painted, taken by John Rewald and Erle Loran in the early 1930s, confirm it.

Cézanne's exhortation to "see in nature the cylinder, the sphere and the cone" is probably the most famous formula in modern art. We do not need to go so far as to see in this formula a call to a new kind of art, as the Cubists were to do, in order to understand its significance for Cézanne. He referred to his paintings many times as "constructions after nature," built out of "plastic equivalents and color." To arrive at these plastic equivalents he in effect reduced objects to their most simplified forms, omitting a great deal of detail that the eye would normally see. These simplified forms constituted a sort of geometrical shorthand (comprising considerably more forms than the basic cylinder, sphere and cone Cézanne mentioned), and they account for much of the structural effect characteristic of all of Cézanne's mature paintings. One becomes aware of these structural elements while still readily recognizing the objects they help delineate. It is as if the painter had managed to extract the significant form from the envelope that contained it.

If carried to an extreme, this reduction of forms leads to an abstract art, as the Cubists demonstrated when they began taking their inspiration around 1908 from what Venturi called Cézanne's "constructive" paintings. But an abstract art would not have been possible for Cézanne, for it would have denied the fidelity he felt he owed to nature. The subjects of his paintings did become increasingly abstract as he grew older, but they never became so disoriented as to make it difficult to identify them with the things of the real world.

Still, it must be emphasized that Cézanne was not an illustrative painter in the ordinary sense. If he painted a mountain so that it could be recognized and identified, he did so to convey his own meaning—not so that a viewer might experience secondhand the emotions the actual scene would evoke in him. Cézanne did not paint baskets of fruit in

order to stimulate the appetite or trees to evoke the languor of summer. In fact, he wanted to suppress those emotions that grew out of the subject matter or that were the recollections of former sensations, for he considered them destructive to the real purpose of painting, which was to express ideas and emotions purely through forms and colors. This conviction was echoed in the next decade by other Post-Impressionists, and was to have momentous implications for 20th Century art as it became more and more personal.

There followed from this position another very important conviction: that a picture is important in its own right and that it must remain faithful to itself—to its basic two dimensions. The aim of painting, in other words, is not to pretend that the viewer is looking through a window, but to make him aware of the picture surface itself as well as the motif it is "realizing." The painter must therefore hold in balance *two* realities—that of nature, of the three-dimensional world, and that of the two-dimensional image. This notion does not seem startling now, but it was a radical concept in Cézanne's day, and it had important consequences for his painting.

One of these consequences was that he found it necessary to loosen the mathematically based system of linear perspective introduced by the Florentine architect and sculptor Filippo Brunelleschi in the 15th Century. Brunelleschi's system regulates the sizes of objects and the convergence or divergence of lines to create an illusion of three-dimensional depth on a two-dimensional canvas: the picture seems to be a real view seen through a window, as though the space depicted were an extension of the space in which the viewer is standing. Cézanne was as anxious to avoid this effect as many academic painters of the day were to achieve it, because concentrating the viewer's attention on the il-

Because Cézanne painted so carefully from nature, it has been possible for students of his pictures to locate the actual sites of his landscapes. The photograph at the right was made by Professor Erle Loran, who found and photographed dozens of the Provençal sites where Cézanne had set up his easel. The painting at the far right shows that when the photograph was taken, some 40 years after Cézanne had been there, the scene was virtually unchanged. But Cézanne's view is not literal; he reordered nature to suit his picture—his well at center is larger, his pattern of trees at the right is more orderly than the natural one.

lusion of depth in the picture interfered with his perception of the canvas' two-dimensional pattern that Cézanne valued so highly.

Moreover, linear perspective—and the normal way of looking at things—imposed too strict a scale of dimension for Cézanne's liking. He often preferred to give objects in his paintings a size commensurate with their significance to the motif as he "realized" it. For example, in his landscapes of Mont Sainte-Victoire *(pages 154-157)* he almost always exaggerated the size of the mountain, from whatever position he painted it.

Cézanne's distrust of linear perspective was matched by his distrust of aerial perspective, in which colors are dimmed and forms blurred to indicate distance. This device, which was very important to the works of the Impressionists, was foreign to Cézanne's desire to emphasize the surface pattern of the picture. By reducing the clarity of certain colors and forms, aerial perspective also violated another of the artist's convictions—that the sequence of color and form must be felt throughout the entire picture, with every section of the composition having equal importance.

This equality of all its parts is one of the most striking features of a Cézanne painting. All textural distinctions are notably lacking. The use of small, strictly parallel strokes gives a mass of foliage, say, precisely the same woven appearance as a mass of rock—an effect evident in *Rocks—Forest at Fontainebleau (pages 90-91)*, with the result not only that the composed structural quality of the painting is made more apparent but that everything portrayed has a striking material unity. Objects obviously lie at different depths, but one object is not more detailed than another or better defined in space, as witness any of Cézanne's panoramic views of Mont Sainte-Victoire or the Bay of Mar-

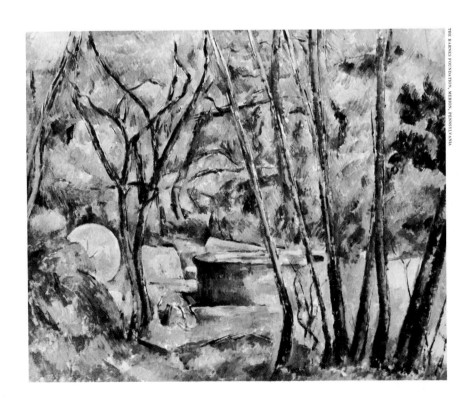

Cézanne's oft-quoted remark that he wished to "do Poussin again after nature" has troubled art historians for many years. Exactly what did Cézanne mean? The most logical explanation is that, while Cézanne greatly admired the 17th Century Classicist's sense of order and solid structure, he would have softened it with some of the vibrant color and natural light that he himself observed in nature. The only real clues to Cézanne's intent are a few fragmentary sketches he made of Poussin paintings. The one directly above is from a detail of *The Shepherds of Arcadia (top, above)*, which Cézanne probably copied in the Louvre and a reproduction of which was in his studio.

seilles *(page 152)*. There is also an equality of the intensity of light in different parts of a picture. Cézanne preferred a pictorial light that has been described as "internal"—that is, one that seems to emanate from the picture itself and that bears comparatively little relation to the theoretical position of the sun. (Struck by this, critics once assumed, incorrectly, that Cézanne painted all his landscapes under the diffuse light of an overcast sky.) In practice, this sourceless light meant that Cézanne's colors were evenly illuminated throughout the entire picture. The overall effect was to reinforce the unbroken continuity of form and color that Cézanne so valued.

He learned to value this continuity, it would seem, in the paintings of the 17th Century artist Nicolas Poussin. For Cézanne, this painter was something like a touchstone. "Every time I take leave of Poussin," he is reported to have said, "I know myself better." What appealed to him was Poussin's total way of organizing a picture so that its various parts were balanced and so that everything in it had equal importance and contributed to a single, unbroken composition of paint on canvas. In thus insisting on the balance and continuity of the whole structure, Poussin was embodying a classical ideal of painting. Like Cézanne after him, he realized the importance of holding the picture to the surface of the canvas. From him Cézanne undoubtedly learned much about the organization of his canvases in rhythmic patterns through the repetition and variation of forms.

Poussin, of course, differed from Cézanne in many respects, two of the more important ones being his subject matter—"battles, heroic actions and divine things," as he said—and that he painted in the studio rather than outdoors. When Cézanne remarked that he wanted to "do Poussin again after nature," he was saying in effect that he wanted to apply the lessons he had learned from the Impressionists about the direct observation of nature to the classical method of composition that had been revived by Poussin.

Given his dislike of both linear and aerial perspective and his insistence on the two-dimensional unity of the canvas, Cézanne was faced with the problem of finding other ways to suggest depth and the location of masses in space. The primary method he arrived at was based on two simple visual phenomena—the obvious assumption that if one object or plane overlaps another the former must be in front of the latter, from the observer's viewpoint; and the fact that cold colors—blues and greens—tend to recede and warm colors—reds, oranges, yellows—to advance. By exploiting the effects of overlapping forms and juxtaposed warm-to-cold color planes, Cézanne was able to diminish greatly the importance of converging and diverging lines and still achieve distinct spatial effects.

For example, a typically Impressionist landscape achieves depth by employing linear perspective such as a foreshortened, curved river bank and aerial perspective in which the colors dim toward the horizon. But the broad areas of color are very similar to one another in brightness and strength, and have in themselves very little space-creating power. By contrast, a Cézanne landscape such as *Mont Sainte-Victoire*

as *Seen from Bibémus Quarry (pages 86-87)* abolishes aerial and linear perspective entirely and relies on sharp warm-to-cold contrasts and overlapping forms to suggest depth.

The marvel of this "flat depth" (which is similar to what Seurat described as "the art of hollowing out a surface") is that it makes both flatness and depth apparent at the same time. With the aid of color gradations and repetitions, Cézanne was able to link objects in the background to objects in the foreground, giving a sense of simultaneous nearness and distance that, as Lionello Venturi remarked, is "one of the miracles of art."

Cézanne developed other means of suggesting a three-dimensional world on a two-dimensional canvas without destroying the unity of the surface. In one solution, which was to have a strong impact on the painters of the next generation, he shifted the theoretical eye level of the observer so that an object was seen from two or three different angles simultaneously. In a picture like *Still Life with Fruit Basket (pages 136-139)* the basket and ginger jar are tipped forward as if viewed from above, but their front surfaces are painted as if seen on a level. This has the odd result of binding the two forms more closely to the flat surface of the picture and at the same time emphasizing their three-dimensional character. The same device was taken over by Picasso, Braque, Matisse and others in their multiple views of objects and people; the technique gave these painters a freedom unknown to naturalistic painters, for whom a mirror was the only means of presenting simultaneous views of the same object.

As still another way of suggesting three-dimensionality, Cézanne developed a system of indicating bulk by what he called "modulating" with color, rather than by contrasting highlights and shadows in the traditional chiaroscuro method. Cézanne wished to avoid the effects that chiaroscuro tends to have, first, of breaking up a canvas into areas of light and dark, and, second, of creating an exaggerated sculptural effect which tends to create holes in the picture and detach forms from its surface. "Only Courbet," Cézanne once supposedly said, "can hurl black on a canvas without crashing through it." The Impressionists, too, were dissatisfied with chiaroscuro, but they rid themselves of it only at the expense of the solidity of their forms.

Cézanne learned that he could bind forms to the surface and still give them volume and solidity if he "modulated" with small brush-strokes of different colors, changing from cool colors, mostly blues of varying shades, to warm colors as the contour of an object emerged from shadow into light.

It was Cézanne's practice to begin with the shadowed outer contours and to work inward toward the warm highlights of the object itself. "Begin lightly and with almost neutral tones," he advised. "Then go on mounting the scale, intensifying the colors more and more." The principle involved here again is that cold colors appear to recede while warmer colors advance. Thus, instead of modeling in shadows and highlights, Cézanne might achieve the effect of the roundness of an apple by modulating from blue to green to yellow and

finally to red. Or he might modulate the coloration of a shirt sleeve from violet through blue to green and gray.

Color in his hands thus functioned not as the mere "adornment" of form that Ingres and his followers believed it to be but as the very stuff out of which form was created. Cézanne made no distinction between drawing and color, believing that the artist should build forms in the process of putting paint on canvas. The more carefully he modulates his colors, the more precise the drawing becomes. "The secret of drawing and modeling," he remarked to Émile Bernard, "resides in the contrasts and relationships of tone." This emphasis on color's form-building properties set Cézanne apart not only from the academic painters of his day but also from the Impressionists, who used broken color to convey the qualities of light rather than to build volumes.

In Cézanne's painstaking and extremely complex method of building a painting, color played yet another role. Each individual stroke was part of a "color composition" and had to be related to every other stroke throughout the whole of the picture. It was impossible, in other words, for color to function merely locally, as some of the academic painters thought it did. In the eye of the viewer, whether he realized it or not, every color on the canvas was modified by every other color, and the painter always had to bear this interrelationship in mind.

In summary then, Cézanne had three prime objectives in mind as he laid on color: first, to give his pictures depth by means of overlapping color planes and exploitation of the warm-to-cool properties of color; second, to give his objects solidity by "modulating" with color; third, to create a strong two-dimensional pattern by the repetition of colors to tie together on the picture plane objects lying at different depths. Collectively, these objectives account for the amazing color variety of Cézanne's mature paintings.

Several people over the years watched Cézanne at work, although he permitted this reluctantly and infrequently. From their accounts, from partially completed canvases and from Cézanne's own letters we know a good deal about his methods of composition. He painted a picture, either oil or watercolor, in a way that was uniquely his own.

It can perhaps best be described as a perpetual upsetting and restoring of balances. Cézanne began by sketching in pencil the dark outer contours—the areas of shadow—of the principal forms. With the first light pencil stroke he was in effect upsetting the balance of the empty canvas, and he had to restore it with another stroke—a diagonal in one direction counterbalancing a diagonal in another perhaps, or a vertical counterbalancing a horizontal. An examination of a work abandoned at this early stage reveals that the rhythmical relationship of the principal masses has been established before objects have even assumed a recognizable form.

At the same time that he made these first sketching indications of contour, Cézanne began putting next to them unconnected dabs of color—a red where an apple would be, a green, complementing the red, next to a contour that would become a vase. He was here not only modulating the forms with color so that volumes gradually emerged

from the shadowed contours, but also building a color composition. The first touch of red became, in effect, the keynote of the composition; from this point on, the composition grew according to what Cézanne called the "logic of color," involving another complex scheme of balancing and counterbalancing—this time of colors rather than contours —throughout the canvas. This explains why Cézanne did not pause to complete any single part or object in its entirety, literally advancing "all of the canvas at one time."

The fact that Cézanne's canvas was in continual flux, with outlines expanding or contracting as the color structure became more defined, meant that he constantly had to re-establish lines that had been painted over with layers of color. He reinforced these disjointed lines with repeated hatchings that are unlike the work of any other painter, and that give the lines a strangely vibrant quality.

This method of composition was an exceptionally slow one. Cézanne would sometimes stand, brush in hand, for a quarter of an hour or more, staring at the canvas without touching it, and he might spend a week of daily work simply sketching in the bare shadow contours of his motif and a few indications of color. Sometimes a composition occupied him intermittently for months or even years. He did a great deal of overpainting—he is said to have repainted certain pictures more than a hundred times—and his ability to put layer upon layer of pigment and still maintain a feeling of fluency and spontaneity has always astounded critics. "I cannot convey my sensation immediately," he explained, "so I put color on again, and I keep putting it on as best I can." (On the other hand, if he suddenly decided that he had irretrievably upset the color balance, he would then impulsively abandon or even destroy the picture, no matter how far advanced it was.)

It was undoubtedly from Delacroix, more than anyone else, that Cézanne learned how to compose in color. Delacroix was concerned with the problem of constructing paintings by color relationships rather than by line. His "color-division" involved laying on innumerable small patches of color side by side so that nothing appeared to be a single color; the technique was an intensification of the broken-color technique that Rubens had adopted late in his career. Although Cézanne turned seriously to broken-color painting under Pissarro's influence, he was interested, as the Impressionists were not, in the structural potential of color, and he found his best model in Delacroix.

Cézanne so admired Delacroix that he planned a tribute picture to honor him, an *Apotheosis of Delacroix*. Although it was never painted, Cézanne made two sketches for the work. This one shows the painter being transported heavenward by angels. In the foreground, Cézanne stands with a walking stick and Pissarro is at the easel. Monet takes shade under an umbrella while the art patron Victor Chocquet applauds the scene. The barking dog represents hostile critics, from whom Delacroix is now presumably safe.

It was once thought that Cézanne was a primitive who painted almost entirely by intuition. In fact, he was probably one of the most conscious and intellectual painters of his time. What emerged from his meditations and from his assimilation of other men's techniques and visions was painting of great power and apparent contradictions: serene yet full of tension—or, as Cézanne himself said, imbued with "an exciting serenity"; rational yet charged with feeling; remote yet compellingly real. It was painting, finally, from which movement was virtually banished, for movement involves transition—the process of becoming—and Cézanne's paramount concern was to create a world that is stable, in which objects have assumed their final and essential form.

The Master's Method

Cézanne was a troubled man, obsessed with unfulfilled passions, bedeviled by self-doubt. And like many men tormented by inner confusion, he displayed a contrasting orderliness in his approach to his work. He developed what could be called a system, a clearly defined method for organizing his visual sensations of the natural world and transforming them into paintings that conveyed this personal way of looking at things. "In art," he said, "everything is theory, developed and applied in contact with nature." But Cézanne's method was always freely mixed with his sensitive intuition, and it would be a mistake to assume that he always followed rigid rules. Nevertheless, his pictures are such plain demonstrations of his artistic precepts that close examination of the paintings reveals the theories behind them.

Cézanne's purpose was twofold. He wanted to paint nature convincingly so as to reveal its basic structures and their relationships in space. Seldom did he abandon nature and paint solely from his imagination or fail to create a solid, well-balanced form. His second aim was to convey the unequivocal message that his pictures were flat, painted canvases, not imitations of reality. To achieve these ends, Cézanne devised his own ways of using color and rendering geometrical forms, combining them into a method of painting that is at once complex and beautifully simple, intellectual and highly intuitive—one that has given us an original view of nature.

This enlarged detail of a landscape by Cézanne shows how he created forms with color alone rather than by outlining them. Rigorously patterned strokes of pigment blend into trees, houses, rocks— the slash of pure white at the left of center becomes a sailboat. Enforcing his notion of the picture as nothing more than a painted plane, Cézanne has painted the water as an opaque, flat, blue area, almost as solid as the underlying canvas.

The Sea at L'Estaque, 1883-1885, detail

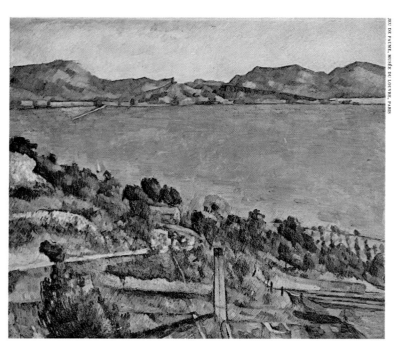

The Sea at L'Estaque, 1883-1885

These two paintings illustrate Cézanne's remarkable principle of "flat depth," the simultaneous creation of a sense of deep space and flatness. In the picture above, for example, a mountain range and shoreline are seen across a body of water. The impression of distance is partly created by the lack of detail on the far shore. (If it were closer, individual objects—houses, trees, docks—would be delineated.) Cézanne has further emphasized depth by overlapping forms: trees on the edge of the near shore clearly precede the waterline; the chimney at center is obviously closer to the viewer than the intersecting railroad cutting. But at the same time, Cézanne has achieved flatness by using bold rather than misty colors on the far shore and by painting with firm strokes to make everything seem to come forward. Similarly, his choice of a strong blue for the water makes that area on the canvas stand out.

In the picture at the right, a later work, Cézanne emphasizes flatness to a greater extent, although he never denies depth. Here, the mountain's size and sharp delineation make it seem to loom near. But by using warm orange tones for the rocks in the center, Cézanne moves them further forward than the mountain. Having achieved depth, Cézanne integrates the foreground with the background by using the mountain's pale blue-grays in touches on the edges of the central rocks, relating the distant and the near on the plane of the canvas.

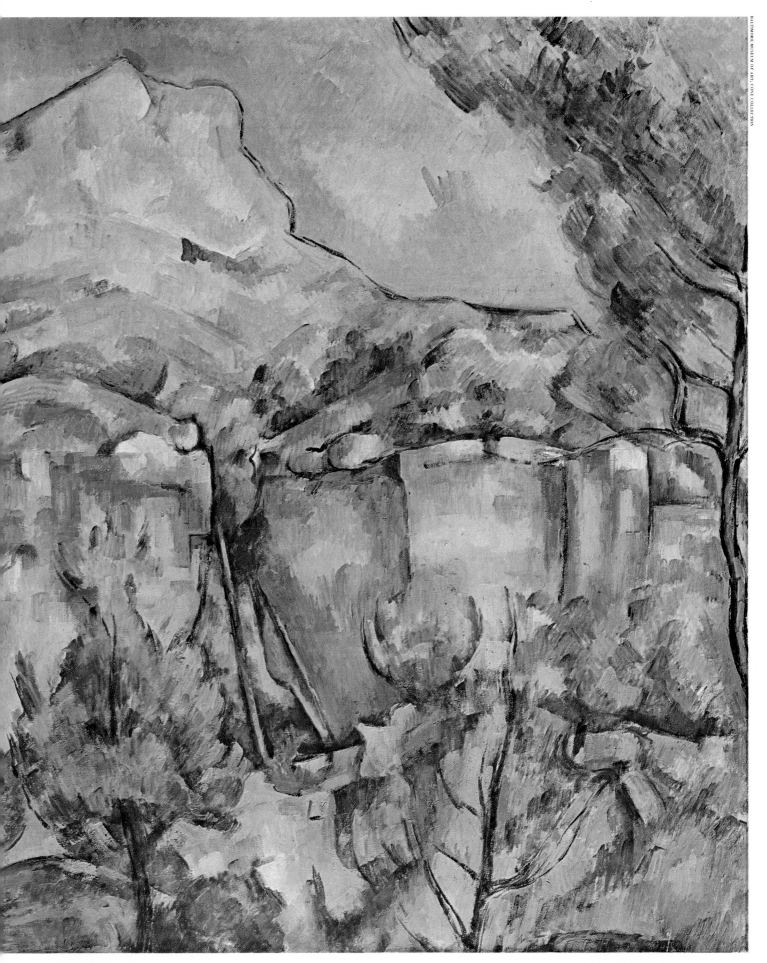

Mont Sainte-Victoire as Seen from Bibémus Quarry, 1898-1900

87

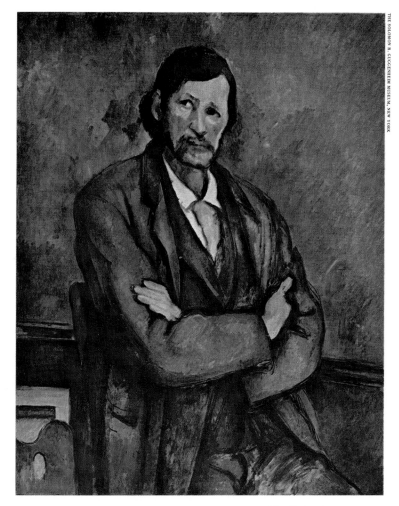

The Clockmaker, 1895-1900

While Cézanne usually painted from a model, he never hesitated to depart from the model while organizing a harmonious picture. In the portrait above, for example, the man's head seems undersized in relation to his body; and in the life-sized detail at right, the plane of the eyes is clearly out of line with the axis of the nose, and also not parallel with the mouth. In the still life below, Cézanne breaks both the front and back edges of the table, creating discontinuous lines. Such distortions occurred often during Cézanne's construction of a picture.

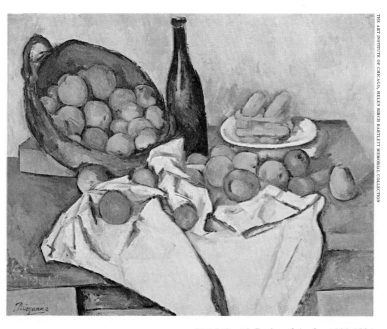

Still Life with Basket of Apples, 1890-1894

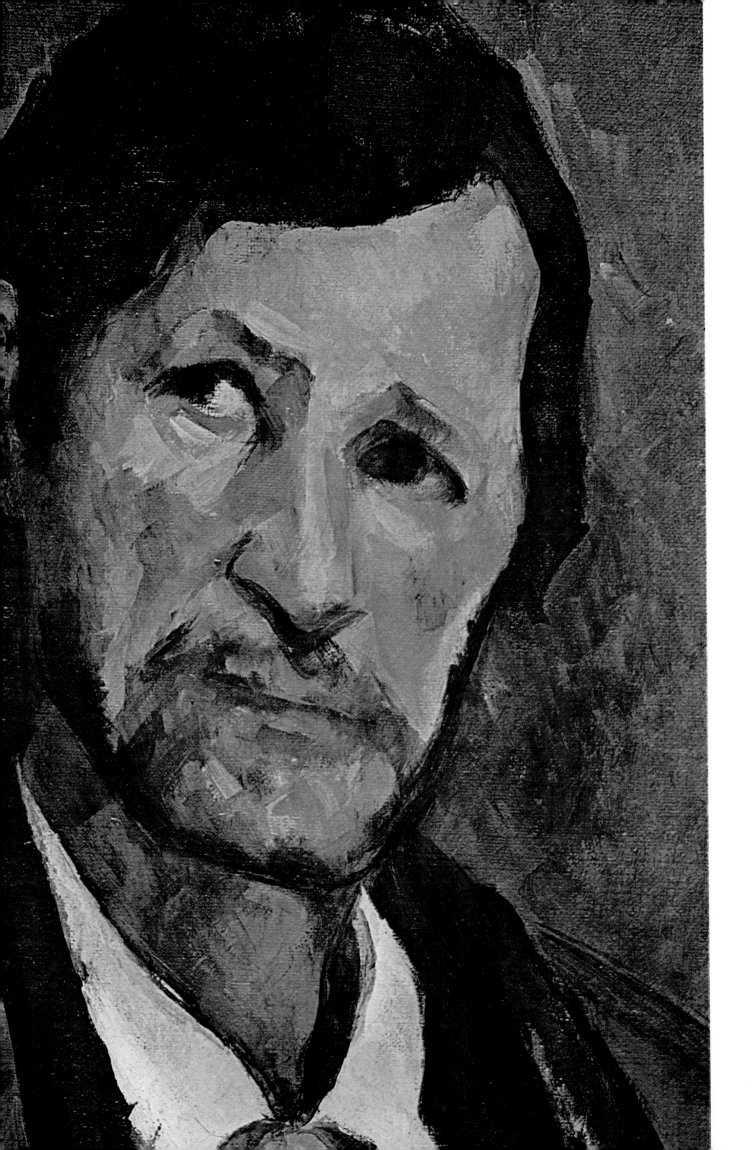

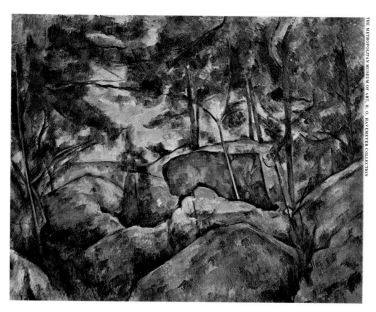

Rocks—Forest of Fontainebleau, 1894-1898

Cézanne believed that it was unnecessary to use a drawn
outline to create form. "Drawing and color," he said, "are
by no means two different things. As you paint, you draw.
The more harmoniously colors are combined, the more clearly
outlines stand out. When color is at its richest, form is at
its fullest." For traditional modeling—the darkening and
lightening of the so-called "local color" of an object to create
its form—Cézanne substituted what he called "modulating,"
the careful use of warm and cool colors to define advancing
or receding surfaces. In the detail, for example, the warm
ochres and yellows atop the rock at center lift that area
out of the cooler purple surrounding. Touches of reddish
brown on the front surface of the rock in the foreground of
the full picture seem to make it project forward.

Finally, to create a harmonious picture surface, Cézanne
used color in what often seems to be an arbitrary fashion.
Patches of color appear where they seem out of place—flecks
of green and blue on the vertical surface of the large rock at
the center of the detail at right, for example. But with this
seemingly random use of color Cézanne balanced his entire
picture, repeating a color in one place because he had used
it in another, creating a firm and totally coordinated canvas.

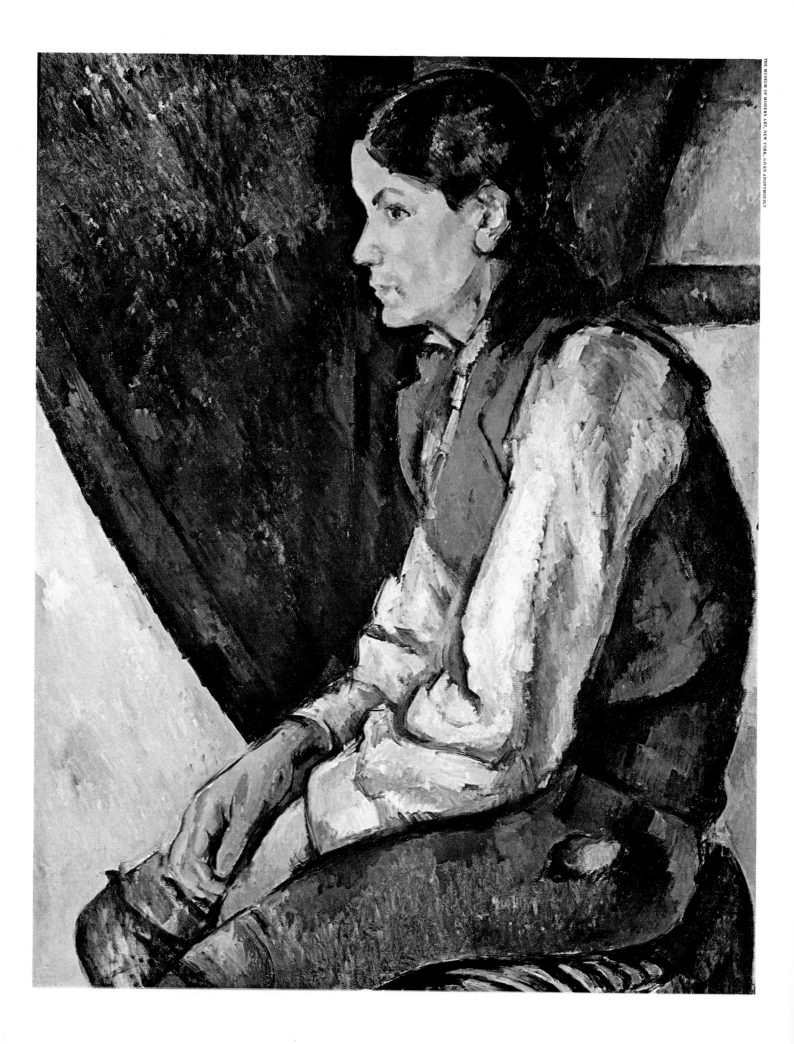

V

Retreat
in Provence

At 40, Cézanne was finally achieving maturity as a painter, but he was
still emotionally unstable and socially inept. His idiosyncrasies became
more pronounced, his concentration on painting more intense. Yet his
achievement remained largely unknown, even to the painters of the
Batignolles group. "We used to hear about him," recalled the Irish
critic and novelist George Moore in his *Reminiscences*. "He used to be
met on the outskirts of Paris wandering about the hillsides in jack-
boots." But Moore himself never met Cézanne: "He was too rough,
too savage a creature, and appeared in Paris only rarely."

This was in 1879, when Moore was spending much of his time at the
Café Nouvelle-Athènes—successor to the Guerbois as the gathering
place of Manet's circle—jotting down his impressions of the painters
who met there. Cézanne, as Moore noted, was not of the company.

What bulletins there were about him came mostly from Renoir, Mo-
net and Pissarro, who were the only ones who saw him with any fre-
quency. Although the three were of very different temperaments—
Pissarro being unusually patient and forbearing, Monet markedly ener-
getic, Renoir mercurial and gay—they shared an appreciation of Cé-
zanne's artistic importance and a tolerance for his difficult personality.
They remained his friends and supporters for more than 30 years.

Long after he had learned what he could from Pissarro, Cézanne
continued to work with him—particularly during the summers of
1877 and 1881 in Pontoise. Renoir and Monet occasionally visited their
friend in Provence. Renoir remembered a visit in 1882 with special
pleasure, although he contracted pneumonia while working outdoors
with Cézanne. "I cannot tell you how kind Cézanne has been to me,"
he wrote to Chocquet. "He wanted to bring me his entire house." Cé-
zanne's mother, he added, had prepared him "a ragout of cod that is, I
think, the ambrosia of the gods."

It was during this trip that Renoir noticed that Cézanne occasionally
discarded among the rocks works that he was dissatisfied with—indeed,
abandoned them on the ground wherever he happened to be painting.
In the hills above L'Estaque, Renoir one day stumbled upon a "magnifi-

cent watercolor by Cézanne, *The Bathers*." Cézanne had thrown it away, Renoir later recalled, "after spending 20 sessions on it."

Such stories were all that George Moore and most of the other habitués of the Café Nouvelle-Athènes knew of Cézanne. During his occasional stays in Paris he saw almost nobody. Most of the time he stayed in Provence. Between the fall of 1882 and the summer of 1885 he hardly left there, working either in Aix, where he lived with his family at the Jas de Bouffan, or in L'Estaque, where he lived with Hortense and young Paul in "a little house with a garden just above the station." He reported to Zola that his mother had come to visit, which would seem to indicate that Madame Cézanne accepted her son's liaison with more warmth than did the rest of the family.

One of the few times he left the South was to journey to Paris in May 1883 to attend the funeral of Manet, who had died unexpectedly of a gangrenous infection of the leg. Most of the painters of the old Batignolles group, including Renoir and Pissarro, were on hand to say farewell to the man who had been their guiding spirit. Among the pallbearers were Zola, Degas and Monet.

It is curious that at the time of Manet's death Cézanne was beginning to concentrate on still-life painting. His interest in still life had first been stimulated by Manet's own masterful still lifes, with their quiet harmonies of blacks, grays and whites, and perhaps also by Manet's praise of a few Cézanne still lifes some 20 years earlier.

Cézanne painted still lifes throughout his career—indeed, he was unusual among great artists in that he divided his attention equally among still life, landscape, figure and portrait painting—but he concentrated especially on still lifes between 1883 and 1895; 59 such paintings date from those years.

If Manet was the man who first encouraged Cézanne's enthusiasm for still life, the artist who most influenced the still lifes of his middle years was Jean-Baptiste Chardin. Cézanne's interest in the 18th Century French master was stimulated in 1869 when the Louvre acquired 12 Chardin paintings, and his respect for Chardin increased as he grew older. "This painter," he wrote to Émile Bernard a few years before he died, "was as cunning as a fox."

Superficially, Chardin and Cézanne have little in common. Chardin's still lifes have themes relating to kitchen and household activities, Cézanne's do not. Moreover, Chardin's concern for texture—the springy fur of the rabbit, the slippery skin of the grape—introduces into his still lifes precisely those overtones of recalled sensation that Cézanne was anxious to avoid. But Chardin's solid construction profoundly impressed Cézanne. The weight of Chardin's masses, the close interweaving of the various parts of his canvases gave Cézanne an entirely new understanding of the potential of still life. When his most prolific still-life period came, Cézanne showed how greatly he had benefited from the understated, strongly composed Chardin pictures that had so interested him in 1869.

A revealing description of Cézanne at work on a still life came from the young painter Louis Le Bail, who at the suggestion of Pissarro

For an irascible man, Cézanne was a remarkably permissive father, occasionally allowing his son Paul to scribble in his sketchbooks. As a boy of eight, Paul copied a landscape drawing of his father's *(top)*, in one of Cézanne's sketchbooks. The resulting scrawl *(above)* showed little artistic promise and Paul wisely decided not to be a painter.

visited Cézanne in 1898 to pay his respects. Le Bail watched while the master arranged the objects—peaches, a napkin, a glass of wine. His customary practice, Le Bail later remembered, was to tilt his objects forward, toward the picture plane. "The cloth was very slightly draped upon the table, with innate taste," he wrote. "Then Cézanne arranged the fruits, contrasting the tones one against the other, making the complementaries vibrate, the greens against the reds, the yellows against the blues, tipping, turning, balancing the fruits as he wanted them to be, using coins of one or two sous for the purpose. . . ."

As this suggests—and contrary to the practice of most still-life painters—Cézanne made no effort during the actual process of painting to conceal the contrived nature of his subjects. For instance, in the *Still Life with Basket of Apples (page 88)* he portrays a basket that has been carefully propped on a block of wood and a plate of biscuits that has been placed on a book to give it elevation. The arrangement is obviously an invention of the artist's. It is as if Cézanne deliberately insisted on the artificial nature of his still-life compositions in order to draw attention away from the subject matter and focus it on the arrangement of colors and forms. Still-life painters before Cézanne, by contrast, devoted considerable effort to concealing all traces of contrivance.

The deliberation with which Cézanne set up a still-life subject was also characteristic of his painting of it. He often spent months on one work. The frustrating saga of one Cézanne effort, a bunch of roses, is contained in a series of notes Cézanne addressed to a friend in Paris. On January 23, 1902, he wrote: "I am still working at the bouquet of flowers, which will doubtless take me until about the 15th or 20th February." Early in April he wrote again: "I find myself obliged to postpone sending you the picture of your roses to a later date. . . . On the other hand, I shall not give up this study, which will have caused me to make, as I like to believe, not unproductive efforts." Finally, in January 1903, he announced that "I have had to drop your flowers." And he added sadly, on that note of discontent that runs like a leitmotiv through his letters: "I am not very satisfied."

The materials he used in his still lifes were neither varied nor sumptuous. They were familiar things, unpretentious and relatively durable, and except for the richly convoluted tablecloths that lend drama to certain of these works, he preferred simple plastic shapes. Jewelry, beautiful china, fine silk or linen or velvet did not interest him. He painted apples over and over again. He also favored peaches, pears, oranges, lemons and onions. With them he put a few ordinary objects of simple shape—pots, jugs, bottles, bowls, dishes, glasses and plates. These are the basic materials of Cézanne's compositions. Many of them, still to be seen in his last studio in Aix *(page 130)*, have achieved a kind of immortality through their repeated appearances in his canvases.

The mood of the still-life pictures Cézanne painted during the 1880s and early 1890s ranges from the opulent exuberance of the *Apples and Oranges (page 135)* to the subdued gravity of the *Still Life with Onions (page 134)*. Most of them are full of optical contradictions. In the *Apples and Oranges*, for example, the apples clearly recede toward the

elaborate drapery in the background; on the other hand, the drapery, because of color links with the pitcher, fruit, tablecloth and what is visible of the table beneath it, advances into the foreground. The result is a composition that gives a sense of depth while also taking on some of the characteristics of a flat pattern.

The structure of that surface pattern was so important to Cézanne that he did not hesitate to alter the conventions of seeing when he felt the composition called for it. Hence the asymmetric flasks and the glass with its stem off-axis in *Still Life* ("The Peppermint Bottle") *(page 134)*. Although many of Cézanne's lines are so straight they look as if they were drawn with a straightedge, he would also—if he felt it helped provide the thrusts and counterthrusts he wanted—make a floor bend, or interrupt the edge of a tabletop with a napkin and resume it again at a different level, as in *Still Life with Fruit Basket (pages 136-137)*.

It is unlikely that he introduced these distortions consciously. Cézanne could be extremely articulate about his work, and he spoke often of stylistic matters, such as his color modulations, to Bernard and others. The distortions, on the other hand, he never mentioned, and they were probably involuntary and instinctive. Conscious or not, they were clearly prompted by Cézanne's desire to effect rhythmic balances in the composition and give it the drama and unity he felt it deserved.

The full development of Cézanne's mature still-life style, seen in his work of the early 1890s, came slowly and, as in everything he did, only with painstaking effort. In fact, few major artists have given as much attention to still-life painting as Cézanne did. Fewer still have had so much impact on it. Largely through his example, and to a lesser degree that of Manet, French painting gradually turned away from landscape—the consuming interest of the 19th Century—and toward the still life. In the canvases of the Cubists and other modern artists it regained a prominence it had not known since the 18th Century.

In all of Cézanne's still lifes there is an eloquent quality that is beyond technique and finally escapes definition. Rilke remarked that the still lifes moved him because Cézanne "forced them to signify the universe"—made them express the real world's oppositions, harmonies and contrasts. Roger Fry said more simply that the still lifes were "dramas deprived of all dramatic incident."

Perhaps the first painter to be aware of the importance of what Cézanne was doing in his still-life painting was Gauguin. Sometime in the mid-1880s he bought Cézanne's *Still Life with Compotier* from Tanguy, and so extravagantly admired it that in 1888 he refused an opportunity to sell it even though he was then very poor. "I would part with it only after my last shirt," he wrote. He painted it into his *Portrait of Marie Derrien*, in 1890, and 11 years later Maurice Denis also included it in his work, *Homage to Cézanne (page 176)*.

Gauguin's admiration of Cézanne's still lifes and other works he saw at Tanguy's shop moved him to a famous description: "Look at Cézanne," Gauguin urged in a letter to an artist friend in 1885, "that misunderstood man, whose nature is essentially mystical and Oriental (his face is like an old Levantine's). His form has all the mystery and

oppressive tranquillity of a man lying down to dream, his color has the gravity of the Oriental character. He is a man of the Midi and spends whole days on the top of mountains reading Virgil and gazing at the sky; his horizons are lofty, his blues very intense and his reds have an astonishing vibrancy." In less lyric words, Gauguin would say simply as he set off to paint: "Let's go and make a Cézanne."

In the spring of 1886 Cézanne married Hortense Fiquet. Why he did so we do not know. The assumption has been that his mother and sister wanted him to regularize the liaison, and certainly they must have used their influence with Louis-Auguste to get him to consent to the marriage. Presumably Cézanne himself was anxious to legitimize his son Paul, of whom he was very fond. And the marriage may have been precipitated by another, more intriguing factor—Cézanne's apparent attachment to another woman early in 1885.

Very little is known about what happened, or even who was involved. Given Cézanne's vivid imagination, it is not at all impossible that the whole affair existed largely in his mind. The most important evidence is a fragment of a letter, scrawled on the back of a drawing in Cézanne's hand: "I saw you and you permitted me to embrace you; from that moment on a profound emotion has not ceased tormenting me. You must excuse the liberty that a friend, tortured by anxiety, takes in writing to you. I do not know how to excuse this liberty, which you may think a great one, but could I have borne the burden that oppresses me? Is it not better to give expression to a sentiment rather than to conceal it? . . . I realize that this daring and premature letter may seem indiscreet, and that it has to commend me to you only the goodness of. . . ." Here, tantalizingly, the fragment ends.

Some biographers have conjectured that the object of his adoration was a servant girl named Fanny who worked in his father's house and whose robust physique Cézanne particularly admired. But there is little evidence to support this speculation; it is not even known whether he actually sent the letter. He did go so far as to ask Zola to act as an intermediary, to receive letters and forward them to the post office at La Roche-Guyon, a small town near Paris where Cézanne went with Hortense and Paul in June of 1885 to visit Renoir and his wife.

Cézanne obviously had deeply divided feelings. "I am either mad or very sensible," he wrote Zola. "*Trahit sua quemque voluptas.*" ("Each is led by his own desire.") He somehow neglected to call for mail at La Roche-Guyon, though there is no evidence that any letters were sent to him; yet in August, when he was back in Aix, he was writing Zola of "stumbling blocks under my feet which are like mountains." He blamed family interference, but it seems clear that he himself was seriously disturbed by the prospect of an affair—whether the prospect was real or imaginary. In another letter to Zola he announced the failure of this rather pathetic attempt to assert his sexual freedom: "As for me, the most complete isolation, the brothel in town, or what have you, but nothing else. I pay—it's a disgusting word—but I need peace, and at a price I can get it."

For Cézanne the abortive love affair must have had a very upsetting

effect; he apparently did not complete a single painting between May and August of 1885—the only hiatus in his production that we know of in the whole of his career. But this effect, like the affair itself, was short-lived. By the end of August 1885, Cézanne could write to Zola: "I am beginning to paint because I am almost without troubles."

On April 28, 1886, Cézanne married Hortense at the town hall in Aix. The next day a religious ceremony was held at the church of Saint-Jean-Baptiste. Six months later Cézanne's father died, leaving his son, then a man of 47, financially independent for the first time in his life. "My father was a man of genius," said Cézanne. "He left me an income of 25,000 francs." Cézanne kept a third of this and gave two thirds to his wife, who moved to Paris with young Paul (who was now 14) and thereafter lived only occasionally with her husband.

However unsatisfactory Hortense proved as a wife, she was extremely useful to Cézanne in one capacity at least—as a sitter. Before and after the marriage he executed more than 40 likenesses of her, more than he painted of anyone else. Along with his landscapes and still lifes, Cézanne had been painting portraits ever since the first one he did of his father in the early 1860s. But his portraits, like so much of his work, were radically unconventional. Most of them have one striking quality in common: Their interest in characterization is so slight that they seem scarcely portraits at all. The three paintings that bear the title *Madame Cézanne in a Yellow Armchair*, for example, not only tell us nothing about the character of the sitter but do not even appear to be studies of the same person—and this despite the fact that they were probably painted within a span of three or four years.

Too much has perhaps been made of the impersonality of Cézanne's portraits, but it is nevertheless true that a viewer approaching them for the first time is often struck by the rigidity of their poses and the apparent vacuity of their expressions. The subjects are sometimes posed fullface, with their arms hanging loosely and symmetrically at their sides or with their hands clasped in their laps; inert and resigned, they suggest the dim figures that stare blankly from faded daguerreotypes. Their lack of individuality is reflected in their clothes, which are oddly timeless and which indicate that Cézanne had very little interest in the fashions of the day.

One of the foremost admirers of Cézanne's starkly impersonal portrait style was Henri Matisse, who owned, among other Cézanne paintings and watercolors, a powerful *Portrait of Madame Cézanne* of 1885-1887. Matisse, in fact, could have been speaking for Cézanne when he wrote in his famous *Notes of a Painter* of 1908: "Expression to my way of thinking does not consist of the passion mirrored upon a human face or betrayed by a violent gesture. The whole arrangement of my picture is expressive. The place occupied by figures or objects, the empty spaces around them, the proportions, everything plays a part." A portrait, in other words, is not distinct from a still life, a landscape or a figure painting; it must function as a unified plastic composition, and its subject is no more important than its background. Hence the impersonality of Cézanne's portraits. He invests his subjects with only

the barest vegetable existence; as nearly as he can make them so, they are geometric structures in space.

After Hortense, the person Cézanne painted most often was himself—he left more than 35 self-portraits in various mediums. These, with the pictures of Hortense, make up almost half of the portraits painted in his maturity. But the two portraits that attracted the most attention in Cézanne's own lifetime and that had the most important influence on the painters who followed him were his first two studies of the art collector Victor Chocquet *(pages 70-71)*.

When the first portrait, a head study, was shown at the Impressionist exhibition of 1877, the critic Louis Leroy, writing in *Le Charivari*, warned pregnant women not to linger before "that very strange head, the color of boot-tops" for fear that it would infect the unborn child with yellow fever. What disturbed Leroy were Cézanne's novel color distortions. Chocquet's face is of a yellowish hue, touched with red; his hair is predominantly blue, highlighted in gray-green; his beard is flecked throughout with touches of green and blue. This was scarcely how Chocquet looked, as any visitor to the exhibition could plainly see, since Chocquet himself was on hand every day to defend the portrait and praise its creator.

The second Chocquet portrait, showing the sitter in an armchair, likewise shocked Cézanne's contemporaries and for similar reasons. Cézanne's aim in this strong, mosaic-like canvas was clearly to force all forms, whatever their theoretical position in depth, to play a part in the surface pattern. Nothing, therefore, remains in a single plane. By linking colors and forms of one plane with those in another, Cézanne created almost the impression of a single, vertical plane at the picture surface. Carpet, floor, wall, Chocquet himself—no one is more prominent than the other.

These are, of course, the same devices that Cézanne used in the still lifes. What made them particularly controversial when applied to portraits was that viewers found it difficult to understand a portrait in which a wall contained as many complexities of color and movement as a face. Serious artists, on the other hand, found it impossible, after Cézanne, to see the face without seeing the wall—and with it, carpets, draperies, potted plants and the whole setting of shapes and colors in which the subject was placed.

Cézanne was a trying painter to sit for, because he was so irritable and demanded that his subjects remain still so long. This explains the large number of self-portraits and paintings of Hortense, who was not only available but stolid by nature. He very seldom used a professional sitter, although one who evidently pleased him was a young man named Michelangelo di Rosa, whom Cézanne painted four times in oil and once in watercolor. All five pictures, probably executed around 1890 in Paris, are titled *Boy in a Red Vest (page 92)* and are among his finest and best known works.

Occasionally Cézanne attempted portraits of friends with results that were highly frustrating for him. He was satisfied enough with the portraits of Chocquet to complete them, but not with that of another friend

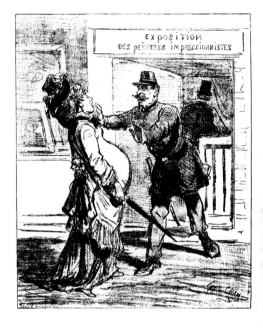

This cartoon was only one of many public jibes at the Impressionists' exhibition of paintings in 1877. It plays on a sarcastic review of the show that warned pregnant lady visitors away from Cézanne's mustard-toned portrait of Victor Chocquet, since it might have distressing effects on their unborn children. The cartoon's caption has the frantic gendarme saying, "But Madame, it would not be wise. Go away!"

and patron, Gustave Geffroy. A distinguished writer and critic, Geffroy was also Director of the Manufacture Nationale des Gobelins, the state-controlled tapestry manufactory in Paris.

Geffroy met Cézanne in the fall of 1894, took a great interest in his work and soon joined the small group of his critical supporters. (He remarked justly enough of one *Boy in a Red Vest* that it could "bear comparison with the finest figures in painting.") Cézanne, for his part, conceived the idea of painting Geffroy's portrait. In April 1895, while he was living in Paris in the Rue Bonaparte, he sent Geffroy a note requesting a meeting and signed it, somewhat cryptically, "Paul Cézanne, Painter by Inclination." There followed three months of daily sittings in Geffroy's study. At the end of that time, Cézanne suddenly sent for his paints and his easel, writing to Geffroy that the painting was beyond him, and that he must abandon it. Geffroy persuaded him to continue, but after another week Cézanne left abruptly for Aix, and his work on the portrait was over.

He had a similarly frustrating time with a portrait he tried to paint of another man who admired his art. That was Ambroise Vollard, a native of the French island of Réunion in the Indian Ocean, who had come to Paris in 1890 bent on practicing law. He became excited by the world of art and intrigued by the potential profit to be made as an art dealer. He knew almost nothing about art at first, but was shrewd enough to ask the advice of those who did, such as Pissarro and Renoir. He learned fast, and soon his small gallery replaced Tanguy's shop as a showcase of modern art. He was particularly interested in Cézanne's work, and he made a special effort to earn the artist's trust—which he did despite Cézanne's inordinately suspicious nature. Cézanne quickly took to him (years later he wrote to a friend, "I am glad to hear that you esteem Vollard, who is both sincere and earnest"), and Vollard soon took a leading role in making Cézanne known to the world.

Vollard was not a man to let fact stand in the way of a good story, so his account of the first sitting for his portrait by Cézanne must be taken with reservations. According to Vollard, he sat in a chair perched on a rickety packing case. Trying to please Cézanne by staying completely still, he fell asleep, lost his balance and fell off the packing case. "Fool!" cried Cézanne, "You've ruined the pose!"

For 115 sittings, by Vollard's count, Cézanne struggled to realize the picture *(page 160)*. Then, as with the Geffroy portrait, he abandoned it in despair and acknowledged only that he was "not displeased with the shirt front."

Although Geffroy found it hard to understand a man who would labor over a portrait for three months only to abandon it and retire to seclusion, he could not have been totally surprised by Cézanne's erratic behavior. The first time they met each other in 1894, Cézanne had demonstrated just how strange he could be. He was staying in an inn near Monet's home in the village of Giverny. To Monet it seemed obvious that Cézanne badly needed to have his confidence built up. He set about it by inviting Cézanne to a luncheon party along with Geffroy, Auguste Rodin, the novelist-playwright Octave Mirbeau, and the

journalist-politician and future French premier Georges Clemenceau. "I hope Cézanne will still be here and of the party," Monet wrote to Geffroy. "But he's so odd, so shy of seeing new faces, that I fear he may let us down. . . . What a tragedy that the man should not have had more support during his life! He is a true artist who has too much self-doubt."

On this particular occasion, however, Cézanne appeared and proved to be very convivial—in fact, too convivial. He roared at Clemenceau's jokes, told Mirbeau and Geffroy with tears in his eyes that Rodin had shaken his hand and after lunch fell on his knees before Rodin in the garden to express his gratitude personally.

Nevertheless, Monet rashly decided to hold a second luncheon— this time expressly in Cézanne's honor. He invited Renoir and Sisley, among others, and at the luncheon's beginning rose to express the admiration they all felt for Cézanne's art. "You, too, are making fun of me," replied Cézanne angrily, and he abruptly departed the table, the house and the village of Giverny. When Monet next got word from him, he was back at Aix.

Cézanne's behavior was not always so outrageous. During his 1894 visit to Giverny, when he met Geffroy, he also became acquainted with the American painter Mary Cassatt. Daughter of a wealthy Pittsburgh banker, she had become a painter against her family's opposition, had settled in Paris and had come under the artistic influence of Manet and Degas. Miss Cassatt was curious about Cézanne as a "celebrity" and as "the inventor of Impressionism." Her first unpleasant impression of him was altered after she spent some time in his company, as she related in a letter to an American friend:

"I found later that I had misjudged his appearance, for far from being fierce or a cutthroat, he has the gentlest nature possible, '*comme un enfant*,' as he would say. His manners at first rather startled me— he scrapes his soup plate, then lifts it and pours the remaining drops in the spoon; he even takes his chop in his fingers and pulls the meat from the bone. He eats with his knife and accompanies every gesture, every movement of his hand, with that implement, which he grasps firmly when he commences his meal and never puts down until he leaves the table. Yet in spite of this total disregard of the dictionary of manners, he shows a politeness towards us which no other man here would have shown. He will not allow Louise to serve him before us in the usual order of succession at the table; he is even deferential to the stupid maid, and he pulls off the old tam-o'-shanter which he wears to protect his bald head when he enters the room. . . .

"The conversation at lunch and at dinner is principally on art and cooking. Cézanne is one of the most liberal artists I have ever seen. He prefaces every remark with: '*Pour moi*' it is so and so, but he grants that everyone may be as honest and as true to nature from their convictions; he doesn't believe that everyone should see alike. . . ."

This obviously, was Cézanne at his best, and it gives us some idea of what Pissarro meant when he spoke of the "beautiful temperament" of his old painting companion of Pontoise.

"Does an Apple Move?"

In view of Cézanne's notorious inability to get along well with other people, it is remarkable that he persisted in painting them. But he did so, sometimes to the great discomfort of his models. When he painted portraits, for example, the irascible demands he often imposed on his sitters made their posing sessions miserable. Once in position, they were ordered to freeze in place and remain for hours on end as immobile as the props in a still life; if they became restless and shifted their cramped muscles, he would snap, "Does an apple move?"

It was Cézanne's view that the human head, like an apple, could be seen as nothing more than a convenient geometric starting point for a composition in which every element—human or nonhuman—was treated with equal respect and attention. As a result, the most striking feature of Cézanne's brilliant and unconventional portraits is the absence of emotion and personality.

Cézanne also expressed his life-long interest in the human figure in compositions portraying groups of people. Some of his figure studies depict small groups, like the famous series on cardplayers; others, particularly his paintings of bathers, contain more than a dozen figures. In the latter works, Cézanne had a definite goal in mind, for he sought to integrate two great modes of art—figure painting and landscapes—an objective that he achieved magnificently at the very end of his life in *The Great Bathers (pages 114, 115).*

A page from Cézanne's sketchbook illustrates three ways in which the artist depicted the human face and body. The nude is copied from a statue of Psyche by Pajou in the Louvre; in the upper right-hand corner is a self-portrait; the boy shown sleeping in an armchair is probably Cézanne's son.

Sheet of studies, 1879-1882

102

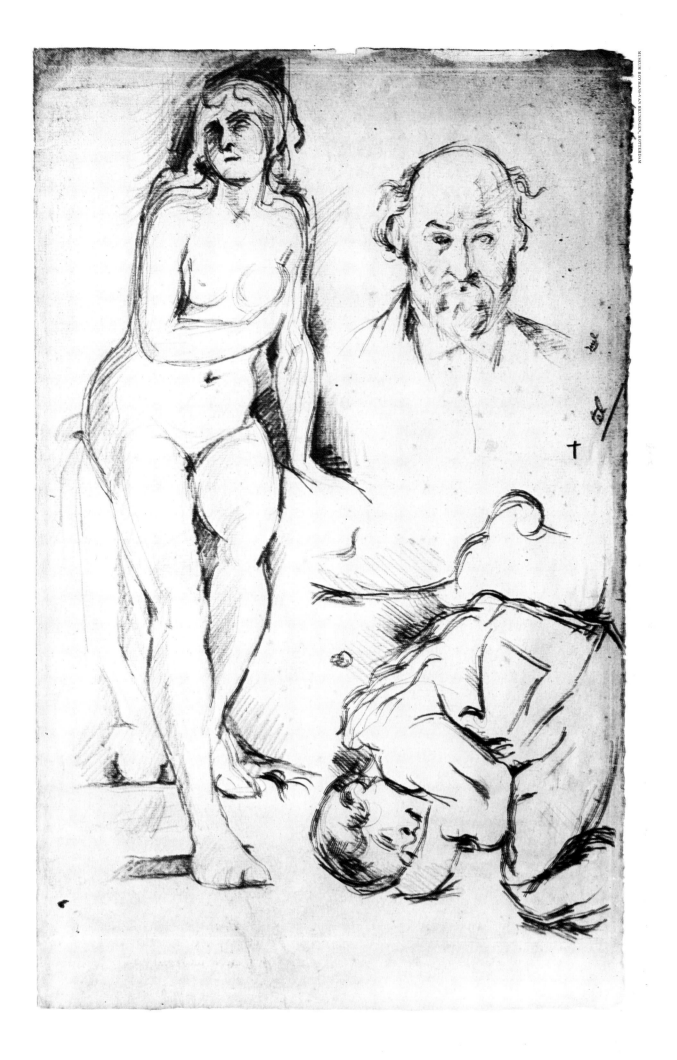

103

Page from one of Cézanne's sketchbooks

Cézanne had little interest in revealing character in portraits. From the 27 paintings he did of Hortense Fiquet, his mistress and later his wife, it is difficult to tell what she was like or even what she looked like. There is, moreover, rarely a hint of how he felt about her. He took as much trouble with the chairs in which she posed and the wallpaper behind her as he did with her face, hands and clothing.

Cézanne's cool objectivity is reflected in three of the portraits shown at right. In the top two, showing Hortense at about 30, she seems lifeless and sullen; there is not a hint of a lover's affection. In the last painting *(lower right)*, done only 10 years later, she appears prematurely old and unattractive. Inexplicably, the work at lower left is an exception; Cézanne made her appear gentler and lovelier than would seem warranted from her photographs.

Some of the most intimate pictures of Hortense are contained in a linen-bound notebook that Cézanne carried about with him. One of its pages *(above)* shows a sketch of his wife with "Madame Cézanne" scribbled on it, probably by their son Paul.

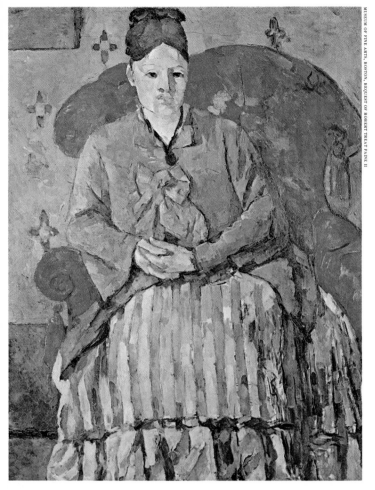

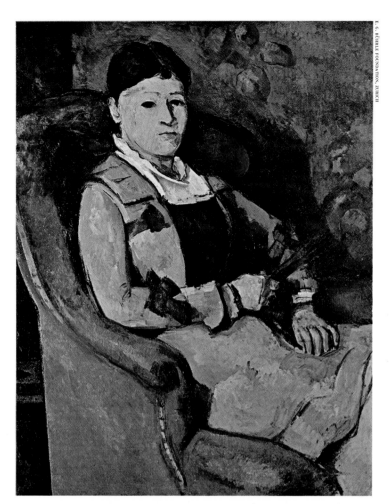

Madame Cézanne in a Red Armchair, 1877

Portrait of Madame Cézanne, 1881

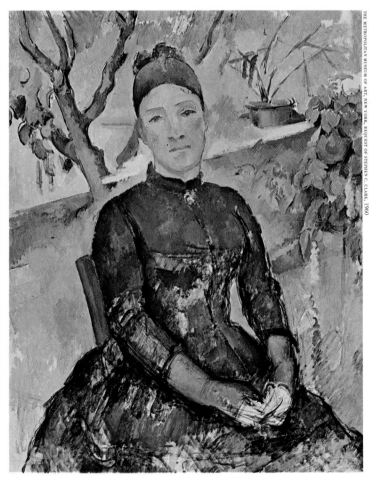

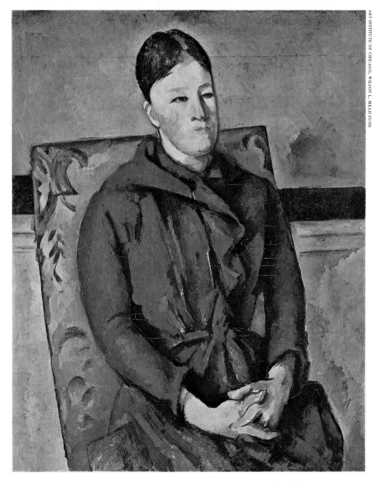

Madame Cézanne in the Conservatory, c. 1890

Madame Cézanne in a Yellow Armchair, 1890-1894

105

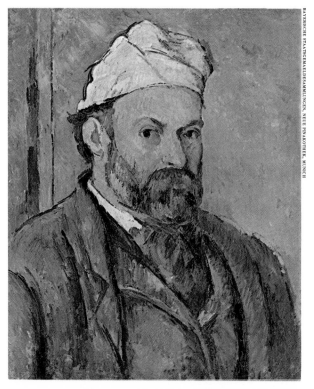

Self-Portrait, 1879-1881

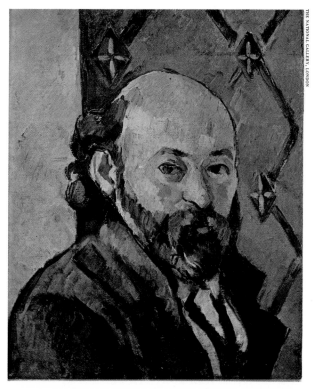

Self-Portrait, 1879-1882

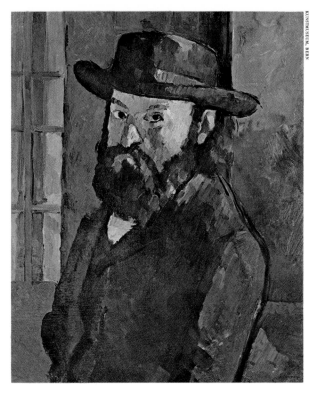

Self-Portrait, 1879-1882

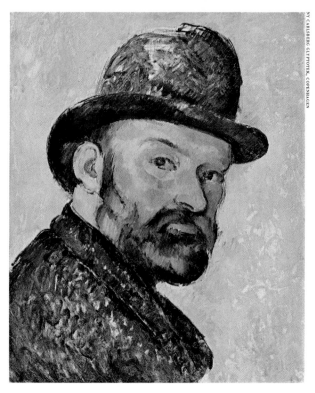

Self-Portrait, 1883-1887

It is not surprising, in view of his abiding aversion to strangers, that Cézanne ultimately turned out to be his own best model. Indeed, over a 30-year period ending in his early fifties, he sketched or painted his own likeness at least 36 times.

The five self-portraits shown here span one decade of his life. Although his fiercely direct expression and scruffy appearance change very little from picture to picture, he varied his compositions and posed in assorted headgear, sometimes a stocking cap, at others a favorite hat. Curiously he made himself look oldest in the work that was painted first *(opposite)*, when he was only 38.

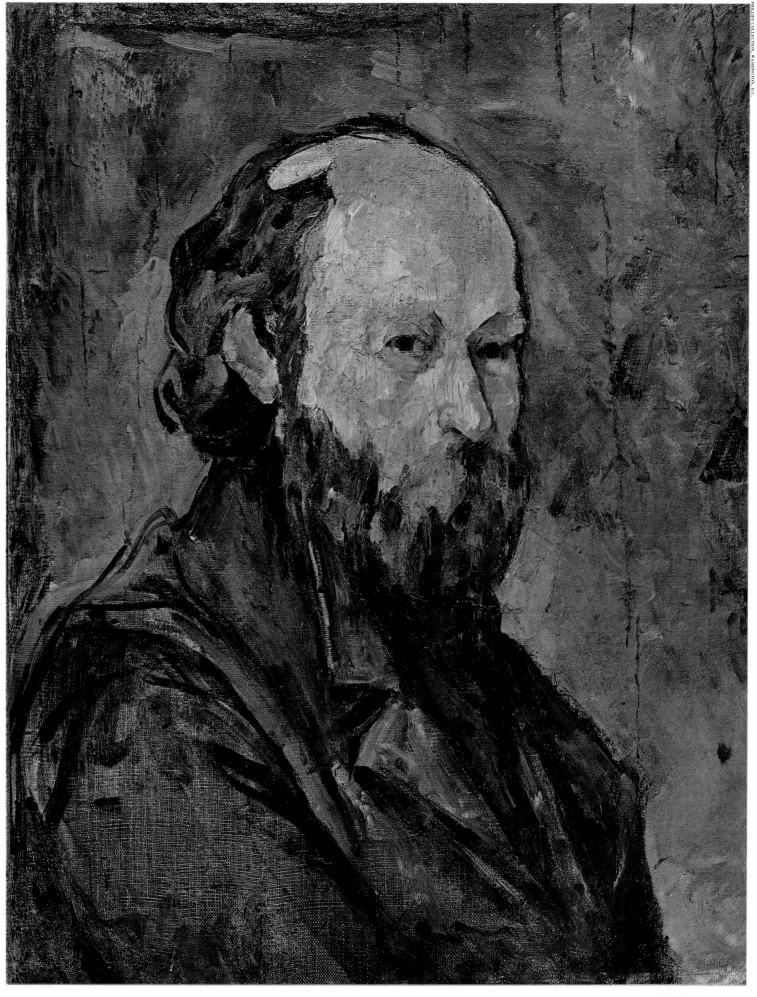

Self-Portrait, c. 1877

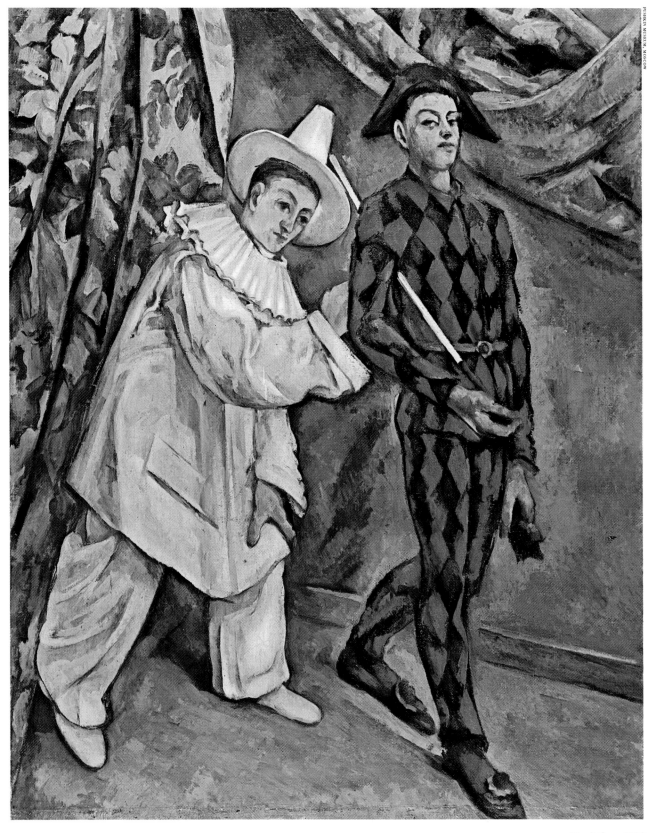

PUSHKIN MUSEUM, MOSCOW

Mardi Gras, 1888

For centuries before Cézanne, artists had been captivated by the tragic humor of clowns. Parading absurdly in bizarre costumes, arousing the scorn and laughter of their audiences at countless comic plays and pantomimes, clowns had symbolized the pathetic folly of all men. Painters like Watteau and Daumier had caught this essence, and Cézanne produced his own variation on the theme in four oils and a single watercolor.

Cézanne's son Paul posed for all of these paintings. In *Mardi Gras (left)*, Cézanne's first Harlequin painting, Paul, then 16, became the model for the figure of Harlequin himself, dressed in the traditional

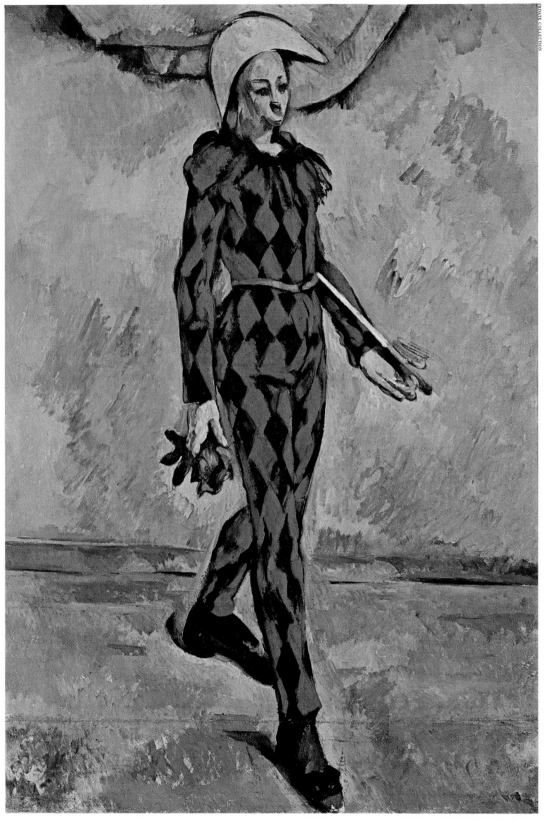

Harlequin, 1888-1890

diamond-patterned garb of the sly and quick-witted clown of French and Italian comedies. In the same picture, Paul's friend Louis Guillaume posed in the baggy, white, ruff-necked costume representing Pierrot, the pathetic character in *commedia dell'arte* plays who conceals his unrequited love behind a comic mask.

Cézanne's last Harlequin painting *(right)*, completed within two years after his first, is no longer either a recognizable image of Paul or the familiar clown figure. With a ravaged snoutlike countenance and distorted fingers and limbs, the haunting figure seems an almost abstract prototype of the alienated man.

109

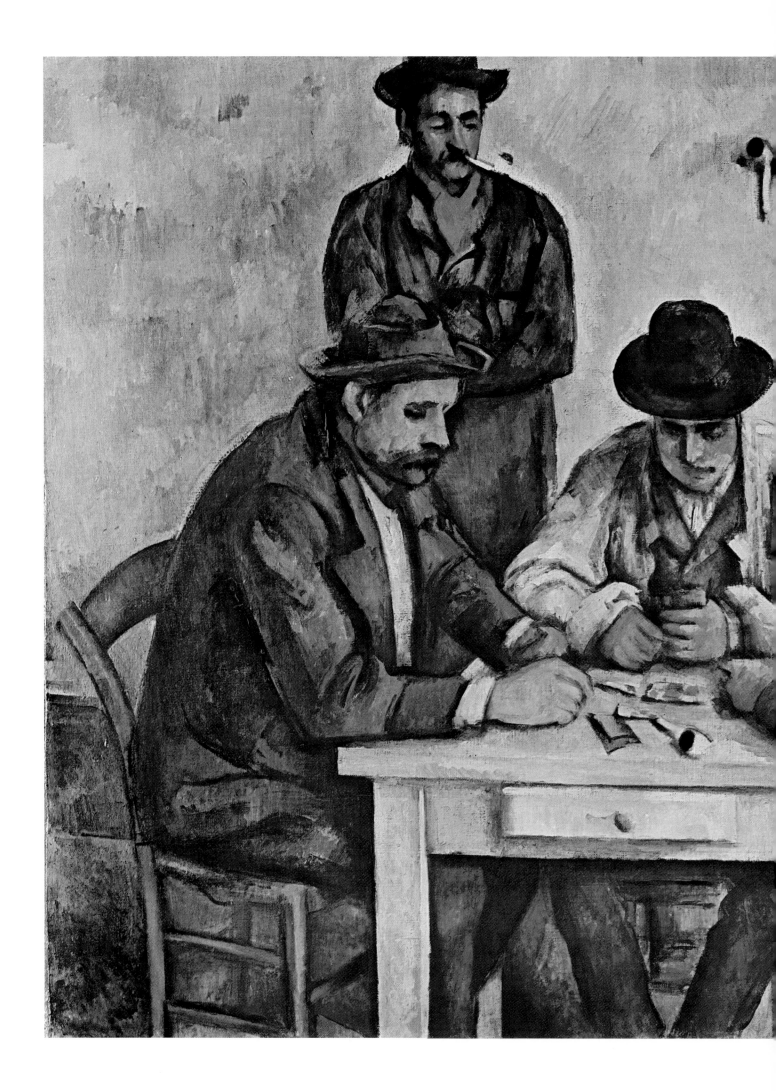

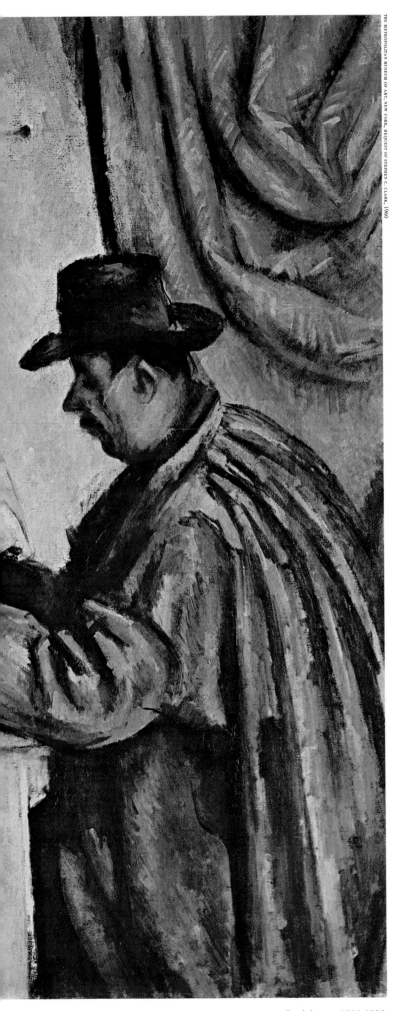

Cardplayers, 1890-1892

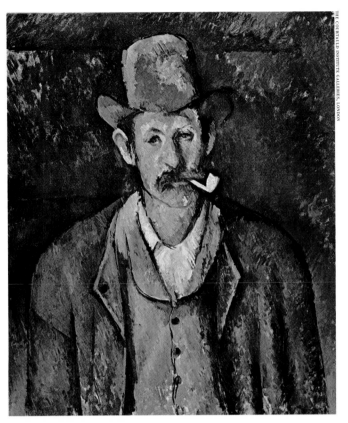

Man Smoking a Pipe, c. 1892

Among Cézanne's best-known and most popular paintings of people are those that show some of the sturdy peasants of Provence concentrating on games of cards *(left)*. The scene was a familiar one in genre paintings of the 17th Century—one of Cézanne's favorite old pictures in the local Aix museum was an anonymous *Cardplayers*. But in his five versions of the subject, in which the number and grouping of figures varied from five players and onlookers to just two solitary opponents, Cézanne totally suppressed the storytelling aspect that had made older paintings so appealing. Past masters had illustrated such heightened moments of small drama as "the cheater exposed" or "the trump card." Instead, Cézanne evoked the simple dignity of the slow, reserved, deliberate men of Provence *(above)*— some of whom worked on his family's estate and were paid to sit for him—by arranging them into a stable, almost classical group of figures. Clothed in their easy, loose-fitting peasant garments and posed in natural, unself-conscious attitudes, they have a monumental grace that Cézanne has perfectly memorialized.

111

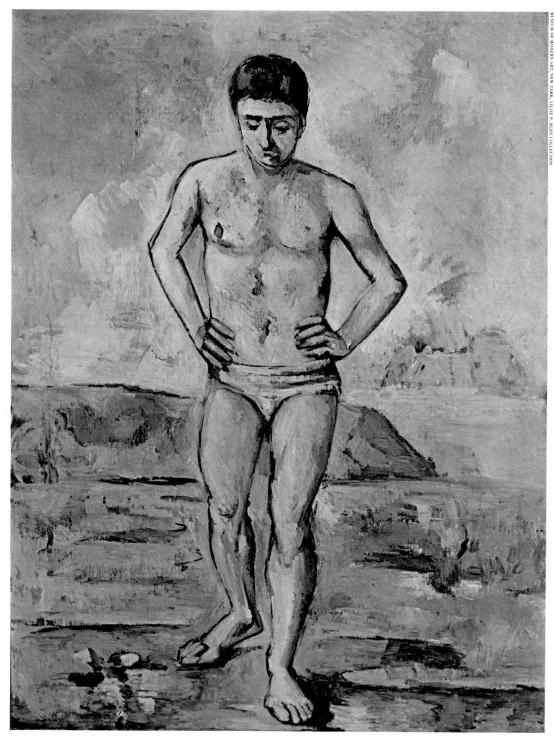

The Bather, 1885-1887

From the very beginning of his career, Cézanne attempted to solve the many problems of painting figures in a landscape. His early efforts were wildly imaginative: in the paintings shown on page 25, nude temptresses lure a saint; a woman is brutally attacked. Later, Cézanne suppressed erotic, violent and literary elements in his work, and in the 1870s he began a series of pictures, half-classical, half-romantic in character, of bathers on a shore. He was hampered by the provincial morality of Aix, where he found few models willing to pose in the nude. For the painting above he may have relied on a photograph *(page 147)*; the group at the top on the right was probably composed from sketches that he made as he observed soldiers, bivouacked near Aix, who came to the local river to bathe. Despite the difficulties he encountered, Cézanne grew increasingly skillful. In the picture above, the monumental figure dominates the setting, but in those at the right, man and nature are more closely integrated; in the lower picture, the agitated brushwork, intense color and nervous line serve to unify the whole composition into a luminous tapestry. Cézanne was approaching his goal.

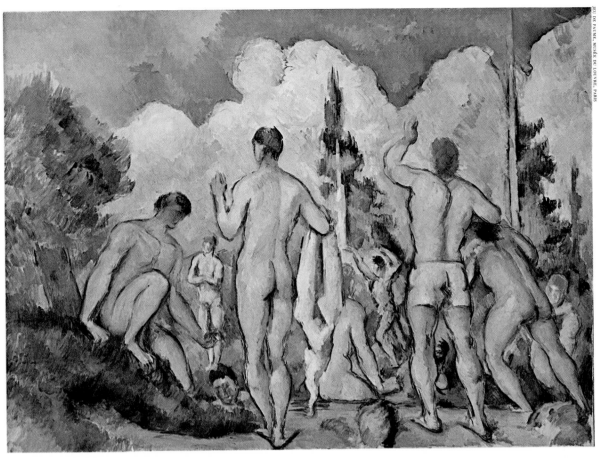

The Bathers, 1892-1894

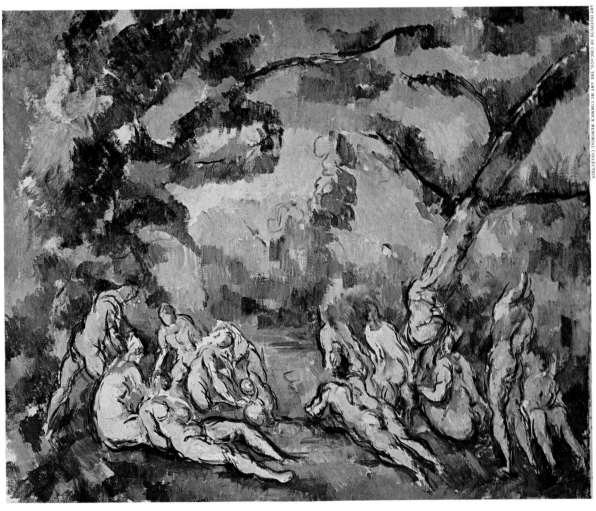

The Bathers, 1900-1905

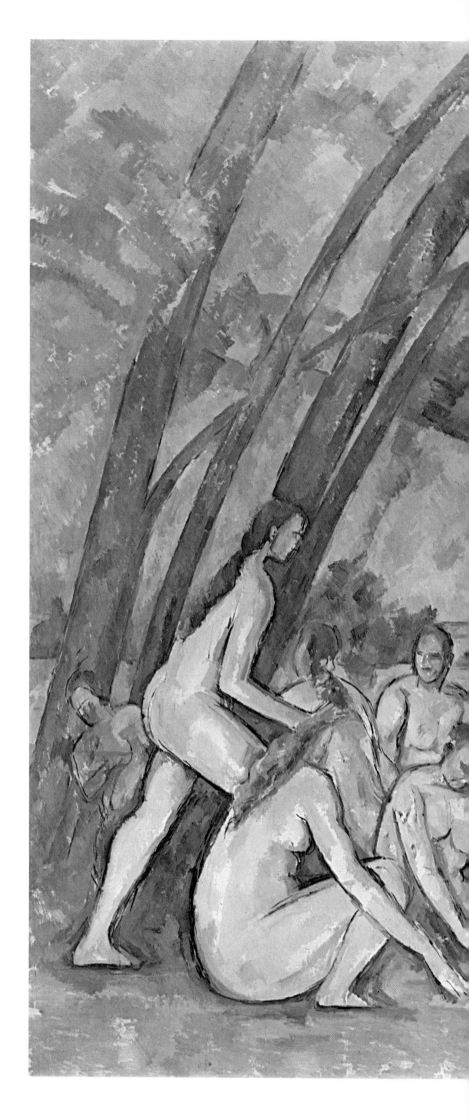

Perhaps the finest of all of Cézanne's landscape-figure paintings is this *Great Bathers*, so-called because it is the largest in the series using this subject—nearly seven feet high and over eight feet across. Cézanne continued to work on it for seven years, and it was still unfinished at the time of his death in 1906.

However, the picture is by no means incomplete. Of all the *Bathers*, this is probably the most firmly constructed and subtly colored. And yet how simple it seems! It is composed as a pyramid whose sides are a truncated arch of towering trees and whose base is a plinth of nudes, artfully arrayed across the foreground. This formal, geometric structure gives the painting its solid, architectural quality, a quality that is characteristic of the best of Cézanne's landscapes.

In other such scenes, those on the previous page for example, the landscape either dwarfs the figures or is overpowered by them. Here, both elements are integrated: through the arch a long vista opens up, creating an illusion of deep space. And in the distance figures and a building are visible—it is a peopled landscape. In the foreground, the nude bathers are active, but Cézanne leaves ambiguous exactly what they are doing. He has done so to maintain the delicate balance between the landscape and figures: by leaving out details, both of story and anatomy, Cézanne gives setting and figures equal emphasis. In his treatment too, Cézanne has unified the scene. A prevailing blue tonality links sky, trees, building and figures; a vigorous, animated line defines the forms, and throughout the canvas bold, rectangular strokes of color enliven the surface. Through his integration of style and subject Cézanne created the triumphant masterpiece that is *The Great Bathers*.

114

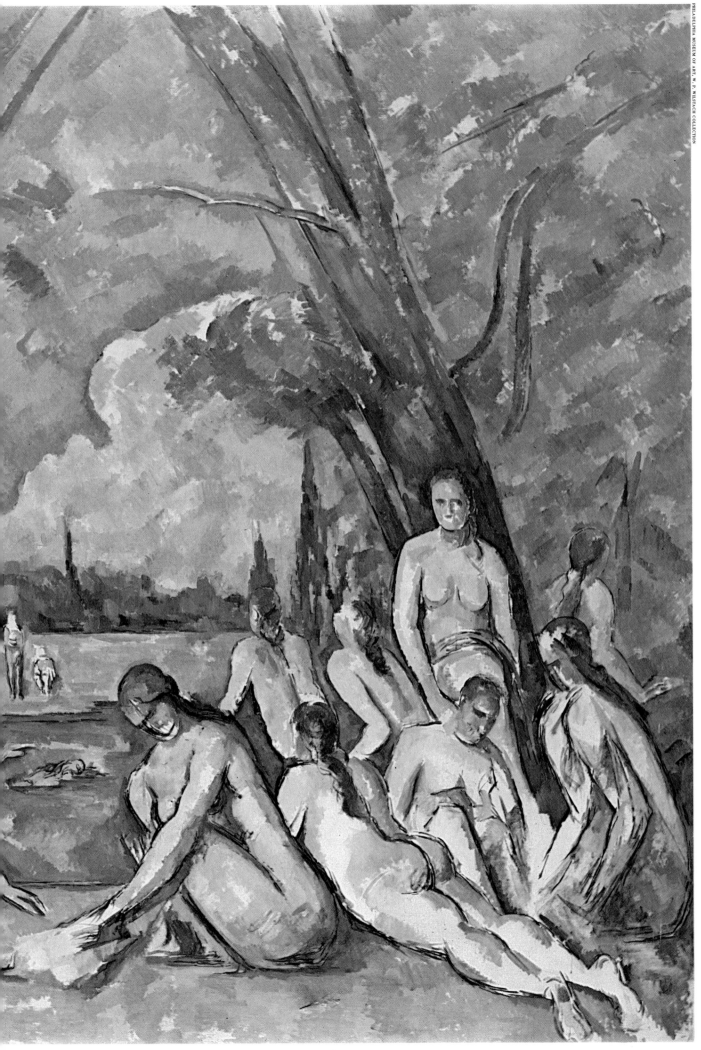

The Great Bathers, 1898-1905

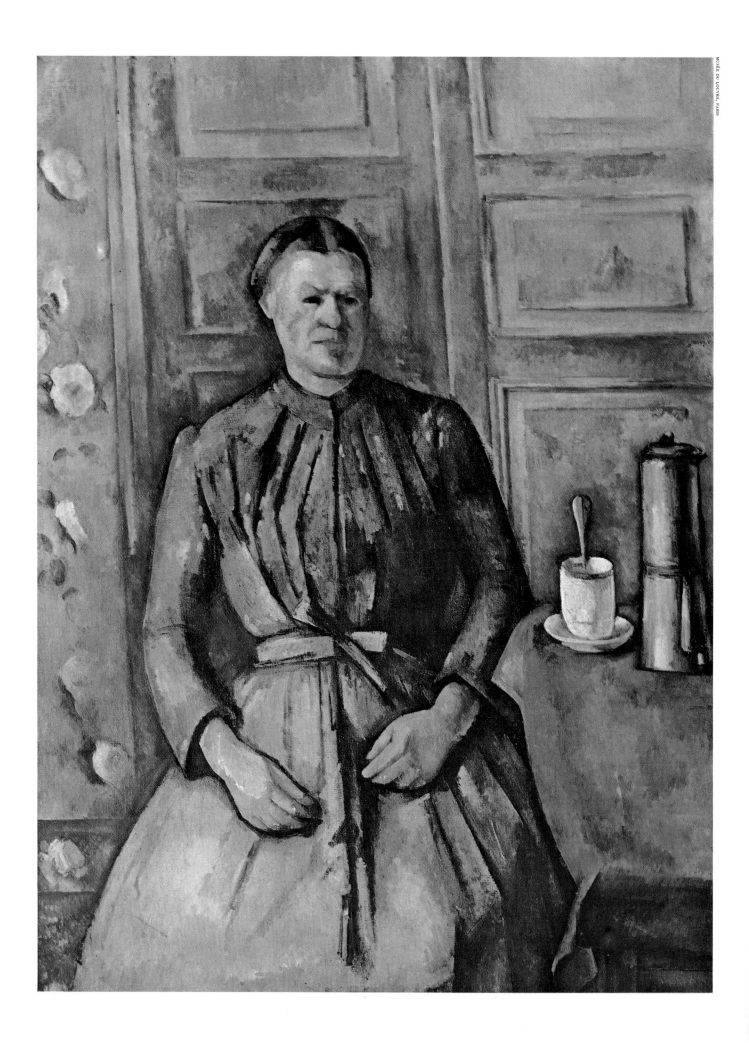

VI

A Friendship
Ends

In posing for this portrait, Cézanne's stolid housekeeper faced the artist squarely, exhibiting the kind of rigidity that grips most people when they are confronted with a painter's probing gaze. Cézanne has emphasized her flat, frontal posture with other elements in the composition; the spoon bolt upright in its cup, the straight cylinder of the coffeepot and the rectangular pattern of the door.

Woman with Coffee Pot, 1890-1894

Life changed very little for Cézanne after his father died in 1886 and left him comfortably well off. He still painted furiously—in the late 1880s and 1890s he turned out some remarkable figure paintings and a flood of landscapes. He became more and more isolated. And he was still being badgered by the women in his life: his mother, his sister Marie and his wife (whom his friends still called "The Ball").

Numa Coste sought out Cézanne during a visit to Aix in 1891 and later described, for Zola's benefit, what life was like at the Jas de Bouffan at that time. "How could a rapacious banker ever produce a being like our friend Cézanne?" wrote Coste. "He is well and physically solid, but he has become timid and primitive and more childish than ever. He lives at the Jas de Bouffan with his mother, who has quarreled with The Ball, who is also, of course, on bad terms with her sister-in-law, as they all are among themselves. So Paul lives on one side, his wife on the other. And it is one of the most pitiful sights I know to see that decent chap, still with the naïveté of a child, overlooking slights in the attempt to achieve a work he is incapable of."

Even after her marriage to Cézanne, Hortense Fiquet was not welcome at the Jas de Bouffan. According to people who knew the artist, Cézanne's mother and his older sister Marie quarreled bitterly with Hortense and banned her from the house, even though Cézanne himself usually lived there when he was in Aix. They complained to Cézanne that he gave too much money to Hortense, and berated her for spending it extravagantly. To make matters worse, Marie and her mother also quarreled incessantly with each other. (Cézanne's younger sister Rose had prudently married a successful local businessman named Maxime Conil in 1881 and had moved to a country house outside of Aix known as Bellevue.)

When Cézanne was staying with his family, Hortense sometimes took an apartment in Aix or the general vicinity—in Gardanne or Marseilles—but more often stayed in Paris, where Cézanne would join her and Paul on his periodic visits. Occasionally, however, he felt that their presence in Paris cramped his freedom there. His old schoolmate

The one person for whom Cézanne never lost his affection was his son, Paul. Although the painter lived apart from his son much of the time, he made frequent sketches of the boy, like the one seen above. Below is a photograph of Paul at 14, already a proper young man with a walking stick, ascot and watch chain.

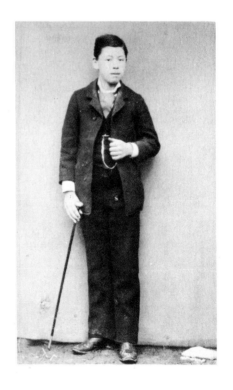

Paul Alexis notes in a letter to Zola that Cézanne had succeeded in making his wife and son settle down in an apartment in Aix by the effective means of cutting down her allowance. "Now," added Alexis, "if, as Cézanne hopes, the Ball and the brat take root here, there will be nothing to prevent his going to live in Paris for six months from time to time. 'Hurrah for sunshine and liberty!' he cries."

So far as is known Cézanne took only one extended trip with Hortense and Paul. That was in the summer of 1890, when the three of them went to Switzerland—the only time he ever left France. The trip was not a success. At Neuchâtel, dissatisfied with his efforts to capture the Swiss landscape, he left behind two canvases in his hotel room. At Fribourg he disappeared entirely, and his wife and son did not know where he was until he wrote them from Geneva four days later. However, despite his objections, Hortense managed to drag the trip on for five months.

By the time Cézanne got back to Aix he was in a rage, much to the amusement of Alexis, who apparently took a perverse pleasure in Cézanne's domestic difficulties. "He is furious at the Ball," wrote Alexis to Zola, "who . . . last summer inflicted upon him five months of Switzerland and of *table d'hôte*. . . . After Switzerland, the Ball, escorted by her bourgeois son, made off again to Paris. . . ."

Paul attended school in Paris during his father's middle years, and the two did not see each other for months at a time. But despite these absences and despite the tensions Cézanne felt when he was with Hortense and Paul, he seems to have been genuinely attached to the boy. He fretted over him when he was ill, and it is believed that he wrote to him every few days, although only the last 16 letters of the correspondence survive. In 1903 he described Paul to an artist friend as "rather shy, indifferent, but a good fellow," and added, touchingly, "He helps me to overcome my difficulties in understanding life."

Cézanne also used Paul as a model a number of times; the earliest existing studies are a pencil sketch and an oil, both done when Paul was seven or eight years old. When he was 13, Paul appeared again in another oil, wearing a bowler hat. But the most important of the pictures for which Cézanne's son served as a model were the four versions—three oils and a watercolor—of a walking Harlequin, together with the related oil composition known as *Mardi Gras (page 108)*. These are among the strangest pictures Cézanne ever painted. Nothing in his past seems to have prepared for them, nothing in his future looks back to them. Produced in the years 1880-1890, they stand inexplicably apart from all the rest of his work.

Harlequin, a familiar comic character traditionally dressed in a many-colored costume, dates back to the Italian *commedia dell'arte* of the 17th Century. The theme has a long and respectable lineage in painting, but no one has yet explained the source of Cézanne's sudden—and transitory—interest in it. He had shown some previous inclination for subjects from mythology and the drama but none at all for fancily costumed figures. At the time of the Harlequin series, he was living in Paris with Hortense and Paul, who was in his late teens by then, and it is

conceivable that he simply noticed the youth dressed up for a masque-
rade and decided to paint him. One of Paul's friends was Louis Guil-
laume, son of a cobbler who was a neighbor of the Cézannes on the
Quai d'Anjou; Cézanne used Louis as the model for the other figure,
Pierrot, in *Mardi Gras.* Louis is said to have fainted at one session be-
cause of the artist's insistent demands that he remain motionless.

No Cézanne paintings are more surely handled or more expressive
than the Harlequin pictures. The finest, and probably last, of the group
(page 109) has the simplicity and force of all Cézanne's great paintings
and, in addition, a grace that is rare in his work. The sheer energy of the
color is extraordinary and so is the tapestry-like web of color in the
background, which is neither overpowered by the checkered diamond
pattern of the harlequin costume nor out of harmony with it. The
prominence that Cézanne gave to this costume, and also to the scimi-
tar-curve of the harlequin hat, lends a decorative effect to the painting
that, for Cézanne, is extremely unusual.

The most striking aspect of the figure is the extreme distortion and
abstraction of its features. Two sheets of preliminary drawings for the
Harlequin's head still exist, and they show the gradual elimination of
recognizable detail in the face until it assumed the mouthless, muzzle-
like look it has in the finished work.

Mardi Gras is a less successful effort, chiefly because the composition
is looser, but the painting remains, like the *Harlequin,* one of Cé-
zanne's most intriguing works. Its curious composition, its style and ex-
pressive power greatly influenced later painters, particularly Picasso,
whose own Harlequin series was in part inspired by Cézanne's haunt-
ing exploration of the theme.

Aside from the four Harlequin paintings and the *Mardi Gras,* the only
other large figure compositions that Cézanne painted directly from live
models were the five oils known as *The Cardplayers*—perhaps the most
famous of all his works. They were preceded by 10 preparatory studies,
some drawn and some painted. Among these are three oil studies
called *Man Smoking a Pipe (page 111)* that can stand comparison with
the best of Cézanne's portraits.

The various versions of *The Cardplayers* have been called Cézanne's
only genre paintings—casual scenes from everyday life. But what is
most striking about the paintings is that, although the scene may be
casual, the works have a grave and monumental quality entirely out of
keeping with the triviality of the activity depicted. Like the Harlequin
theme, the subject of cardplayers was one that had often been painted in
previous centuries. But always before there had been elements of story-
telling or hints of sentimental anecdote. Cézanne eliminated narrative
completely from his *Cardplayers* and concerned himself, as usual, with
form and color and composition.

As he worked on the theme he progressively simplified it. There is
some confusion as to the order in which he painted the pictures, but
the largest version—it has five figures—almost certainly came first, and
then the version with four figures *(pages 110-111).* Three smaller can-
vases with only two figures followed; the two models who sat for them

Cézanne's wife Marie-Hortense, a matronly
looking woman of the Victorian Age, posed
for the photograph above in 1900, when
she was about 50. At the time it was taken,
Cézanne was living permanently in Aix and
Madame Cézanne, who preferred the more
active life of Paris, visited him in the
summer, accompanied by their son
Paul, then in his 20s.

do not appear in the larger compositions. In the simplest one of all, generally accepted as the last, the two cardplayers are shown in strict profile, and the supporting shapes—table, chair, bottle, wall—are arranged absolutely parallel to the surface of the picture; there are no distracting complexities of design. This treatment has given *The Cardplayers*, as Roger Fry noted, the "weighty solemnity of some monument of antiquity. This little café becomes for us, in Cézanne's transmutation, an epic scene. . . ."

Cézanne actually painted *The Cardplayers* in his studio, but it is quite possible he did some preparatory sketching in a café in Aix; there is little doubt that his models were local peasants—one is said to have been a gardener at the Jas de Bouffan. Humble café habitués were in many ways ideal subjects for Cézanne because he seemed to understand their slow, deliberate ways, and he particularly appreciated their patience as sitters. They in turn probably paid him little attention—in their eyes he was, after all, nothing more than a slightly crazy but harmless old dauber.

It has been suggested that Cézanne's interest in the cardplayers theme had its roots in the rupture of his friendship with Zola. The two figures confronting each other across the table in the later versions, according to this interpretation, stood in Cézanne's mind for Zola and himself. This theory seems improbable, but certainly it is true that Cézanne was deeply affected by the break with his oldest friend. The two men never openly acknowledged that their friendship had ended, but they did not see each other after the publication in 1886 of Zola's *L'Oeuvre*.

The theme of this novel is artistic impotence, embodied in the person of a painter named Claude Lantier. As Zola indicated in his notes for the book, Lantier was drawn as "a Manet, a dramatized Cézanne, more nearly Cézanne." To Zola, Lantier-Cézanne was "a great painter who failed," "an incomplete genius," "a soldier of the uncreated"; his life was "the terrible tragedy of a mind that destroyed itself." At the end of the book Zola has Lantier hang himself before an uncompleted canvas, his "masterpiece."

L'Oeuvre merely summed up what Zola had been saying privately about Cézanne for many years. The relationship between the two men was a complicated one. The genuine affection they felt for one another was offset to some degree by the sense of rivalry that dated back to their school days. Both Cézanne and Zola were proud men, and as they grew older, the sharply contrasting circumstances of their careers put more and more strain on their friendship.

Zola was the most successful novelist of his day, Cézanne the most dramatically unsuccessful of painters. Zola, who by now had grown fat—only five feet seven inches tall, he weighed 192 pounds—was lionized socially and was constantly surrounded by other famous writers and critics; in 1888 he became a member of the Légion d'Honneur. Cézanne was almost a recluse, immoderately shy in company and neurotically sensitive to imagined slights. Once, on a visit to Zola at Médan, he walked into a room laden with painting gear and caught

On a warm August night in 1961, art thieves brazenly broke into a floodlit museum in Aix and stole eight paintings from a traveling Cézanne exhibit. In November, the French government in recognition of the loss, issued the large, four-color stamp *(above)* showing the most valuable of the missing canvases, *The Cardplayers*, one of five paintings to which Cézanne gave the same title. All ended well a few months later, when a ransom was paid and the paintings were returned.

what he deemed to be an amused look passing between Zola and a servant; he immediately left the house. Another time at Médan, he was interrupted while painting a portrait of Madame Zola in the garden; he broke his brushes, tore holes in his canvas and stalked out in a rage.

In his letters to Zola, however, Cézanne continually protested his friendship and his gratitude. "I am your grateful old schoolfellow of 1854," he writes, typically, at the close of a letter of April 1, 1880. And yet, ever since the first successes of the sensational novels in Zola's long series on the Rougon-Macquart family, there had been in some of Cézanne's letters an undercurrent of criticism and even mockery that Zola must have detected.

One of these letters, in which Cézanne gives the impression that he is unaware of the extraordinary uproar that attended the publication of Zola's novel *Nana*, has often been cited as a measure of the extreme isolation in which Cézanne lived. It seems far more likely that it simply suited Cézanne's ironic temper to pretend that in certain corners of France, at least, the noisiest success of Zola's career had attracted no attention at all.

The facts of the situation are these. *Nana*, the ninth volume in the Rougon-Macquart chronicle, had begun to appear in serial form in the Paris daily *Le Voltaire* in October 1879. Very soon it so monopolized the attention of the French reading public that it seemed to a contemporary critic to have become "an obsession, a nightmare." Its author was the subject of newspaper caricatures, and its courtesan heroine was both denounced as obscene and acclaimed in popular songs—such as *Nana, la Vestale de la Place Pigalle*. Enormously publicized, the book sold 55,000 copies in the first 24 hours after it appeared.

Cézanne at the time was spending the winter in a rented house with Hortense and Paul in the village of Melun, 27 miles from Paris. The weather was exceptionally severe, and he was indeed isolated. But he read several Paris newspapers regularly, writing Zola six months before *Nana* appeared that he took these papers to "get news of what you do and what you have done." Cézanne had also attended a dramatization of Zola's highly successful novel *L'Assommoir*, and at the theater had seen a huge poster advertising the serialization of *Nana*. Moreover, at the time *Nana*'s scandalous success was at its height, he exchanged a number of letters with Zola.

Under these circumstances, the letter he wrote to Zola in February 1880 is extraordinary. *Nana*, Cézanne notes, is "a magnificent work, but I fear the newspapers have entered into a conspiracy not to mention it. Indeed, I have seen not a single announcement or review of it in the three little papers I take. And this vexes me because it is indicative of a profound lack of interest in art. . . . Now it may be that the stir that should have been caused by the publication of the book *Nana* did not reach me here. . . ."

If Cézanne preferred to ignore Zola's success it was probably partly out of envy, partly out of a desire to deflate the man who in his eyes seemed to have become almost the prototype of the solid bourgeois they had both so scorned in their youth. Zola, in his turn, may have felt

a certain envy: Although it is doubtful that he ever understood Cézanne's work, he may have suspected that Cézanne, of the two of them, was the authentic genius.

In 1880 Zola wrote a series of four long articles on Impressionism in which he devoted one sentence to his old friend: "M. Paul Cézanne has the temperament of a great painter who still struggles with problems of technique and remains closest to Courbet and Delacroix." When Zola mentioned Cézanne again, it marked not only his farewell to Cézanne as a painter but his farewell to all the Impressionist painters he had once so vigorously defended. This was in 1896, when Zola once again wrote a review of the official Salon for *Le Figaro*. In it he celebrated the triumph of Impressionism but argued that Impressionist theory had been carried too far and had "borne fruit of a monstrous kind." Looking about him at the Salon he wondered: "Was it really for this I fought?" The effect of the review, Gustave Geffroy noted, was that of a "flourish of the trumpets of victory played like a funeral march." Of Cézanne, Zola said: "I grew up almost in the same cradle as my friend, my brother Paul Cézanne, and only now do people recognize the elements of genius in that great painter who never matured."

Zola's opinion of Cézanne was also held by many of his literary friends, and over the years Cézanne's reputation had suffered accordingly. In 1883 Pissarro reprimanded the critic J. K. Huysmans for failing, in his newly published book on contemporary painters, to mention Cézanne—who, Pissarro noted perceptively, "has had a very great influence on modern art." Huysmans replied: "I find Cézanne's personality congenial, for I know through Zola of his effort, his vexations, his defeats when he tries to create a work. . . ." But Cézanne's paintings, concluded Huysmans, were "not likely to live." Similarly, Thiébault-Sisson, critic of *Le Temps* and a friend of Zola, told his readers in 1895 that Cézanne "remains today as he has always been, incapable of self-judgment and . . . too incomplete to be able to . . . produce his full measure in definitive works."

So, in creating the character of Claude Lantier in *L'Oeuvre*, Zola was merely giving dramatic expression to certain antagonisms long latent in his relationship with Cézanne. When Zola sent him a copy of the book, as he did of all his works, Cézanne replied in April 1886 with a brief and formal note of thanks: "I have just received *L'Oeuvre*, which you were good enough to send me. I thank the author of *Les Rougon-Macquart* for this kind token of remembrance and ask him to allow me to clasp his hand while thinking of bygone years. Ever yours under the impulse of past times, Paul Cézanne." The note marks the end of their long correspondence.

More than a decade after the rupture, Zola cast himself in the most controversial role of his career—as a leading figure in that convulsion of the French conscience, the Dreyfus Affair. Although this bizarre, almost incredible case had little effect on Cézanne's life, it sheds an interesting light on the personalities of the two men and on the nature of the time in which they pursued their careers.

On September 26, 1894, a cleaning woman at the German embassy in

Paris delivered to Major Joseph Henry, second-in-command of the counter-espionage bureau of the French War Office, the contents of the wastepaper basket of Lieutenant Colonel Max von Schwartzkoppen, a military attaché at the embassy. This was standard procedure, and normally the colonel's wastebasket contained nothing more interesting than the love letters he received from the wife of the counsellor at the Dutch embassy. This time, however, Schwartzkoppen's wastebasket contained a memorandum, a *bordereau*, that listed five secret French military documents that the anonymous writer would be willing to sell to the German high command.

The assumption was that some French general-staff officer was acting treasonably. Among the four or five suspects in a position to have furnished the secret information was Captain Alfred Dreyfus, a Jewish artillery officer whose handwriting bore a likeness to the handwriting of the *bordereau*. Ostensibly because of this similarity but also because of anti-Semitism among the French officer corps, Dreyfus was tried by court-martial, sentenced to life imprisonment and, on February 21, 1895, shipped to the French penal colony of Devil's Island. He remained there in solitary confinement for more than four years. Major Henry was promoted to Lieutenant Colonel.

The case roused only temporary interest. The ironic fact is that the French Socialists, who were later for political reasons to become Dreyfus' most vociferous champions, were at the time of the original trial inclined to anti-Semitism on the grounds that all Jews were capitalists. Accordingly, the Socialists criticized the government for not imposing the death sentence.

In the summer of 1895 the War Office ordered Lieutenant Colonel Marie-Georges Picquart, Henry's superior officer, to re-examine the evidence in order to discover Dreyfus' motives. Instead, Picquart came to the conclusion that Dreyfus was innocent and that the *bordereau* had actually been written by Major Marie-Charles-Ferdinand Walsin-Esterhazy, a bitter and insolvent French infantry officer who had once declared to his mistress his ambition to be at the head of a company of lancers, "sabering the French." Henry, however, refused to acknowledge that Dreyfus was innocent. Believing that the reputation of the army was at stake, he forged documents to prove Dreyfus' guilt. Picquart was transferred to Tunisia.

Not until November 1897, nearly three years after the first trial, did the Dreyfus Affair become an important political issue. Dreyfus' brother Mathieu, having also become convinced, independently, of Esterhazy's guilt, accused him openly. The accusation got enormous publicity, particularly in *Le Figaro*, and Esterhazy, confident of War Office support, requested a court-martial to clear his name. He was duly acquitted; and some months later Picquart was arrested and imprisoned for revealing confidential military documents to a civilian.

By now the case had ramifications that went far beyond the question of Dreyfus' guilt or innocence or even the issue of anti-Semitism. The Dreyfus Affair, in somewhat the way a magnet affects iron filings, had polarized the currents and cross-currents of feeling that had shaped

the course of events in France ever since the Revolution. Lined up against Dreyfus were royalists, militarists, Catholics, rich merchants—all those of the right who stood to lose by a strong shift to the left. Supporting Dreyfus were republicans, socialists, anti-clericalists, anti-militarists—all those of the left who were anxious, as André Maurois put it, "to continue the Revolution, or to protect its conquests."

In the autumn of 1897, Picquart's lawyer—knowing Zola's reputation as a fighter for unpopular causes—had shown him the evidence assembled by Picquart of Esterhazy's guilt. On January 13, 1898, the day of Picquart's imprisonment, Zola's now-celebrated article *J'Accuse* appeared in the Paris newspaper *L'Aurore*. Addressed to Félix Faure, the president of France, it demanded Dreyfus' retrial and accused the officers who had tried Esterhazy of a deliberate attempt to obstruct justice. "The Dreyfus court-martial may have been unintelligent," wrote Zola, "but the Esterhazy court-martial was criminal." Three hundred thousand copies of *L'Aurore* were sold that day.

Zola was brought to trial by the government for libel, and he showed to less advantage before the court than he had in his magnificent protest. Alternately sulky and boastful, he made remarks like: "I don't know your law, and I don't want to know it," and "I have won with my writings more victories than the generals who insult me," and "Through my works French thought has been carried to the four corners of the world." He was given the maximum penalty of a year's imprisonment and fined 3,000 francs. He appealed, was retried with the same result and on July 18, 1898, reluctantly and under pressure from friends, fled to England to escape imprisonment.

Nevertheless, so many others shared Zola's conviction that something was wrong in the Dreyfus case that the new Minister of War examined Colonel Henry's forged evidence and found to his own apparent surprise that it was indeed completely fraudulent. Henry was arrested and the next day slit his throat from ear to ear. The decision of the first Dreyfus court-martial was annulled by the Court of Appeals and a second court-martial ordered.

Astonishingly, Dreyfus was again found guilty, by five votes to two, but with extenuating circumstances. Offered a presidential pardon, Dreyfus accepted. Many of the Dreyfusards, to whom Dreyfus had long since ceased to be a human being and become merely a symbol, were bitterly disillusioned. They believed that Dreyfus should have refused the pardon on the grounds that he was innocent of any crime. "We were ready to die for Dreyfus," peevishly wrote the socialist editor Charles Péguy, "but Dreyfus was not." In fact, Péguy asserted, if Dreyfus had been a member of the court-martial he would have found himself guilty for purely disciplinary reasons. Dreyfus himself was thoroughly weary of the whole affair. "I hate all this moaning about my sufferings," he confided to a friend.

Although Dreyfus withdrew to private life, agitation for his complete exoneration continued. In 1906 the Supreme Court of Appeals, a civil court, cleared him of all charges and reinstated him in the army with the rank of major. He was also made an officer of the Légion d'Honneur.

Esterhazy was dismissed from the army, and Picquart became a general and soon, Minister of War. The later publication of Colonel Schwartz-koppen's personal papers proved beyond any doubt that Esterhazy had written the *bordereau* and that Dreyfus was innocent. The ultimate effect of the affair is difficult to measure, but certainly it discredited the monarchists and clericalists and the entire right wing of French politics, and hastened the separation of church and state in France.

In rushing to the aid of Dreyfus, Zola displayed the courage and passion for justice that were characteristic of him—and also the flair for publicity and self-aggrandizement that often made him mistrusted. Zola's action did not in itself turn the tide in Dreyfus' favor; many other factors and many other people were involved. But there can be no question that he dramatically focused public attention on the case at a time when interest in it had begun to flag.

Cézanne's reaction to the affair was far less dramatic, but in its way it was just as revealing. Questioned in 1898 about Zola's defense of Dreyfus, Cézanne remarked, simply, of his old friend: "They took him in." Here, obviously, spoke not only the recluse but that "timid little country gentleman," as Fry described him, who, despite his revolutionary artistic impulses, was inclined to take a conventional political position that would establish his respectability.

Cézanne had only one other recorded reaction to the Dreyfus case. From a Paris newspaper he cut several anti-Dreyfusard drawings by the popular cartoonist Forain and pinned them in the well of the stairway of his studio in Aix. "How beautifully drawn they are!" he would remark to visitors.

Violent disputes over the guilt or innocence of Captain Alfred Dreyfus, who had been convicted of treason by a military court, created divisions among the French that split not only the country but families and friends as well. In this pair of cartoons of the time, the caption for a congenial family dinner party *(above)* was "They've sworn not to discuss the Dreyfus Affair." The caption for the sequel *(below)* was terse: "They've discussed it."

What preoccupied Cézanne during the 1880s and 1890s was not national affairs or his problems with his wife, sister and mother, but the landscape of Provence.

"I began to perceive nature rather late," he had written Zola from L'Estaque in December 1878, "though this does not prevent its being full of interest to me." It was of such interest that Cézanne left 300 landscape paintings—half of them done between 1883 and 1895. These differ in one immediately apparent respect from the work of Cézanne's predecessors and contemporaries; because of his impulse to probe what is essential, solid and enduring in nature, there is in Cézanne's work none of the element of mood that animates most European landscape painting. The concern with structure that replaced mood in Cézanne's art was to have a significant effect on the work of many painters who came after him.

The country depicted by Cézanne is not the comfortable and rather benign land of the Impressionists, with picnickers at ease on the river banks and strollers in the roads and fields. Human figures, in fact, rarely appear in Cézanne's landscapes. Times of day seem to have been abolished and so have the seasons. Forms are enveloped in a great stillness; no wind stirs the trees or ruffles the water, the clouds are dense and immobile. There is the same sense of gravity that is noticeable in the still lifes and portraits.

The Provençal landscape did not produce Cézanne's style, but it ob-

viously influenced it. The natural structure of the forms of that hard, sunstruck land and the clarity of its light reminded Cézanne of what he thought Italy and Greece must be like, and he linked Provence to those countries as one of the "great classical landscapes."

He did not confine his landscape painting to the south; he also painted many landscapes in the north of France. But often in these latter canvases the misty Oise valley or the marshes of the Seine take on much of the structural quality of Provence. He seemed unable to forget the light and strength of his native countryside.

The Lake at Annecy of 1896 *(page 153)* is among the most eloquent of the landscapes Cézanne painted outside Provence, but even that failed to satisfy him. Somehow the country was not right. He explained this in a letter to his old friend Philippe Solari, who was then living in Aix. "It is not worth our country," wrote Cézanne, "although without exaggeration it is fine." But the land of his birth was in his blood, and nothing else could move him as it did. Cézanne expressed his feeling for his land another way in a letter to Gasquet. He loved, he said, "the conformation of my country," and he felt a "sadness in Provence that no one has yet sung." This close emotional identification with the land of the south lasted all of Cézanne's life.

During his lifetime, he painted a great variety of Provençal scenes, but there were a few he painted more often than others. The most deliberately structured of all these works are the views of the hill town of Gardanne, a jumbled little group of buildings clustered on the side of a hill crowned by the ruins of an old church. Cézanne moved there from the Jas de Bouffan in August 1885, shortly after his mysterious love affair that year. He lived in Gardanne with Hortense and Paul for more than a year. During this time he painted not only the steeply pyramided town itself *(page 149)* but the sweeping, barren hill country around it. He often piled his painting equipment on a donkey he had bought and departed on expeditions of several days, during which he ate in peasants' houses and slept in their barns. The series of Gardanne paintings had an important influence on other artists, most notably Georges Braque, whose cubist landscapes of 1908 clearly indicate a familiarity with Cézanne's work at Gardanne.

The countryside around L'Estaque was another favorite subject for Cézanne. In this Mediterranean town, he wrote Pissarro, he found the sun "so terrific that objects are silhouetted not only in black and white but in blue, red, brown, and violet." He worked both in the hills back of the town and on the rim of hills overlooking the bay of Marseilles. The unvarying green of the olive-and-pine landscape appealed to Cézanne's impulse to order and stability. In the same letter to Pissarro, he noted that "motifs could be found which would require three or four months' work, for the vegetation does not change here." He was far more in command of the country now than he had been during his visit of 1870, producing some superb paintings of it that bring to mind the lyric description of L'Estaque and environs that Zola wrote in his notes for *L'Oeuvre.*

Of Cézanne's paintings in the hills behind L'Estaque, the most in-

teresting is the *House in Provence (page 184)*, a powerfully simple composition in almost exclusively rectilinear forms that represents the artist at his most economical and abstract. Many other L'Estaque pictures showed views toward the sea, with two principal motifs: the red roofs of the town against the blue sea through a frame of trees, and the bay of Marseilles overhung by the distant hills. Both of these motifs he painted over and over again, often contrasting the curved tree forms against the rigid geometry of the houses, chimneys and horizon. Sometimes he handled the waveless sea and the sky in an almost flat-pattern fashion, with little attempt at an illusion of depth.

By contrast, the *Gulf of Marseilles Seen from L'Estaque (page 152)* is a picture that has a great feeling of space—both in its horizontal span, emphasized by a canvas considerably wider than it is high, and its extension into remote distance. No painting of Cézanne's demonstrates better how he achieved recession by juxtaposing color areas of different intensities—in this case, the reds and oranges of the near shore against the huge plane of blue water and against the pale, green-tinted sky. The effect is one of ordered vastness—calm, impersonal and enduring.

Cézanne apparently lost interest in the L'Estaque themes around 1890, and increasingly after that he painted views of Mont Sainte-Victoire. The mountain had always had a peculiar fascination for him. He drew or painted it more than 60 times, beginning around 1870 when it formed the background of his landscape *The Railway Cutting (page 30)*. But he did not begin to exploit it as an individual subject until the early 1880s, when he painted a series of canvases from a vantage point to the southwest of Aix. Then he painted it from Gardanne, from the Bibémus quarry to the east of Aix, and finally from his last studio on the Chemin des Lauves north of the city. By the mid-1880s the Sainte-Victoire had become the single most important theme in his landscape painting, and it remained so until the end of his life.

He did not twice paint it the same way. Sometimes he saw it as predominantly whitish in color, sometimes as dull gray or pale violet or pink or blue or even orange. He needed only to shift his easel a few paces in order to find a new motif. "The motifs are very plentiful," he wrote to Paul in 1906. "The same subject seen from a different angle gives a subject for study of the highest interest and so varied that I think I could be occupied for months without changing my place, simply by inclining a little to the right one time and to the left another."

The care with which Cézanne applied himself to landscape was noted with wonder by Renoir in the fall of 1889. At the time, Renoir, his wife and son were staying as Cézanne's guests at the Jas de Bouffan. The visit started well enough but ended badly, when Renoir, perhaps remembering Cézanne's stormy relationship with his father, made some mild joke about bankers. Cézanne took it as an affront to his family; Renoir shortly thereafter left.

What remained fixed in his mind many years later, however, was not so much the quarrel but a vision of his host—the "unforgettable sight" of Cézanne beside his easel gazing at the landscape with "ardent, concentrated, attentive and respectful" eyes.

Cézanne's Still Lifes

Still-life painting was particularly well suited to a man with Cézanne's prickly temperament and methodical painting habits. Human subjects not only failed to sit quietly, they were also hard to get along with. Landscapes, which he enjoyed painting, required laborious selection of just the right viewpoint. But in his studio *(right)* he could arrange apples, pears and plates with meticulous care until he had a motif that satisfied him—and the apples and pears never moved or talked back. Cézanne then spent weeks and often months working on his subject, which explains why he usually preferred not to paint fresh flowers that were likely to wither before he could "realize" his painting.

In devoting so much time and intense effort to still-lifes—he painted almost 200 of them—Cézanne revived a form that had attracted few serious artists, with the exception of Manet, for almost a century. But as he revived the form, he also changed it dramatically. He was not interested, as still-life painters before him had been, in creating scenes of domestic intimacy—a kitchen counter laid out with half-eaten remains. He wanted to achieve instead a canvas that could be appreciated for itself as a solidly composed structure of forms and colors. Rescued from its second-rate status, still-life painting after Cézanne became a legitimate expression of the vision of many major 20th Century artists.

Cézanne's last studio at Aix was a secure world to which he retired for several hours each day to paint. He designed the studio himself and selected its plain, utilitarian furnishings, many of which figured in his paintings. For Cézanne, no object was too prosaic to be interesting, and once, when a young painter asked him for advice, he told him, "Copy your stovepipe."

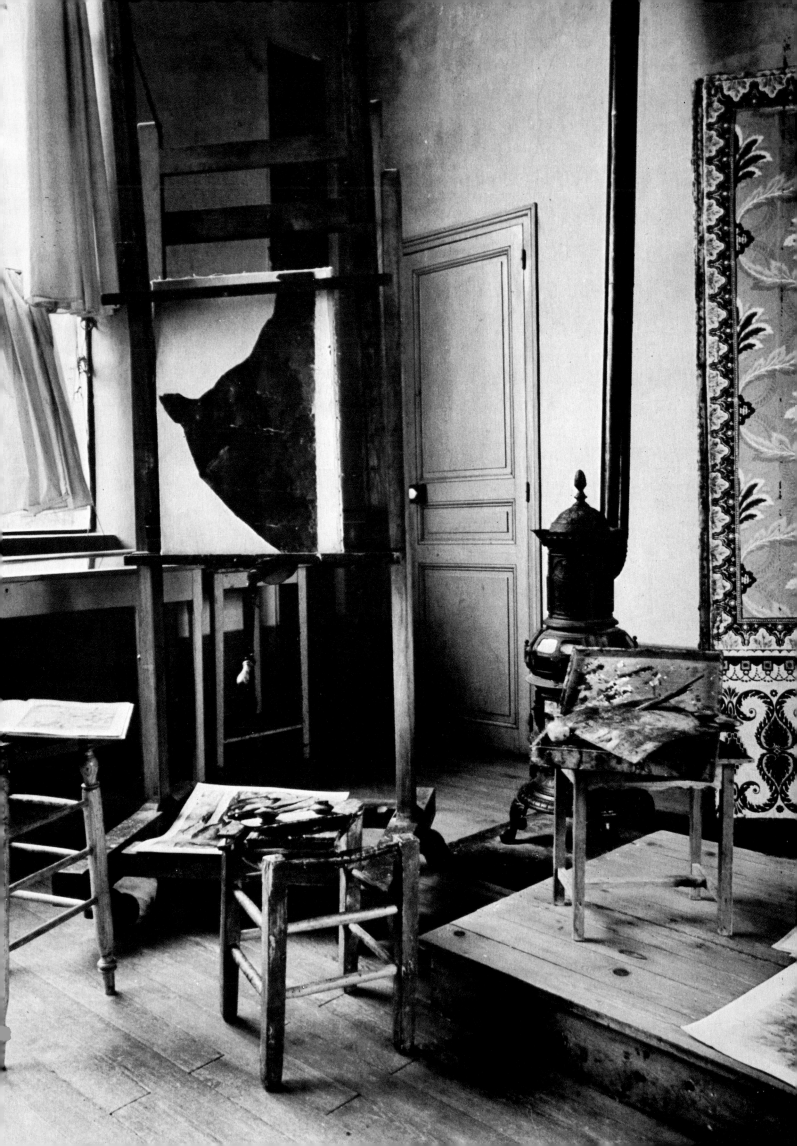

Sketch of the statuette "A Flayed Man," c. 1895

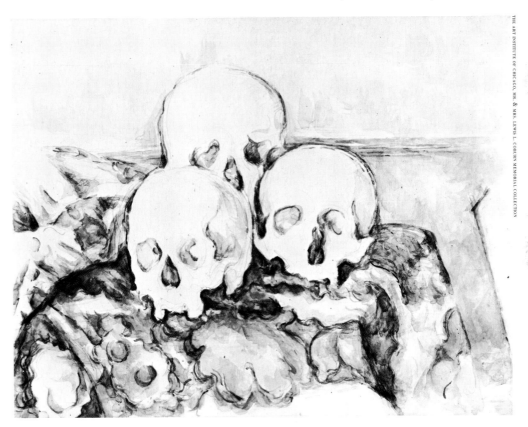

The Three Skulls, 1900-1904

Cézanne's studio in Aix has been preserved as a museum, and its tables and shelves *(left)* still hold the modest household objects he used so often in his paintings: bottles, a pottery ginger jar *(lower right)* and a white fruit dish. Cézanne also owned more formal props, such as the plaster cupid, the statuette and the skull on the marble-topped commode. These objects, commonly found in art studios of his day, Cézanne used for drawing practice as well as in paintings *(next page)*. The sketch at the top, above, is of a cast of a statuette of a flayed male figure erroneously attributed to Michelangelo by 19th Century art historians. The skulls directly above recall 17th Century Dutch still lifes in which a skull stood for the inevitability of death and as a reminder of life's brevity. For the emotional Cézanne, the objects must have had both artistic and personal significance.

Sketch of Cupid, 1888-1895

Sketch of Cupid, 1888-1895

In two of his still lifes Cézanne enriched his usual selection of simple objects by adding the little plaster cupid—a copy of a 17th Century Baroque statuette— seen in the painting at right and in the drawings above.

In the painting, the cupid is the focus of attention, though the "Flayed Man" statuette also appears dimly in the background on a painted canvas. Perhaps, as some have suggested, the two sculptures reflect two poles of Cézanne's emotional life: the cupid representing the erotic, and the "Flayed Man," violence and suffering. But the artist was clearly interested in the cupid's rounded shapes and he emphasized its curves by echoing them in the forms of the apples and onions.

He also created contrasts that infuse the composition with a dynamic tension. The pale sculpture stands out against the vivid fruit; the curves of the cupid are framed by the straight lines of the canvas behind it. Subtle ambiguities further heighten the tension. The blue drapery on the table at left merges imperceptibly with the drapery in what turns out, on close inspection, to be a painting leaning against the wall; while the stem of an onion on the table seems as much a part of the painting behind it as it does of the onion itself.

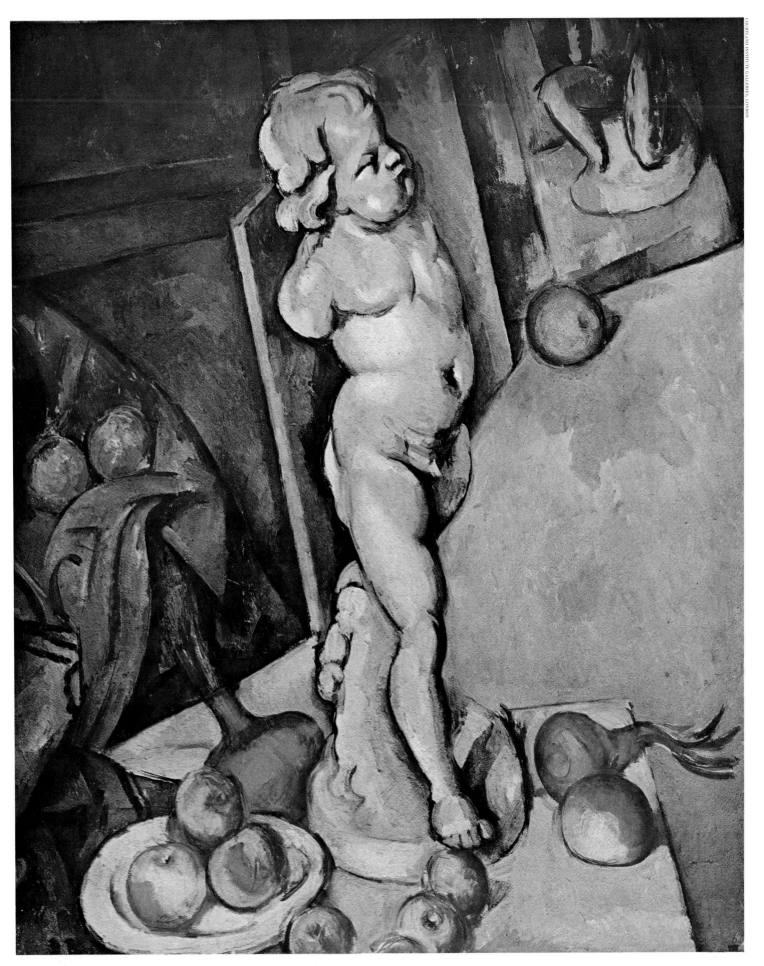

Still Life with Plaster Cupid, c. 1895

133

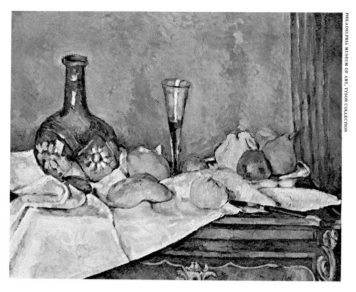

The Dessert, 1873-1877

Still Life with Apples, 1879-1882

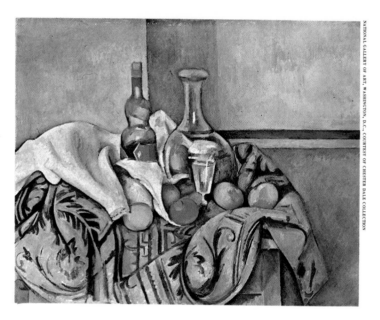

Still Life, 1890-1894

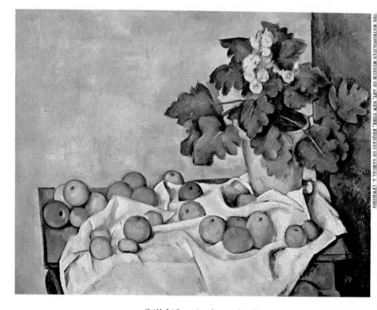

Still Life—Apples and a Pot of Primroses, 1890-1894

A gallery of Cézanne's still lifes—arranged in chronological order across these pages starting at top left—shows the vitality of his work and the simplicity of his subject matter. The sampling also illustrates phases in the evolution of his style. The earliest one shown, *The Dessert (top, left)*, conforms to many conventions of 18th Century still-life painting in its straightforward, linear perspective and the treatment of opulent glassware and gilded furniture. *The Blue Vase (top row, far right)*, shows the Impressionist influence that had lightened Cézanne's palette in the 1870s. The later works reveal the trademarks of Cézanne's mature style, artfully distorted perspective and complex composition. Cézanne worked on the last painting shown here for more than a year and, although it looks perfectly complete, he considered it unfinished.

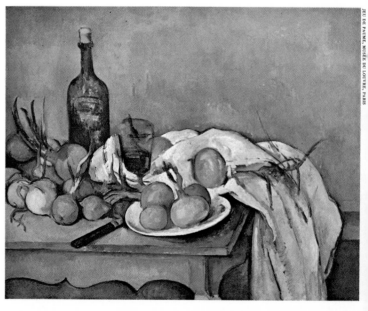

Still Life with Onions, 1895-1900

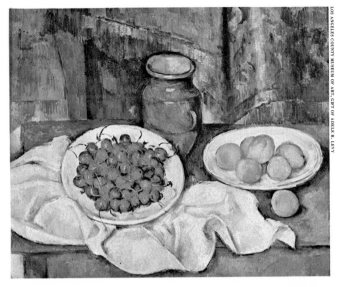

Still Life with Cherries and Peaches, 1883-1887

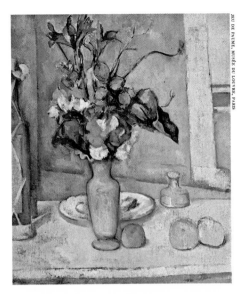

The Blue Vase, 1883-1887

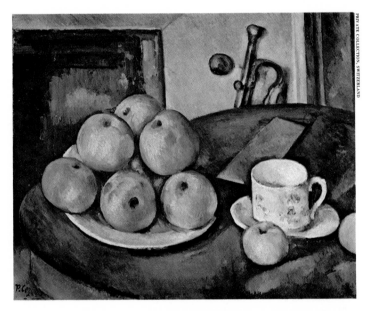

Still Life with a Plate of Apples, 1890-1894

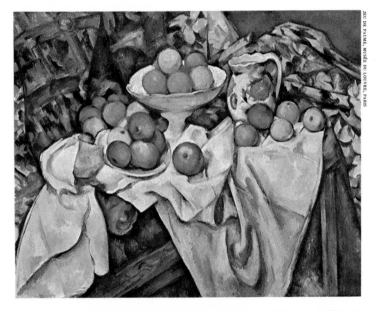

Apples and Oranges, 1895-1900

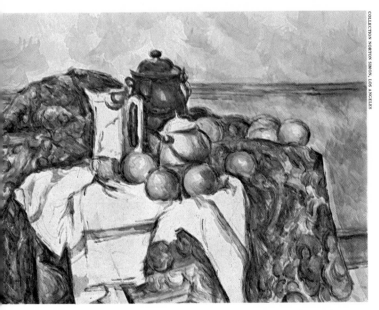

Still Life (watercolor), c. 1895-1900

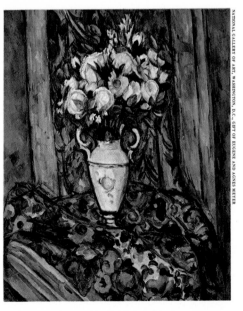

Vase of Flowers, 1902-1903

135

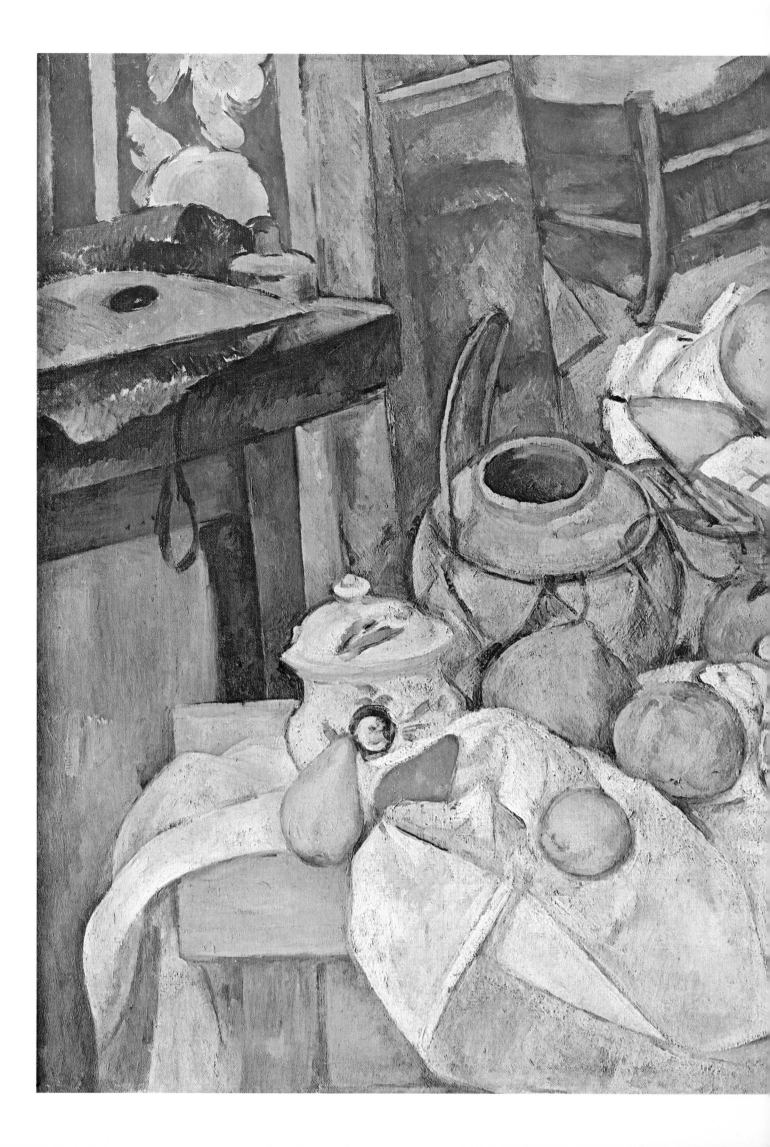

This still life, painted when Cézanne was at the height of his powers, vividly demonstrates his preoccupation with order and harmony. Having arranged his props with his usual care, Cézanne has deliberately given the impression of a random composition, an impression that disappears when the picture is analyzed. Each seemingly insignificant element is vital to the overall design. For instance, if the green pear at the right edge of the table is covered, the composition suddenly becomes unbalanced, falling off to the left. Because of its importance as a formal element, Cézanne has given the pear a disproportionately large size. Other apparent distortions of reality serve to unify the picture surface. The table edge in front is clearly broken under the cloth, the right and left surfaces do not meet; the fruit basket is seen simultaneously from two angles, the top as though from above, the side from straight on. These changing points of view push and pull the viewer's eye across the canvas, emphasizing the surface of the canvas itself as the true reality of the picture.

Cézanne achieved order in a still life, as he did in other paintings, only by long, slow, arduous work. Gradually, he balanced form with form, color with harmonious color, often changing an object's contours several times to make it complement an adjacent shape. In the process he applied many layers of paint, the effect of which clearly shows in the enlarged detail of this picture on the following pages. But Cézanne's methodical overpainting never dulls the brilliance of his colors, nor robs his picture of spontaneity and life.

Still Life with Fruit Basket, 1888-1890

137

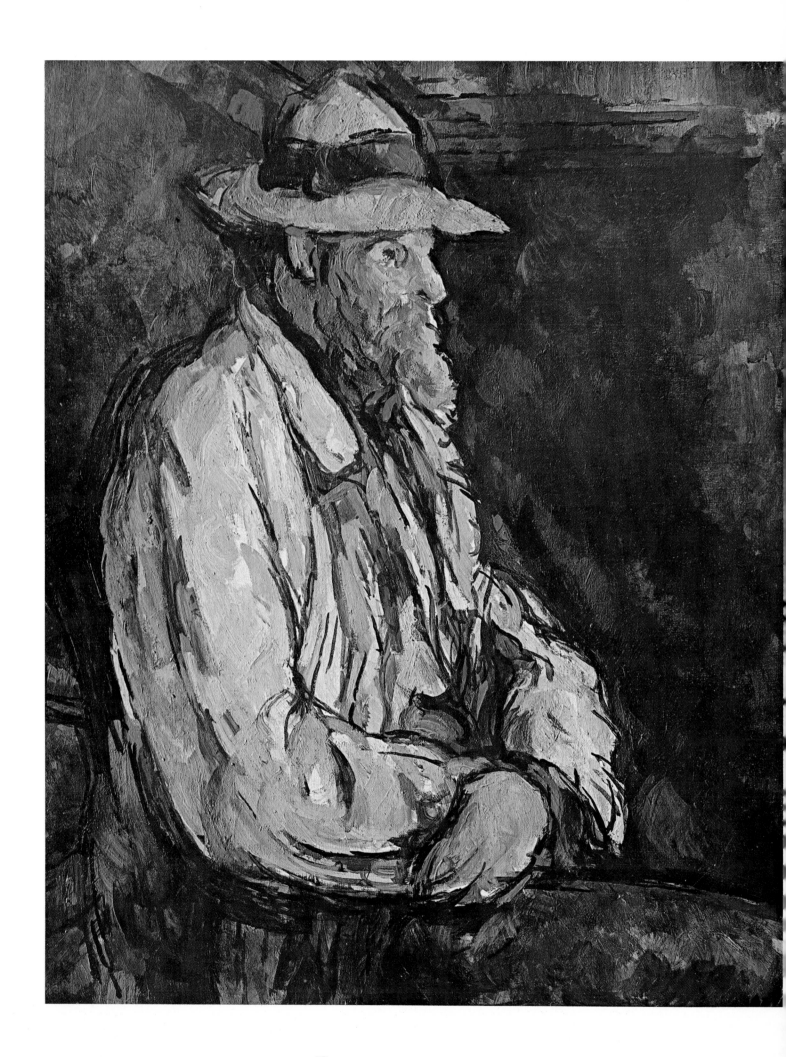

VII

An Explosion
of Color

"Suddenly the door opened. Someone came in with an exaggerated air of prudence and discretion. He had the face of a *petit bourgeois* or a well-to-do peasant, sly and rather formal. He was slightly round-shouldered and had a tanned complexion; a high forehead; long, disheveled white hair; small, piercing and ferret-like eyes; a slightly red Bourbon nose; a short, drooping mustache, and a military goatee. That was Paul Cézanne. . . ."

The writer of these lines was Édmond Jaloux, a young poet and critic. Jaloux met Cézanne in Aix in the late 1890s at a luncheon party given by Joachim Gasquet, son of Cézanne's old schoolmate, the baker Henri Gasquet. Jaloux vividly remembered not only Cézanne's appearance but his speech—"nasal, slow, meticulous, with something careful and caressing about it." On a different occasion in the same house, Jaloux's fellow poet, Louis Aurenche, also met Cézanne. Aurenche, who thought Cézanne seemed "extremely unhappy," watched him come into the drawing room and stop—"silent, intimidated, almost confused. . . . Madame Gasquet took us up to him and introduced each one of us in turn. At every introduction Cézanne bowed deeply, stammering a few unintelligible words; then a long silence fell. At table, Cézanne answered mainly his neighbor, Madame Gasquet, and sometimes I saw him interrupt himself suddenly and blush. Imagining that a slightly crude word might have shocked one of the guests, he remained silent a long moment. He left us before three o'clock so as not to be late for vespers at Saint-Sauveur."

The picture we have of Cézanne in these late years—confused, insecure, but tenaciously pursuing his art—comes to us mostly from young men like Jaloux and Aurenche, aspiring poets and novelists who met the painter through their friendship with either Émile Solari or Joachim Gasquet. Solari and Gasquet in turn were both introduced to Cézanne by their fathers, his contemporaries and old friends. Young Gasquet in particular remembered his first encounter with him. On a Sunday afternoon in the spring of 1896 Cézanne was sitting at an Aix café with Philippe Solari, Henri Gasquet and another friend, Numa

The last portrait Cézanne produced, this painting of his gardener, Vallier, occupied the artist until just a few days before his death. Its easy, flowing brushstrokes and luminous, prismatic colors typify the freedom and vitality that pervades Cézanne's late works.

Portrait of Vallier, 1906

Coste, when Joachim Gasquet passed by. On impulse he stopped at the table to tell Cézanne how much he admired his art. Cézanne turned red in the face, rose, slammed his fist on the table, upsetting bottles and glasses, and with a "terrible glance" shouted: "Don't you make game of me, young man!" When he understood that he was talking to the son of his old friend, he apologized: "I'm just an old fool who feels like weeping to listen to you."

On another occasion young Gasquet and his wife passed Cézanne in the street and greeted him. Cézanne seemed not to see them. The following day Gasquet received a letter from Cézanne: "I met you this evening at the bottom of the *Cours*," it began. "You were accompanied by Madame Gasquet. If I am not mistaken you appeared to be very angry with me. Could you but see inside me, the man within, you would be so no longer. Do you not see to what a sad state I am reduced? Not master of myself, a man who does not exist...."

This misunderstanding was cleared up, and Cézanne and the younger Gasquet were very close for several years. But eventually Cézanne began to suspect that Gasquet was merely trying to obtain paintings from him for speculative purposes, and their friendship ended. Other friendships ended just as abruptly. Cézanne turned on the young painter Louis Le Bail when, acting on Cézanne's instructions, he came to wake him from his afternoon nap and, after knocking loudly with no effect, entered the studio to find Cézanne asleep. Enraged, Cézanne sent for a canvas he had left in Le Bail's studio. "The rather discourteous manner with which you take the liberty of entering my room," he wrote, "is not calculated to please me." He adopted a similar tone in a note of July 5, 1895, to the painter Francisco Oller, whom he had met 30 years before at the Atelier Suisse. The two quarreled when Oller, visiting the Jas de Bouffan, offered Cézanne some advice on painting. "The high-handed manner you have adopted toward me for some time," wrote Cézanne, "and the rather brusque tone you permitted yourself to use . . . are not calculated to please me. I am determined not to receive you in my father's house. The lessons that you take the liberty of giving me will thus have borne their fruit. Goodbye."

In these years Cézanne alienated almost all of the painter friends with whom he was still on speaking terms. Oller and others reported that Cézanne had called Monet a "blackguard," Renoir "a pimp," Pissarro "an old fool," and that he had said Degas "lacked guts." (Yet in his happier moods he was capable of generous judgments: "Pissarro approached nature; Renoir painted Paris womanhood; Monet gave us vision; what followed did not count.")

Even Pissarro despaired of maintaining his ties with Cézanne. A Dr. Aguiar, who was a friend of the Pissarro family, had seen Cézanne in Aix (although he apparently did not examine him) and concluded that he was physically ill and exhausted. After being assured by the doctor that Cézanne was not responsible for his fits of rage, Pissarro wrote to his son Lucien: "Is it not sad that a man endowed with such a beautiful temperament should have so little balance?"

It seems clear that there was a general deterioration of Cézanne's al-

ready disturbed personality during the last decade or so of his life, probably aggravated by the diabetes from which he began suffering in about 1890. A neighbor of Cézanne recalled that as the artist walked to and from his studio he kept casting apprehensive glances over his shoulder as if in fear of being pursued. The critic Jean Royère remembered him in the mid-1890s as being "so nervous that he could not stay still; he would roar with laughter, then suddenly become moody. His twitchings betrayed exasperated sensitivity. . . ." But Royère, like many others, was impressed: "You knew immediately that the person before you was somebody."

As Cézanne grew more difficult, his wife and son spent more of their time away from him, in Paris. In April 1896, Numa Coste went to Aix, and as he had done some years before, wrote to Zola about Cézanne's domestic arrangements: "His wife must have made him do quite a lot of foolish things. He has to go to Paris or return from there according to her orders. To have peace, he has had to give up all he has. . . ."

It seems likely that old friends like Coste relayed news of Zola to Cézanne just as they did news of Cézanne to Zola. But the final blow to the long relationship of the two schoolmates came a few weeks after the letter quoted above was written. Zola visited Coste in Aix, but made no effort to see Cézanne. This tacit acknowledgment that their friendship was over is said to have hurt Cézanne greatly. In 1899, during the Dreyfus Affair, Cézanne had lunch in Paris with Joachim Gasquet, who seized him by the arm after lunch and tried to drag him off to Zola's apartment, where Gasquet was expected. But Cézanne showed such fright that Gasquet was forced to let him go.

Cézanne still had a few friends in Aix, however, and he still enjoyed simple pleasures with them. He had always been a great hiker, and although he usually roamed the countryside alone, he occasionally went on expeditions with others, as an entry from Émile Solari's diary of November 8, 1895, indicates: "Yesterday we went on an excursion—my father, Cézanne, Emperaire and I.

"Cézanne, tall, with white hair, and Emperaire, small and deformed, made a weird combination. One might have imagined a dwarf Mephisto in the company of an aged Faust. Farther on, after having traversed a considerable stretch of ground planted with small trees, we found ourselves suddenly face to face with an unforgettable landscape with Sainte-Victoire in the background, and on the right the receding planes of . . . the Marseilles hills. It was huge and at the same time intimate. Down below, the dam of the Zola canal with its greenish waters. We lunched at Saint-Marc under a fig tree on provisions obtained from a road-menders' canteen. That night we dined at Tholonet after a walk over the stony hillsides. We returned in high spirits, marred only by Emperaire's tumble; he was a little drunk and bruised himself painfully. We brought him home."

Cézanne's base of operations for many of his hikes was the Château Noir, a strange, reddish-tinted, Gothic-windowed building not far from the Bibémus quarry. For some years the artist rented a room in its western wing in which to work and keep his painting equipment (he

To aid him in his study of the human form, Cézanne made many drawings of the sculpture in the Louvre. The pencil sketch *(below)* of the bust of Voltaire was made from a portrait bust by Houdon *(above)* that he saw in the Louvre. Cézanne was obviously intrigued by the man's high-browed, gaunt-cheeked face and caught its salient features in his drawing.

usually slept at the Jas de Bouffan). He set off from there to paint the whole stretch of country to the east of Aix—that is, the Château Noir itself *(page 151)*, with its surrounding vegetation, the pine forests with their massive angular rock formations, the ochre-colored stone of the quarry and the ever-present view of Mont Sainte-Victoire.

In October 1897, Cézanne's mother died at the age of 82. It must have been a great loss to Cézanne, who had been so close to her, but there is little reflection of it in his letters. At the end of a letter to Émile Solari, written two weeks later, he adds, "By the time these few lines reach you, you will have heard of the death of my poor mother." That is the only mention of the event in his correspondence.

But his mother's death did upset his life in a practical way. In 1899, his sisters sold the Jas de Bouffan despite his objections. Presumably, as one of Louis-Auguste's heirs, Cézanne could have contested the sale, but he apparently made no effort to do so. Marie Cézanne looked after her brother's business affairs, and she agreed with her brother-in-law Maxime Conil that the house should be sold quickly in order to settle the estate. It was bought by one Louis Granel in 1899.

Needing a new place to live, Cézanne tried to buy the Château Noir. His offer was rejected, so he moved into an apartment in Aix—at 23 Rue Boulegon, where he was looked after by a housekeeper, Madame Brémond. A stout, good-natured woman of about 40, she seems to have had a quite remarkable ability to get along with her difficult employer. "I have orders never to touch him," she told Émile Bernard, "not even with my skirt as I pass."

This arrangement still left Cézanne without proper studio space, and in 1901 he bought an acre of land on a hill on the Chemin des Lauves, a road leading out of Aix into the countryside (*lauve* in Provençal means "flat stone"). He had a studio built here that gave him a view toward the town and Mont Sainte-Victoire. The building, which still stands, consists of two stories surmounted by a gabled roof of tile. Downstairs is an entrance hall, a small room in which Cézanne took occasional naps, and a moderate-sized dining room in which Madame Brémond sometimes served his midday meal. Upstairs is a large, high-ceilinged studio, with an immense floor-to-ceiling window on the north wall. In the same wall Cézanne had a slit made through which the largest of his compositions could be lowered into the garden so that he could look at them in full daylight.

Cézanne's habits of work were almost monastically simple. Rising before dawn, he got to his studio by six and painted until eleven. After lunch and a nap he would go out to paint "on the motif," often having to weight his canvas against the cold, dry mistral that sometimes blows violently for days on end in Provence. He returned to an early supper and went to bed by six so that he could get up at first light.

In his efforts to "realize" his paintings, Cézanne became increasingly demanding of himself. Many visitors to his studio mentioned that its floor was littered with discarded oils and watercolors. And it is said that when he moved from the room he rented at the Château Noir he burned a number of canvases on the terrace.

As always, he was totally absorbed in his art and in himself. He did not work at his former pace—"One must be young to do a lot," he wrote his son—but he worked steadily and with all his customary concentration. In fact, he seemed to live much of the time in a world no visitor could penetrate. The poet Léo Larguier recalled that in the midst of a general conversation at Sunday lunch Cézanne once remarked, "I am every inch a painter all the same!" in reply to some unvoiced challenge that echoed only in his mind. He then left the table and went to his studio to paint some more.

Cézanne's painting at the end of the century entered a new and final phase in which color was increasingly dominant. As always with Cézanne, the change was not absolute: Elements of his classical style appeared in his work almost until his death. But in the characteristic watercolors and oils of this last period, Cézanne's outlines became diffused to the point where they provided only the barest indication of masses. Color became more intense and more important than ever in determining form and it was laid on freely in broad sweeps of watercolor or thinned paint, or in numerous loaded brushstrokes that produced a shimmering, dense mosaic-like texture. When working in this style Cézanne applied only one layer of paint on an almost unprepared canvas that rapidly absorbed the oil of the pigment.

The effect of his use of color in the last paintings was to dissolve individual shapes and to fuse one form with another, giving an abstract appearance to the surface. As Cézanne became more and more absorbed in the interweaving of color planes as a means of defining space and relating different areas of the picture to one another, he necessarily sacrificed solidity of form. The late paintings, with their freely floating color patches, were as close as Cézanne ever came to an abstract art. Interestingly, this dissolution of form and intensification of color is characteristic of many painters in their old age—Titian, Rembrandt and Monet being notable examples.

Cézanne's preoccupation with freely applied color found fullest expression in the watercolors to which he devoted a great deal of attention during his last years. He had painted in the medium throughout his career, but most of his 400 surviving watercolors were done after 1890. This was partly because, as his health deteriorated, he found it simpler to carry his watercolor box than his oil painting equipment. But it was also partly because watercolor was an ideal medium through which to investigate the constructive potential of color planes; so much so, in fact, that when Matisse later set out to learn how Cézanne handled color he looked at the watercolors rather than the oils.

Cézanne painted two kinds of watercolors. Some of the most remarkable and effective of them are little more than color-accented drawings. The German poet Rainer Maria Rilke, secretary to Rodin and a member of the Parisian artistic circle of the day, described them in this way: "They are very beautiful; they reveal as much assurance as the paintings and are as light as the others are massive. Landscapes, brief pencil sketches upon which, here and there, as though to emphasize or to confirm, falls a trace of color, casually; a succession of dashes,

admirably arranged with a sureness of touch, like the echo of a melody."

The other kind of watercolor was built up of many very light touches and patches superimposed upon one another as in the *River at the Bridge of the Three Springs (pages 158-159)*. To prevent the various layers from running together, Cézanne had to let each one dry completely before applying the next. This extremely slow method yielded a type of watercolor never seen before. The viewer has the impression of looking through many differently colored and restlessly moving translucent layers, with each one distinct but modified by the layers above and below it. These interacting color planes do not so much describe a form, they very loosely suggest its shape and position, with the result that apples, trees, houses seem in constant flux.

Cézanne often used watercolor for preliminary studies for oil paintings but his interest in the medium was far more than merely experimental. He produced many fully self-sufficient works. The best of these combine the strength of the oil paintings with a lightness and delicacy rarely achieved by 19th Century painters.

Cézanne's innovations in watercolor had an effect on his oil painting that is most apparent in his late landscapes. In his many paintings of the Château Noir the forms of the bushes and trees are broken up and then fused into one restless, agitated surface. The paintings of Mont Sainte-Victoire in this period are even more unusual. In three similar views from the Chemin des Lauves *(pages 156-157)*, Cézanne explodes the foreground and middle distance into fragmentary planes—greens, blues and yellows—that are mirrored in the sky. This gives the extraordinary effect of air that is alive over the land, rippling and waving like fast running water.

Cézanne in these final years also painted many portraits, in which he used peasants from Aix as models. This series began soon after 1900 with the *Seated Peasant* and ended with the last *Portrait of Vallier (page 140)*, on which Cézanne was working a few days before he died. Vallier, who was the gardener at the studio, sat for three watercolors and three oils. They are among the most penetrating psychological studies Cézanne ever did. Here the character of the sitter—simple, dignified and full of inner strength—is conveyed less by the features, which are very sketchily noted, than by the contained posture and the fullness of the form. In the characteristic style of the late period, the foreground and background are blended by means of fluctuating color patches that suggest the effect of light passed through a prism.

Toward the end of his life Cézanne also returned to a theme that had haunted him since he saw Manet's *Luncheon on the Grass* in 1863 —that of the nude in landscape. Cézanne had begun painting outdoor nudes as early as 1877, and between 1883 and 1895 he painted 10 compositions of male bathers. After 1895 he painted mostly women bathers. Of the more than a dozen compositions on the theme, the largest and most famous is the magnificent eight-foot-wide *Great Bathers (pages 114-115)*, on which he worked from 1895 until the year of his death, and which he left uncompleted.

Cézanne had always wanted to do a large painting of bathers "from

When Cézanne made this sketch of three lush water nymphs from a Peter Paul Rubens painting, he was following in the steps of other French painters for whom the brilliant color and opulent, Baroque line of the Flemish artist had long held special meaning. Earlier, Watteau and Delacroix had also been inspired by Rubens—in fact, Delacroix once made a sketch of this very group of figures. Despite his admiration for Rubens' style—some dozen copy sketches exist—Cézanne's own treatment of the figure was dramatically different, as is evident from the paintings on pages 112-115.

nature," he explained once to Émile Bernard, but he found many obstacles in his way. "For example," he said, "how to find the proper setting for my picture, a setting which would not differ much from the one I visualized in my mind; how to gather together the necessary number of people; how to find men and women willing to undress and remain motionless in the poses I had determined. Moreover, there was the difficulty of carrying about a large canvas, and the thousand difficulties of favorable or unfavorable weather, of a suitable spot in which to work, of the supplies necessary for the execution of such a large work. So I was obliged to give up my project of doing Poussin over entirely from nature, and not constructed piecemeal from notes, drawings and fragments of studies; in short, of painting a living Poussin in the open air, with color and light."

Forced to construct his painting "piecemeal," Cézanne worked from his collection of reproductions of works by El Greco, Courbet, Delacroix, Poussin and Rubens; from his art school sketches of 35 years earlier; and from sketches after statues in the Louvre.

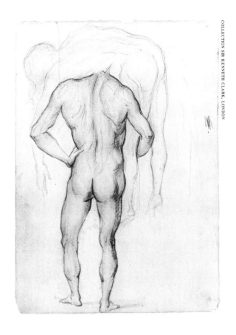

The composition of the *Great Bathers* is severely triangular; with its monumental Gothic arch of trees, it is often cited as the most classical of all Cézanne's compositions, an impression that is reinforced by the formal, frieze-like grouping of the figures. The scene, in fact, has none of the connotations normally associated with bathing. Its atmosphere is extraordinary. Everything seems drenched in blue—a color that became increasingly important to Cézanne as he grew older—and it is difficult at first to distinguish the foliage from sky and water. Even the bodies of the bathers, painted so thinly that they seem almost to be executed in watercolor, are touched by this tide of blue.

It was Cézanne's handling of the figures more than anything else that caused such a furor when this painting was first shown. Nobody before Cézanne had so daringly simplified and abstracted the human figure. His interest in conventional representation was so slight, in fact, that his figures often seem to have no faces, and it is sometimes difficult even to determine their sex.

Cézanne was trying to realize a very elusive goal: to integrate his figures into the overall structure of the picture, to relate them rhythmically to mountains, trees, bushes, clouds, sky, meadows and water, and to give them neither more nor less importance than these other forms. As Joachim Gasquet noted, Cézanne wanted "to marry the curves of women's bodies to the shoulders of the hills."

The success of his efforts was movingly attested to by Matisse many years later. In 1899 Matisse, who was then poor and unknown, had bought from Vollard at considerable sacrifice Cézanne's small canvas *The Three Bathers*, one of many studies that preceded *The Great Bathers*. Matisse kept the painting until 1936, when he presented it to the Petit Palais in Paris. In a letter to the director of the museum he remarked that after 37 years he knew *The Three Bathers* "fairly well, I hope, though not entirely; it has sustained me spiritually in the critical moments of my career as an artist; I have drawn from it my faith and my perseverance."

Uncomfortable in the presence of nude models, Cézanne was forced to work from sketches and photographs in composing his paintings of bathers. The drawing above was copied from a drawing by Signorelli. Below is a photograph of a male model that was later found pasted on the back of a sketch of Cézanne's: the figure appears, almost unaltered, in the painting on page 112.

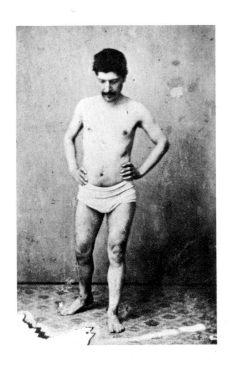

147

Homage to Provence

Cézanne never really left the gently rolling countryside around Aix, his boyhood home in Provence. During the last two decades of his life, he painted more than 150 landscapes in oil and nearly 170 in watercolor, almost all of which were local scenes. While he occasionally painted outside Provence, he returned to this beautiful region time and again, fascinated by its angular outcroppings of rock, its patches of intensely colorful foliage and, especially, its sunlight, a brilliantly steady radiance that illuminates every facet of the land.

These final landscapes, like all of his last creations, convey an uncanny sense of stability and timelessness. It is impossible to tell, for example, exactly what hour of the day or which season is reflected in the painting shown at right. The clock has stopped in a land where it is always summer. That the subject matter—mountains, valleys and forests—is itself enduring only partly accounts for this feeling, for it was Cézanne's deliberate intention to convey only what was changeless. Often he spent months painting and repainting the same canvas until he had identified the immutable forms of a scene.

As Cézanne grew older his canvases became more spontaneous and exuberant. Not committed to a literal representation of nature, Cézanne created vital forms that are almost color abstractions. In these last landscapes, which constitute a paean to his beloved Provence, he is a mature artist with total mastery of his palette.

One of Cézanne's portraits of Provence, this townscape depicts the little village of Gardanne, where his mistress, Hortense, and their child, Paul, lived for a time. The interlocking arrangement of the buildings, which sweeps the eye upward in a rush to the apex of the belltower at the top of the hill, demonstrates how Cézanne pierced directly to the heart of his subjects and found order there.

View of Gardanne, 1885-1886

Many of the buildings that dotted the countryside around Aix appear in one or another of Cézanne's landscapes of the region. Sometimes he was intrigued by a peculiarity in a structure, like the cracked wall of the ruin in the painting at right. At other times, he reacted to local legend: the *Château Noir (far right, above)*, was said to be haunted by the ghost of an alchemist, and Cézanne gave the building an appropriate air of mystery by almost obscuring it behind a dense shroud of foliage.

Often he painted on the estate of his brother-in-law, who owned a pigeon tower *(below)*. Its cylindrical shape was particularly appealing to Cézanne, whose tendency was to reduce his subjects to geometric forms. The *Jas de Bouffan (far right, below)*, the Cézanne family residence for nearly half a century, was among his favorite motifs. Here, as in other landscapes, he has omitted people, animals or anything transient that would disrupt the changeless character of his scene.

House with Cracked Walls, 1892-1894

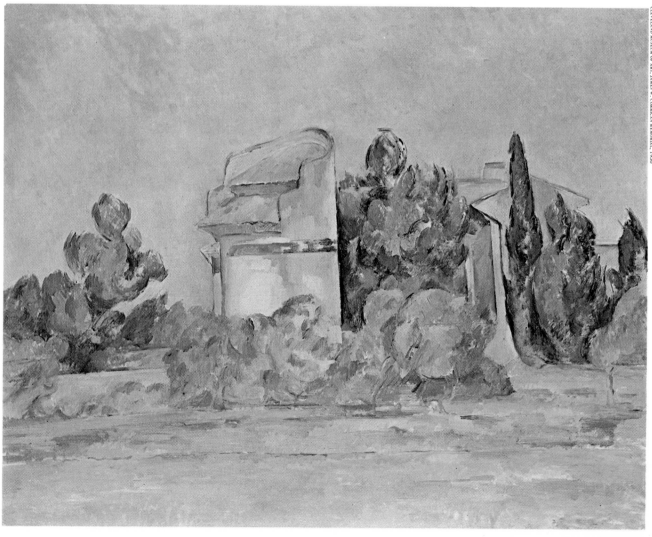

Pigeon Tower at Montbriant, 1888-1892

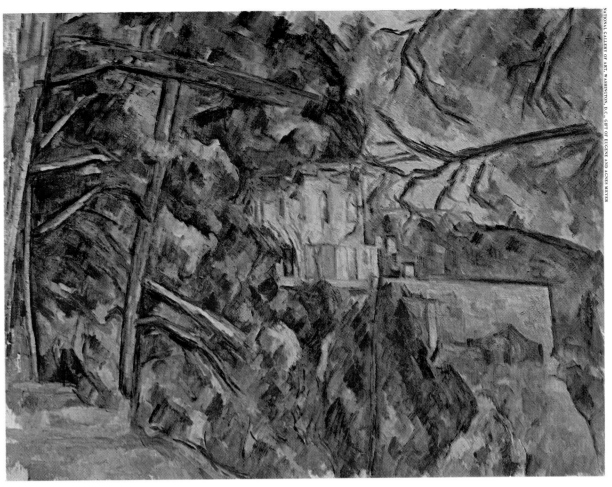

Château Noir, c. 1904

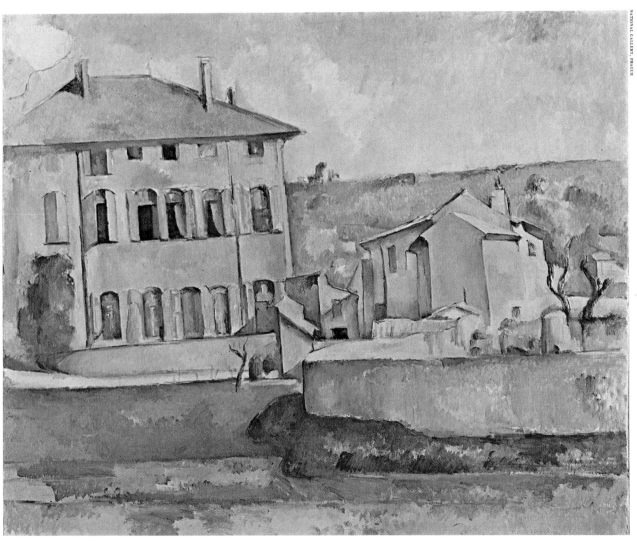

Jas de Bouffan, 1885-1887

Cézanne painted two of the three landscapes shown here outside Provence. The *Château at Médan (bottom, left)* is on the banks of the Seine a few miles from Paris (the dormered building at farthest right was the summer house of his friend Émile Zola). At times, Cézanne was disappointed by the scenery that he saw on his journeys. On a trip to Lake Annecy near the Swiss frontier, he found the Alps almost too picturesque and overpowering,

The Gulf of Marseilles Seen from L'Estaque, 1883-1885

Château at Médan, 1879-1881

and compared their picture postcard quality to the "drawing exercises of young lady tourists."

Cézanne's treatment of water, and particularly his handling of reflections in the painting *(below)* of Lake Annecy, demonstrate how his landscapes differ from Impressionist paintings of the same era. Whenever Cézanne painted water (as in the paintings shown here), he made it appear dense and opaque, never transparent or fragmented as in Impressionist paintings. And when he depicted the reflections of trees across the surface of the lake, they were as stable and defined as architecture.

After excursions beyond his own countryside, Cézanne returned to paint such arresting panoramas as the bay of Marseilles *(top, left)*. As he had written from the Alps to a friend back in Provence, "When one was born down there . . . nothing else seems to mean anything."

Lake at Annecy, 1896

153

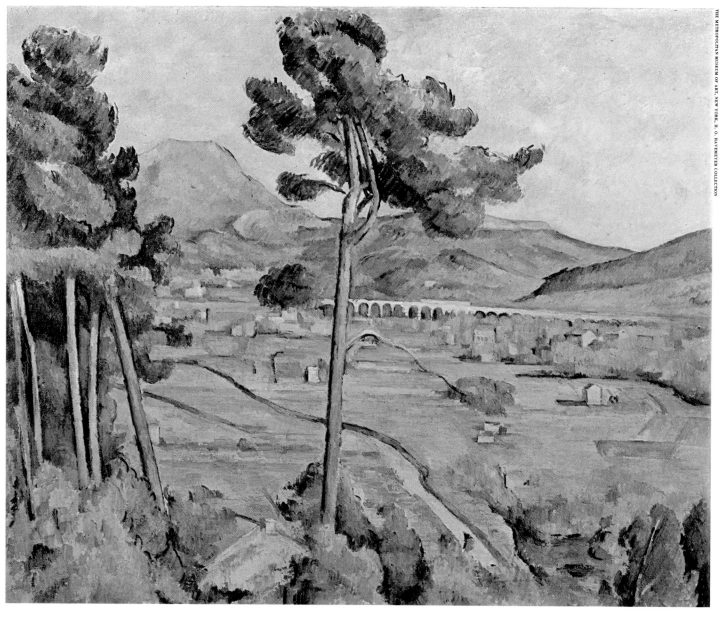

THE METROPOLITAN MUSEUM OF ART, NEW YORK, H. O. HAVEMEYER COLLECTION

Mont Sainte-Victoire, 1885-1887

Throughout his life Cézanne was obsessed by a mountain, a massive limestone ridge located about 10 miles from Aix. Named Mont Sainte-Victoire after a Fourth Century Roman soldier, who converted to Christianity and suffered martyrdom rather than renounce his new-found faith, the mountain is not at all impressive by Alpine standards, rising barely 3,300 feet. But in the low, surrounding landscape of Provence it is a noble and compelling sight. Mont Sainte-Victoire proved an endless source of pictorial motifs for Cézanne, who painted it at least 60 times and from nearly every conceivable angle.

The two views of the mountain shown here—painted a decade apart—illustrate strikingly different approaches to the subject. Only part of the mountain is glimpsed in the

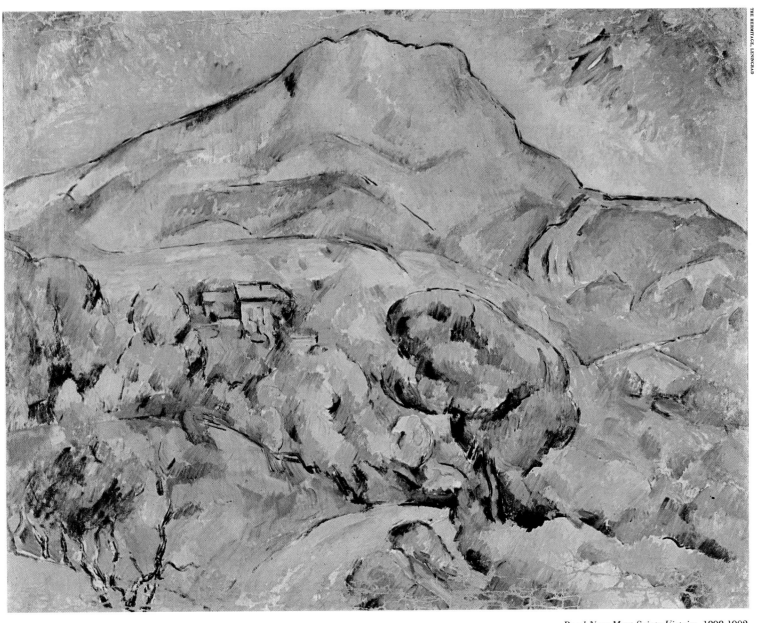

Road Near Mont Sainte-Victoire, 1898-1902

background of the spacious landscape at left. However, it is the most prominent feature of the other picture.

And because Cézanne diminished the illusion of depth in the second painting, the mountain appears to be crowding into the foreground. The two paintings also differ in composition. In the first, the strong vertical-horizontal emphasis set up by the intersection of the central tree and the viaduct is interrupted by the little dirt road that runs diagonally across the valley and by the prevailing panoramic sweep of the land. The second is much simpler, for it consists of only three successive waves of horizontals—the rocks and road in the foreground, the house and bushes in the valley, and finally the mountain —in which bold volumes are built up with vivid color.

Both paintings demonstrate another aspect of Cézanne's fascination with architectural forms. Not only did he include a many-arched viaduct in the work at left and the yellow house in the one at right, but in both instances he ordered nature as if it too were architecture. The entire middle ground of the first painting is composed almost mathematically, forming a complex grid of squares and rectangles; in the other, the slowly rising ridges of the mountain are cut like steps into its rocky surface.

Cézanne's reworking of this one subject reflects the untiring efforts of a thoughtful artist to discover new relationships in nature, ever-deeper perceptions of implicit order that are seldom evident in a cursory examination of the surface of the land.

At the beginning of the 20th Century, Cézanne's canvases became increasingly free and almost abstract. The lively patchwork of colors that make up the valley in this view of Mont Sainte-Victoire —among his very last paintings of the mountain—has an exuberance that is clearly absent from his earlier works. And although the colors and positions of many shapes still suggest concrete architectural forms and real trees, the canvas as a whole possesses a strikingly nonobjective appearance. The forms nearest the lower edge of the painting, especially, bear little resemblance to actual foliage.

The large sections of blue and white, laid broadly into the sky, appear to be floating not in the background but on the picture plane itself. Together with the strokes at the very bottom of the picture, these swatches of color assert that the canvas is a two-dimensional painted surface —a striking refutation of the rigid three-dimensionality found in more conventional landscapes. Earth, mountain and sky are a single, solid entity, bonded by a masterful upward thrust of color that begins at the very bottom of the canvas and culminates in the sky above.

The painting is one of his great, late masterworks, but, tragically, Cézanne was never aware of the perfect union of color and composition that he had achieved so dramatically in this and other of his final creations. Ever the toughest critic of his own work, he lamented in a letter, "Old age and failing health will see to it now that the dream of art I have spent my life pursuing will never come true."

Mont Sainte-Victoire, 1904-1906

In the 1890s, Cézanne began to use watercolors quite frequently. Unlike the painter in oils who can mend his mistakes simply by overpainting or by scraping off a layer of paint and starting again, the watercolorist must be unerring, for each stroke is transparent and indelible. With maturity, Cézanne had acquired the dexterity and dispatch to work faultlessly in this fragile medium, which was better suited to his increasingly spontaneous style than the more time-consuming process of oil painting.

Many afternoons during the last summer of his life Cézanne took his box of watercolors to the banks of the River Arc, where he did this stunning painting. He built up its agitated shapes with touches of pure color and built an arch representing a footbridge across the entire composition; where he required a spot of white he simply let the paper show through—yet another indication of the spontaneity of Cézanne's final creations.

The scene, set under a vault of trees in a valley near Aix, was where Cézanne and Émile Zola had gone swimming during the summer vacations of their boyhood (recorded in the drawing on page 23). Perhaps Cézanne recalled those joyous times as he painted this watercolor, for it is one of the freest and happiest of his career.

River at the Bridge of the Three Springs, 1906

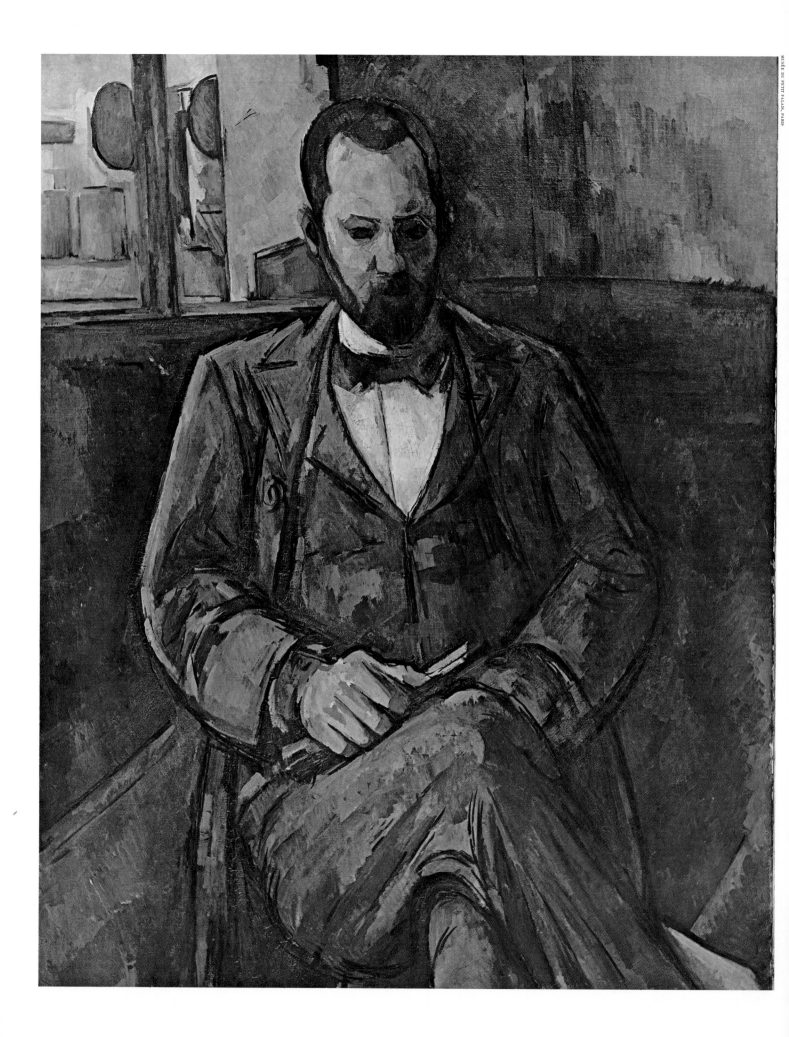

160

VIII

The Illustrious Hermit of Aix

From about the middle of the 1890s, the world began to come, very slowly, to Cézanne. The small coterie of young admirers surrounding him in Aix was augmented by artists, collectors and dealers who traveled to Provence to see the master. Among them were the painters Émile Bernard, Maurice Denis and Ker-Xavier Roussel, all of whom photographed Cézanne at work and questioned him about his art.

That young artists wanted to hear Cézanne's views is a tribute not only to his genius but to the strength of the legend that had already begun to grow up around him. The history of that legend—and of Cézanne's reputation—is a strange one. As late as 1890 some painters held the theory that his name was a pseudonym for a well-known painter who was reluctant to acknowledge such unconventional work. The critic André Mellerio wrote in 1892, "Cézanne seems to be a fantastic figure; although still living, he is spoken of as though he were dead." In the same year Gustave Geffroy wrote: "For a long time Cézanne has had a singular artistic destiny; he might be described as a person at once unknown and famous."

Cézanne himself did not help clarify his image. He confided to visitors his doubts that he would "realize" his visions. These doubts had become sharper as he grew older, and he expressed them in letters and conversation. Sometimes he seemed so rambling and contradictory in his talk about painting that a few of his visitors—Bernard, who liked certitudes, was one—decided that he was plainly not intelligent. Cézanne could say, for example, that "Impressionism is no longer necessary, it's nonsense!" and in the next sentence pay extravagant tribute to Pissarro for being a master of Impressionist technique.

Maurice Denis understood him better than most people. "Cézanne was a thinker," he recalled, "but he did not always think the same thing every day. All those who approached him made him say what they wanted to hear." Denis' acute observation explains, in part, why Cézanne's teaching has been so diversely interpreted and why so many schools have claimed descent from him.

But that was in the future. In the early 1890s few people had ever

seen a Cézanne canvas. There was only one place in Paris to find one and that was in Julien Tanguy's shop in the Rue Clauzel. There Van Gogh, Gauguin, Signac, Seurat and the somewhat younger painters Denis, Édouard Vuillard and Paul Sérusier became acquainted with what Denis called "the absurd and splendid works of Cézanne." These men were part of the avant-garde of the art world, however, and outside their small circle, Cézanne was unknown. In this respect he lagged far behind the painters of the Batignolles group with whom he had begun his career. By the early 1890s these former Impressionists had almost won their battle: they were known, they were collected by some of the most reputable collectors, they commanded fairly good prices—although still only a fraction of what the leading academic painters commanded. What they had failed to do was get into the museums. But in 1895 they achieved this goal—and Cézanne with them—as the result of the death of the wealthy painter-collector Gustave Caillebotte.

Caillebotte had known most of the Impressionists since their first group show in 1874, had loaned them money and had bought many of their paintings. Renoir and Monet had been his particular friends, but he and Cézanne also were fond of each other.

When Caillebotte died in 1894 at the age of 45, he left to the nation a collection that in today's art market would be worth millions of dollars. There were 65 paintings, including four Manets, nine Sisleys, five Cézannes, seven Degas, two Millets and eight Renoirs. Caillebotte specified in his will that the collection must be accepted by the government-directed Luxembourg Museum intact or not at all.

When the terms of the will became known, the traditionalist painters protested violently. "For the nation to accept such filth," wrote Jean Léon Gérôme, a member of the Academy, "there must be a great moral decline." Renoir had been appointed executor of the will, and after a wearying year of wrangling with the conservative directors of the Luxembourg Museum, he, Caillebotte's heirs and the museum officials agreed to a compromise whereby 38 of the paintings in the collection were accepted. Among these were Cézanne's *View of L'Estaque* and *Farmyard at Auvers*, the first of his paintings to be owned by the State.

The relative importance attached by museum officials to the various painters included in the Caillebotte bequest can be determined from a surviving museum memorandum that estimates the average value of each painter's works. From this it is apparent that in the mid-1890s the painters of the Batignolles group most acceptable to the public and the academicians were Manet, whose paintings the Luxembourg assessed at an average of 6,500 francs; Monet, whose works averaged 5,750 francs; then Renoir, 5,000 francs; and Degas, 4,070 francs. Pissarro and Sisley were much less well regarded at 1,857 francs and 1,333 francs, respectively, and Cézanne came in a very poor last. His two paintings were assessed at an average value of 750 francs.

At the end of 1895, however, there occurred a marked change in the critical—as well as the public—appraisal of Cézanne's artistic stature. For at that time Ambroise Vollard organized and presented a large retrospective exhibition of Cézanne's works. This was the first

one-man show Cézanne had ever had, and it came as a revelation even to the painters who were chiefly responsible for it—Renoir, Monet, Pissarro and Guillaumin.

These four had pointed out to Vollard that Cézanne had not only never had a one-man show but that his work had not been seen in Paris for nearly two decades. Chiefly on Pissarro's advice, Vollard bought, on credit, five of the six Cézannes then in Tanguy's collection. Next, again on Pissarro's advice, he sent word to Cézanne that he would like to hold a retrospective exhibition of his work.

From Aix Cézanne sent 150 canvases without stretchers, rolled up in a bundle. They represented the production of more than a quarter century, and the great majority of them had never been seen outside of Cézanne's studio. Vollard's shop was too small to show all the paintings at once, and he was forced to hang them in rotation.

So far as we know, Cézanne sent no comment with the paintings, and as there is a gap of more than 10 months in his correspondence at this point, it is difficult to know just how he felt about the prospect. It is likely that he did not even want to bother to go to Paris to see the exhibition. The story is told that he finally did, though, and made a brief visit with his son to Vollard's gallery the day before the opening. Supposedly, all he said to Paul afterwards about his paintings hanging in the gallery was: "And to think that they are all framed!"

But if Cézanne was noncommittal about the exhibit, the art world, the public and the press gave it a great deal of attention. Pissarro wrote to his son Georges, "The collectors are stupefied; they don't understand anything about it, but nevertheless he is a first-class painter of astonishing subtlety, truth and classicism." To his son Lucien he wrote: "My enthusiasm is nothing compared to Renoir's. Even Degas has succumbed to the charm of this refined savage. Monet, all of us. . . ."

Renoir went on to marvel at "those landscapes composed with the balance of a Poussin, those pictures of bathers . . . in fact, all that extremely sapient art!" Degas and Monet bought paintings and so, among others, did Auguste Pellerin, the margarine king, who thus laid the groundwork for what is now known as the Lecomte collection, the most extensive Cézanne collection in the world.

Predictably, some angry protest was heard. Painters like Jean Léon Gérôme and Puvis de Chavannes protested that the exhibition was an offense against the dignity of art. The critic of the *Journal des Artistes* muttered about "nightmarish atrocities in oil" and warned: "One may get away with pulling the world's leg, but not to this extent!"

But such reviews, which merely echoed what had been said at the time of the first Impressionist exhibition 20 years earlier, were by now rather rare. In 1895 they had an anachronistic sound. Most critics treated Cézanne seriously, and some were openly enthusiastic. Thadée Natanson wrote in *La Revue Blanche:* "He dares to be rough, almost savage, and carries things through to their conclusion, in contempt of all else, with the single-mindedness of all initiators who wish to create something of original significance." Gustave Geffroy, writing in *Le Journal,* said very much the same thing in fewer words. "He is a great

Both Pierre-Auguste Renoir and Edgar Degas wanted the watercolor above, entitled *The Three Pears,* when they saw it at Cézanne's first retrospective show in 1895. Painted in pale tones of yellow and green with tinges of violet, this was one of the relatively few watercolors in the show. In order to settle its ownership, Renoir and Degas drew straws. Degas won.

teller of truth," wrote Geffroy. "Passionate and candid, silent and subtle; he will go to the Louvre."

The fact is that by 1895 a kind of crystallization of taste had taken place. The way had been prepared by the Impressionists, whose works were more easily understood and hence more quickly accepted. One of the reviews of Vollard's 1895 exhibition mentions these links between Cézanne and other, already accepted moderns. Writing in *Le Figaro*, Arsène Alexandre reminded his readers of the strange figure Zola had described in *L'Oeuvre:* "Today it has suddenly been discovered that Zola's friend, the mysterious man from Provence, the painter simultaneously incomplete and inventive, sly and uncivilized, is a great man. . . . The interesting thing about this exhibition is the influence he exerted on artists who are now well known: Pissarro, Guillaumin, and later, Gauguin, Van Gogh and others."

The success of the 1895 show was such that Cézanne's reputation, while by no means widespread, was from that time to rise steadily; the market for his canvases also improved substantially. In 1897 Vollard visited the studio in Fontainebleau where Cézanne was then working and foresightedly bought every picture there—subsequently making a fortune from them. Two years later, when Victor Chocquet's collection was sold (he had died in 1890), the 32 Cézannes in it brought an average of 1,600 francs—more than double the value that had been put on Cézanne by the Luxembourg four years before.

In 1899, and again in 1901 and 1902, Cézanne showed his work at the Salon des Indépendants, which replaced the earlier Salon de Refusés as the chief forum of the anti-academic painters. Suddenly he was a celebrity. At the official Salon in 1901, Maurice Denis exhibited his large *Homage to Cézanne (page 176).* In the next few years, Cézanne was also shown at various exhibitions in Brussels, Vienna and Berlin, where he had a one-man exhibit in 1904.

More important still, the Salon d'Automne honored him in 1904 with a room to himself containing 42 of his pictures. The Salon, founded in 1903, had as charter members most of the talented young painters who had reached maturity during the 1890s—Denis, Vuillard, Sérusier, Félix Vallotton, Odilon Redon, Georges Rouault, Albert Marquet. The prominent position Cézanne occupied at the Salon d'Automne of 1904 was a graceful acknowledgment by these artists of their indebtedness to the recluse of Aix.

By 1904 Cézanne's importance had, in fact, become so overwhelmingly apparent that when the journal *Mercure de France* conducted a survey on "the present tendencies of the plastic arts," it devoted one question to him exclusively: "Where do you place Cézanne?" The replies, predictably, labeled him everything from fraud to genius.

Growing fame had little effect on Cézanne's way of life, and apparently it came too late to give him much satisfaction. From 1900 on he remained in Aix, with the exception of a few weeks in Paris and Fontainebleau when the Salon d'Automne honored him in 1904. Always obsessed by the passage of time, he referred often now to the many acquaintances who had passed out of his life. "How many memories

have been engulfed in the abyss of the years!" he wrote to his son.

He had lost one of his best friends and greatest admirers when Chocquet died. Of the Batignolles group, Berthe Morisot had died in 1895, Sisley in 1899, Pissarro in 1903. By the turn of the century, Renoir had begun to suffer from the rheumatism that would plague him for the last two decades of his life; Degas was threatened by blindness. Only Monet remained in robust health and continued to paint, as he would almost until his death at the age of 86, in 1926.

As for Zola, it is likely that Cézanne heard nothing at all about his old friend for several years following the author's notorious involvement in the Dreyfus Affair. Zola's big literary successes had ended with the completion of the Rougon-Macquart series in 1893; his exile in England virtually ended his concern with public issues.

The exile had lasted for 18 unhappy months. Zola knew no English and intensely disliked English food. Fearing extradition to France, he anxiously concealed his identity and lived in a succession of small, dreary hotels in Norwich, Weybridge and Sydenham. To pass the time, he bicycled about the countryside, presenting an incongruous figure with his professorial beard, pince-nez and knickerbockers.

His solitude was broken by one visit from his wife and two from his mistress, a woman named Jeanne Rozerot, who had been a laundry maid at Médan. Zola had fallen in love with her in 1888 and set her up in a separate establishment in the adjoining village of Verneuil-sur-Seine, to which he commuted by bicycle. Madame Zola had been unable to bear children, but Zola had two children by Jeanne—a son and a daughter (who in 1931 published a biography of her father).

After his return from exile, Zola kept on writing, and published four more novels; but all of them have an air of repetition and fatigue. The truth is that he was no longer interested; most of his attention was centered on his mistress and their two children.

On September 28, 1902, Zola died suddenly and strangely. He and his wife had decided that, because of an early cold spell, they would leave Médan and return to their house in Paris. A coal fire was burning in the bedroom grate, and Zola slept, as usual, with all the windows closed. Apparently the chimney had not been adequately cleaned at the end of the summer; carbon monoxide fumes poured into the bedroom, killing Zola and nearly killing his wife as well.

Cézanne, who heard the news of Zola's death from his gardener, was so upset that he is said to have burst into tears and locked himself in his studio for the rest of the day.

In 1903, five months after Zola's death, an auction was held of his art collection, which included 10 paintings by Cézanne. (An eleventh, overlooked at the time, was discovered in the attic of Zola's house at Médan in 1927.) All of the Cézannes owned by Zola were early works, and the buyers at the auction were surprised to see them get bids far above the official estimates. *The Rape*, one of Cézanne's erotic fantasies, brought the highest price—4,200 francs.

The sale provoked a controversy in the press. Zola still had many political enemies for his part in the Dreyfus Affair, and the anti-Drey-

fusards took the occasion to renew the attack on him and to attack Cézanne, as his friend. One article, in particular, illustrates how closely non-academic art was identified with political radicalism. This was a piece written by Henri Rochefort, a political opponent of Zola, and published in March 2, 1903, in the Paris newspaper, *L'Intransigeant*. It was titled "The Love of Ugliness" and said, in part:

"If M. Cézanne was still being nursed when he committed these daubs, we have nothing to say; but what is to be thought of the head of a literary school, as the squire of Médan considered himself to be, who propagates such pictorial madness? And he wrote Salon reviews in which he pretended to rule French art!

"We have often averred that there were pro-Dreyfus people long before the Dreyfus case. All the diseased minds, the topsy-turvy souls, the shady and the disabled, were ripe for the coming of the Messiah of Treason. When one sees nature as Zola and his vulgar painters envisage it, naturally patriotism and honor take the form of an officer delivering to the enemy plans for the defense of his country.

"The love of physical and moral ugliness is a passion like any other."

The good citizens of Aix were apparently delighted with this polemic, and soon Cézanne began getting threatening and anonymous letters urging him to stop disgracing the town with his presence. Paul wrote to his father from Paris asking if he wished to see the Rochefort article. "It is unnecessary to send it to me," replied Cézanne bitterly. "Every day I find it under my door, not counting the copies of *L'Intransigeant* sent by mail."

If the reaction of the citizens of Aix seems extreme, it must be remembered that most of those who were even aware of Cézanne's presence regarded him with varying degrees of condescension, suspicion and hostility. They misunderstood and mistrusted what they knew of his art, and they were baffled by the personality of this banker's son who roamed the countryside with his painting equipment strapped to his back, looking like a tramp in his old clothes, slouch hat and unkempt beard. Because of this suspicion, Cézanne had difficulty renting sites around Aix from which to paint; and he was an object of derision for small boys, who from time to time jeered at him in the streets and once or twice pelted him with stones.

What wounded Cézanne most was the fact that almost nobody in Aix had any regard for his painting. A half-dozen local nonentities whose works hung in the Musée Granet were more highly valued than he was. In fact, the director of the museum, Auguste-Henri Pontier, had sworn that while he was alive no Cézanne would hang there.

As Cézanne's reputation slowly increased after the 1895 retrospective, however, a suspicion began to grow in the minds of at least a few inhabitants of Aix that they were not doing justice to one of their distinguished citizens. At Cézanne's death, the critic of one local newspaper wrote:

"I would wish the town of Aix to remember Cézanne, whose canvases are in the Luxembourg in Paris, in Berlin and in the principal collections of Europe, though neither Aix nor Marseilles possesses even a

The elegant, long-limbed female nude above was created by sculptor Aristide Maillol as a monument to Cézanne. It was originally commissioned by dozens of Cézanne's admirers, including the painters Monet, Renoir, Redon, Vuillard, Bonnard and Denis, also art dealers, and collectors. The statue was subsequently rejected by the town of Aix, but it was bought by the city of Paris and finally, in 1929, some 20 years after the project was conceived, the figure was placed in the Tuileries gardens near the Louvre.

sketch by him. Homage, though belated, is due to the memory of this painter whose fame is continually increasing. We should be able to show visitors to our fine museums that we are not ungrateful, ignorant, narrow or behind the times, and that, when one of our fellow citizens is an honor to our town, our town is anxious to commemorate him."

Eventually, the city did commemorate Cézanne by changing the name of the Chemin des Lauves to Avenue Paul Cézanne and by fixing a bronze medallion of Cézanne's head into a public fountain. But it was not until after Pontier's death in 1926 that a work by Cézanne was accepted into the Musée Granet.

Cézanne's diabetes grew rapidly worse after 1902, and his working habits changed accordingly. He now painted almost exclusively at his new studio on the Chemin des Lauves and at various sites nearby. When he ventured farther afield in these last years, he usually rode in a hired carriage.

His illness made him especially sensitive to the heat of the Provençal summers, and in the last summer of his life he took to rising at four and working until eight, when the temperature became so "stupefying" he could not continue. "This temperature," he wrote to his son, "can be good for nothing but the expansion of metals; it must help the sale of drinks and bring joy to the beer merchants . . . and it expands the pretensions of the intellectuals of my country, a pack of ignorants, cretins and fools." But every afternoon at four, when the heat had abated a bit, the carriage came for him, and he found some relief working at his watercolor sketches on the banks of the river Arc where, as he wrote Paul, "large trees form a vault over the water."

Long shunned by most of the citizens of his native Aix, Cézanne was honored by the town some 20 years after his death. At that time, a medallion bust surrounded by a wreath was fixed to an old stone fountain in the town. The bronze sculpture was designed by Cézanne's friend Renoir, who was then so crippled by rheumatism that a young assistant had to execute the work.

Paul, who was by now a man of 35, still lived with his mother in Paris. He had no profession, but he acted as a kind of unofficial agent, representing his father in dealings with Vollard and sometimes with the private collectors who in increasing numbers inquired about Cézanne's work. His chief family role, however, was to provide his father with the advice and guidance in practical affairs that Zola and Marie Cézanne had once supplied. Toward the end of his life, Cézanne came to rely on him more and more.

There were times when he badly needed support, as his letters to Paul indicate. Some of them reflect an exhausted physical condition and a sad, perplexed and bitter mental state. "I have come to the conclusion," he wrote on September 22, 1906, "that one can be of no use to another person." At times the world disgusted him, and he had little confidence in the consolations of the church. "I think that to be a good Catholic," he remarked wryly, "one must be devoid of all sense of justice, but have a good eye for one's interests."

Despite his illness and fits of depression, Cézanne went to his studio every morning almost literally until the day of his death. "I have sworn to die painting," he wrote to Émile Bernard on September 21, 1906, "rather than waste away in the debasing paralysis which threatens old men." And to Louis Aurenche he wrote: "I have lots of work to do; it is what happens to everyone who is someone."

In the autumn of 1906 he dismissed his hired carriage because the

driver had proposed a trifling increase in the rate; after that, his usual practice was to walk with his box of watercolors to the edge of town or up the slope behind his studio until he reached the crest of the ridge called Les Lauves. From here he could look across the fields and wooded valleys to his favorite motif, Mont Sainte-Victoire.

That was where he was on the afternoon of October 15, 1906. In the morning he had written a letter to his son in which he sounded a familiar theme: "I have difficulty in carrying on with my work, but in spite of that there is something. That is the important thing." And he added, also typically: "All my compatriots are clods compared with me."

A sudden rainstorm caught Cézanne on his way home late in the afternoon; chilled and weakened, he collapsed in the road. The driver of a passing laundry cart took him, unconscious, to his apartment on the Rue Boulegon. His housekeeper, Madame Brémond, sent for the doctor, who told Cézanne to remain in bed. Nevertheless, he went to his studio the next day to work on the portrait of the gardener Vallier *(page 140)*—then felt too ill and returned to his apartment. He still planned to resume his painting, however, and he wrote an angry note to his color merchant in Paris: "It is now eight days since I asked you to send me ten burnt lakes No. 7, and I have had no reply. What is the matter? A reply, please, and a quick one. . . ."

This note, dated October 17, was the last Cézanne ever wrote. He became rapidly weaker and Marie Cézanne summoned Hortense and Paul from Paris. In moments of delirium Cézanne called out, "Pontier! Pontier!"—referring to the museum director whose refusal to accept his paintings had enraged him.

Marie Cézanne now sent an urgent telegram to her nephew, but he and his mother arrived at Aix too late. On October 22, Cézanne died of pneumonia, complicated by diabetes, at the age of 67.

The astounding thing about Cézanne's reputation is the speed with which it grew after his death. A year later, he was honored with a show of 79 watercolors at the Galerie Bernheim-Jeune. Shortly after, a great memorial exhibition of 48 canvases was held at the Salon d'Automne. Studies of his work were already being written, and in the fall of 1907 the *Mercure de France* published his correspondence with Émile Bernard. In 1910 and again in 1912 Roger Fry organized Post-Impressionist exhibitions at the Grafton Galleries in London, with generous sections devoted to Cézanne's oils and watercolors.

In 1914 Cézanne's work appeared for the first time in the Louvre. The pictures exhibited included *The House of the Hanged Man (page 66)*, one of the *Cardplayers* series, *The Blue Vase (page 135)* and various other still lifes and watercolors, all bequeathed by the banker-collector Isaac de Camondo. In 1920 the Louvre bought its first Cézanne, *The Poplars*, and in 1928 the Cézannes that had gone to Luxembourg Museum as part of the Caillebotte bequest were transferred with the rest of the bequest to a special room in the Louvre.

As Cézanne the revolutionary faded into Cézanne the Old Master, the prices of his paintings went up: the *Boy in a Red Vest* was sold for 56,000 francs (approximately $11,000) in 1913; in 1958 it was sold

for $616,000. The 1958 purchaser was the American collector Paul Mellon, and, some ten years later, he surpassed even himself by paying a reported $1.6 million for *Portrait of Louis-Auguste Cézanne (page 21)*, which he then donated to Washington's National Gallery of Art.

"They have cut Cézanne's apple into four pieces in order to eat it better." This remark, by the painter André Masson, sums up succinctly the many-faceted effect Cézanne has had on painters of the 20th Century. Few figures in the history of art have been claimed by so many movements, looked to for inspiration by so many artists, anatomized and eulogized by so many critics. In the process, there has been much misreading of Cézanne's intent. His comment to Émile Bernard that he was "the primitive of a new art" encouraged all manner of diverse movements to believe that theirs was the art he was referring to and to see in his painting the first glimmers of their own innovations.

Each movement found its special inspiration in a different aspect of Cézanne's painting, but the elements of his art that have had the most direct effect on later artists are his color, his composition and, most recently, the abstraction of his later works.

Many modern painters have paid homage to Cézanne. But Francis Picabia, one of the founders of the Dada movement, nailed a stuffed monkey to a board and labeled the product "Still life; Portrait of Cézanne, Portrait of Renoir, Portrait of Rembrandt." Even before he made this mocking gesture to deflate the reputations of the masters, Picabia had written: "I have a horror of Cézanne's painting; it bores me stiff."

His use of color was what first attracted the attention of those who followed. The "Nabis" (the name derives from the Hebrew word for "seer") were already speaking of it in the late 1880s. This group was composed almost exclusively of the young painters who had become acquainted with Cézanne's work at Tanguy's—Bernard, Bonnard, Denis, Sérusier, Vuillard. Color, the Nabis argued, must be restored to a position of supremacy in painting; therefore, Cézanne's color modulations fascinated them. In practice, however, there were fundamental differences between their style and his, the most obvious one being that while Cézanne used color structurally the Nabis tended to use it for decorative effect.

The Fauves—literally "wild beasts"—who came to prominence in the Salon d'Automne of 1905, set out to use color with even greater freedom and intensity. Many of the compositions of men like Henri Matisse, André Derain, Othon Friesz, and Maurice de Vlaminck, with their heavy bounding lines, thickly rolled impasto, distortions of contour and explosive color juxtapositions, have echoes of Cézanne's strong, harmonious color and fresh, unconventional way of painting the figure. The Fauves also clearly felt an indebtedness to Cézanne's late watercolors, with their intensification of color and dynamic flow.

But for all their knowledge of Cézanne's work, the Fauves and the Nabis actually came to him through the mediation of Gauguin. This was partially because Cézanne had always been, in Denis' words, "a difficult artist, in particular for those who love him best." Gauguin had carefully studied Cézanne's method of constructing in color planes, and served, in a sense, as a translator for the younger artists. He was, in fact, the only truly major painter who, during Cézanne's lifetime, was permanently influenced by him. Gauguin soon went his own way toward a decorative, flat style, but all his life he retained a Cézanne-like brushstroke and a respect for Cézanne's shifting planes.

Henri Matisse, who was a moving force behind Fauvism, was also

ahead of the rest of his contemporaries in his appreciation and understanding of Cézanne. As early as 1897 his still lifes showed the influence of Cézanne's shallow depth, and by the turn of the century he was experimenting with Cézanne's irregular contours and active, angular forms. It is remarkable that Matisse successfully assimilated so many of Cézanne's techniques into a style that was, unlike Cézanne's, basically ornamental.

By 1907 attention began to turn from Cézanne's color to his composition. The memorial exhibitions at the Salon d'Automne and the Galerie Bernheim-Jeune deeply affected many painters then reaching maturity, among them Pablo Picasso and Georges Braque.

Cézanne's influence on Picasso became evident in *Les Demoiselles d'Avignon*, painted by Picasso in 1907. In this widely celebrated work, Picasso employed both the austere structure and the shallow pictorial space that were so effectively combined in Cézanne's late bather paintings. Picasso followed this work with a number of still lifes in which he further analysed Cézanne's compositional techniques. In all of these, space was closely confined, and objects became faceted, as if viewed from several different positions simultaneously.

Braque, a former Fauve painter, was experimenting in 1907-1908 with the same austere, Cézannesque forms and the same shallow space. Out of these preoccupations came several geometric studies of L'Estaque painted in the summer of 1908 and a monumental *Standing Nude*. These experiments by Braque so closely paralleled those of Picasso that the two painters soon began working in close collaboration. Although each retained his identity—Picasso being the more dramatic in style, Braque the simpler and more lyrical—their joint efforts soon gave rise to the method known as Analytical Cubism.

Yet Cubism, like Fauvism, is only a part of Cézanne's apple. It is as unsatisfactory to try to explain Cézanne wholly in terms of Cubism as it would be to try to explain Picasso and Braque themselves simply as Cubists. Furthermore, with the evolution of Cubism into its more abstract phase, sometimes called Synthetic Cubism, a major difference between Cézanne and the painters who came after him became increasingly apparent. Where Cézanne had insisted that "painting is a theory developed and applied in contact with nature," the painters of the 20th Century were turning away from nature—that is, from the model—and were painting from the imagination, without relying on metaphors from the outside world. This trend led to the development of an abstract art. Nevertheless, even though twice removed from him, many of the Abstractionists continued to acknowledge the constructive influence of Cézanne.

At about the same time that Cubism was entering its synthetic phase, the movement known as Orphism came into being. This was a reaction against the almost monochromatic color of Analytical Cubism; the principal Orphist painters, such as Jacques Villon and Robert Delaunay, in breaking away from Cubism, endeavored to combine Fauve color with Cubist form, believing that color could and should be used to create movement. For inspiration they turned to Cézanne's late

paintings, making the case that the late Cézanne was the true Cézanne.

Many critics had felt that Cézanne's late paintings, with their sketchy outlines and apparently uncontrolled use of color, were the work of a declining master. The Orphists, on the other hand, saw in the oils and watercolors of Cézanne's last years a departure, a new expression that was as valid as any that had come before.

Gradually, as the century progressed, this opinion became prevalent. In the 1920s the German Expressionists took inspiration from the abstraction of the late works; in the 1930s the Surrealists saw in them a magical iridescence of color and subject, and welcomed Cézanne into their company. After World War II, Cézanne's late work became important to men like Alfred Manessier and Jean Bazaine *(page 183)*. In fact, it is chiefly in the last 20 years that the full importance of Cézanne's later watercolors and oils has been understood.

Cézanne's influence has been so pervasive that it is difficult to name a major artist or movement that has not been touched by him. "We are all descended from Cézanne," declared Braque, Fernand Léger and Jacques Villon in a public statement in 1953. The extraordinary breadth of his influence is not due simply to Cézanne's technical innovations, far-reaching and important as these are. Cézanne was straddling not only two centuries but two epochs of thought and feeling. Within his lifetime occurred a radical change in man's whole system of reference to the world and reality. By the mid-19th Century, immutable principles, mathematical certainties, eternal truths seemed less immutable, certain and eternal. And as the century wore on, it became increasingly difficult to define the real purely in terms of the visible, external world, as it had been defined since the Renaissance.

The effect of these changes was felt in all spheres of intellectual life, and in painting it led to a turning inward. The thing seen was now no longer as important as the way the artist saw and painted it. "A Cézanne is a moment of the artist," remarked Matisse. "A Sisley is a moment of nature." That is why so many diverse movements were attracted to Cézanne and why he seems today so intensely contemporary a painter. His own repeated assertions that he was "working outside the general trend" and had "come too soon" suggest that he was aware that the future belonged to the subjective artist. From Cézanne, it was not a long step to the point where the primary subject of painting was the creative act itself.

Cézanne left more than a thousand paintings, watercolors and drawings. It is difficult to say, finally, what gives them their distinction and force, but a viewer feels much as Georges Rivière did in his critique of Cézanne in 1877: "The artist produces emotion because he himself experiences a violent emotion which his craftsmanship transmits to the canvas." The source of that emotion in the artist we do not know; but we can guess. "There is a passing moment in the world," Cézanne once said. "Paint it in all its reality. Forget everything else for that." One of the many marvels of this lonely, terrified, courageous man was his ceaseless effort to contain and preserve the passing world, making from the very stuff of change that which is unchangeable.

This 1930 photograph shows three generations of Cézannes: the painter gazes from a self-portrait; his son Paul stands at the right; grandson Jean-Pierre, born 12 years after his grandfather died, is seated. Paul, who as a boy poked holes through the windows of houses in his father's discarded canvases, never adopted a profession. Until his death in 1947, he lived comfortably on his inheritance, principally Cézanne's paintings. Jean-Pierre followed in his grandfather's footsteps by painting, but although he has had a Paris exhibition, he has never had to consider art a main source of income. He has operated a shop dealing in rare books and manuscripts.

171

"The Father of Us All"

When fame finally came to Cézanne, in the last decade of his life, he seemed hardly to notice it. Living quietly in Aix, he continued to turn all his energies toward painting. "I have caught a glimpse of the Promised Land," he wrote his dealer in 1903. "Am I to be like the great leader of the Jews, or am I to be allowed to enter it?"

Among later generations there was no doubt that Cézanne, like a latter-day Moses, had indeed led the way to a whole new world in art. School after school of modern painters—from the color-conscious Fauves to the Abstract Expressionists—took inspiration from the vibrant colors, geometric compositions and textured surfaces of Cézanne's work. But even more than his painting style, younger artists admired the example of Cézanne's life—his single-minded dedication to his own ideals in art. "Everything about him was sympathetic to me," wrote the Cubist Georges Braque, "the man, his character, everything."

Many of Cézanne's admirers made trips to Aix to ask his advice on painting. Cézanne replied by urging painters to make their own artistic discoveries rather than borrow his. "If they try to create a new school in my name," he wrote, "tell them they have never understood, never loved what I have done." But Henri Matisse, the leader of the Fauves, spoke for most modern painters when he called Cézanne "the father of us all."

The patriarch of modern painting, Cézanne is shown seated in front of his monumental *Bathers* in this photograph, which was taken by the young artist Émile Bernard. The painting, so large that a special slot had to be cut in the wall of Cézanne's studio to get it outside, was one of several that exerted a strong influence on Pablo Picasso's *Les Demoiselles d'Avignon*, the great herald of Cubism.

172

Vollard's gallery, showing *(left to right)* Pissarro, Renoir, Vollard, a customer, Bonnard and Degas.

Catalogue cover for the 1898 exhibit of Cézanne's works, using the artist's drawing of four bathers.

Art dealer Ambroise Vollard *(right)*, who first snared the attention of the public for Cézanne with an exhibit of his works in 1895, made a fortune for himself by promoting and aiding the careers of avant-garde painters. His instinctive good taste, combined with an acute business sense, led him to accumulate a picture collection worth some eight million dollars at the time of his death in 1939. In addition to canvases by Cézanne, Vollard owned works by Picasso, Gauguin and Bonnard, who drew the caricature of the dealer in his cluttered Paris gallery at the top of the page. Vollard's continued backing helped keep Cézanne in the public eye. He arranged a second exhibit in 1898, and in 1915 he wrote and published the first biography of Cézanne.

Vollard in his Paris office in the late 1930s.

Maurice Denis: *Homage to Cézanne*, 1900

Homage from fellow artists

Cézanne's mounting fame at the turn of the century rekindled the controversy that had plagued his earlier years. Even while his paintings hung in museums in Paris and Berlin, one conservative critic branded them "the greatest art joke in fifteen years," and another claimed that "if we agree with Mr. Cézanne, we might as well set fire to the Louvre."

But among his fellow artists, enthusiasm for Cézanne was overwhelming. Maurice Denis even painted an *Homage to Cézanne (above)*, which, ironically, was accepted for display by the Salon, the institution that over the years had only hung one painting by Cézanne himself. The Denis work shows a group of painters in Vollard's shop admiring Cézanne's *Still Life with Compotier*.

The same still life forms the background of Paul Gauguin's *Marie Derrien (right)*. Gauguin was such an admirer of Cézanne that he owned 12 of his pictures, including the *Compotier*, which he refused to sell "even in the case of utmost necessity." In his own work, Gauguin often employed Cézanne's tightly woven brushstrokes and his patterned areas of color. Despite these tributes, Cézanne disliked Gauguin personally and accused the younger painter of plagiarizing his technique and "trailing the poor thing about in ships . . . , across fields of sugarcane and grapefruit . . . to the land of the negroes and I don't know what else."

176

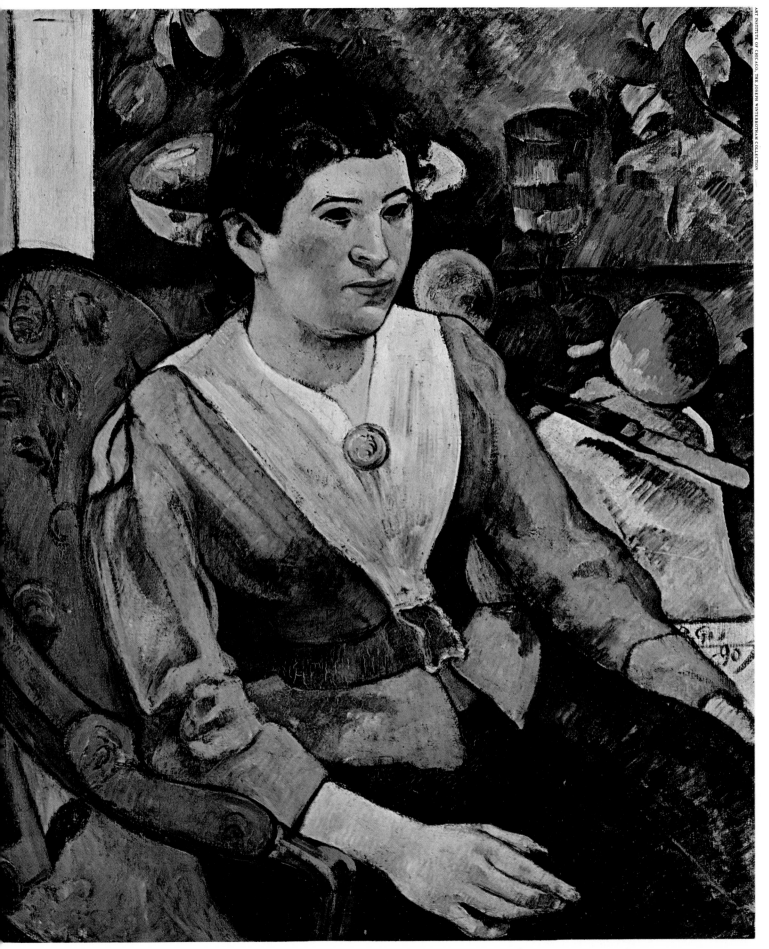

Paul Gauguin: *Marie Derrien*, 1890

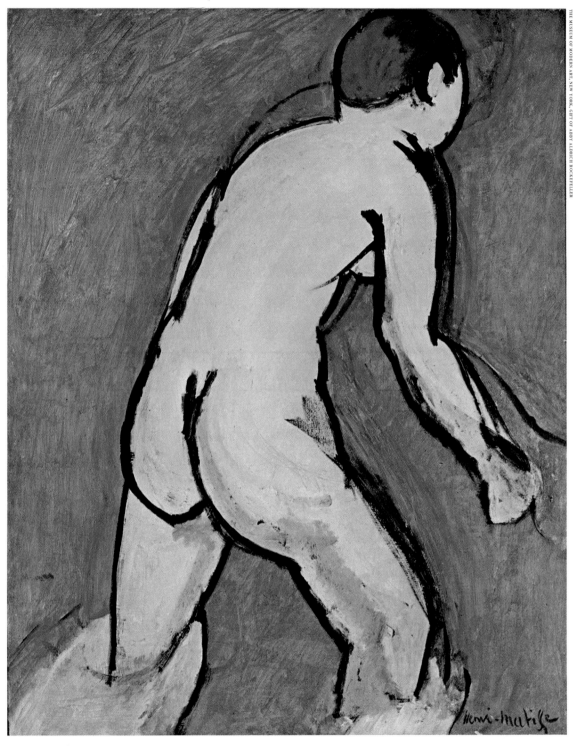

Henri Matisse: *Bather*, summer, 1909

Like jewelers cutting up a diamond, various schools of modern painting have taken separate facets of Cézanne's art as inspiration for their own work. Cézanne's lively use of color to balance a composition, for example, was seized upon by one group of painters whom the critics derisively named the Fauves—literally "wild beasts."

Fauvism made its public debut at the Salon d'Automne of 1905 (which also exhibited 10 Cézannes), and earned

Three Bathers, 1879-1882

August Macke: *People by the Blue Lake*, 1913

its name by its exaggeration of color techniques pioneered by Cézanne, Gauguin and Van Gogh. The movement adopted a violent, intensified palette and chose colors arbitrarily. In the painting above by a German, August Macke, the sky has darkened to deep ultramarine, tree trunks have changed from brown to burning red, and grass and foliage glow with neon hues of orange and yellow.

Henri Matisse, the unofficial leader of the Fauves,

claimed that Cézanne had made him realize "that tones are the force in a picture." As a young painter, Matisse became so enamored of a Cézanne *Bathers (opposite)* that he went into debt to buy it. Ten years later, after he had abandoned pure Fauvism, he used one of the figures as a model for his own *Bather* composition, transforming Cézanne's cool yellows and greens into pancake-flat planes of pure vivid pigment.

Georges Braque: *La Roche-Guyon, Le Château,* 1909

Pablo Picasso: *Bread and Compotier with Fruit on a Table*, 1908

Fernand Léger: *Woman Sewing*, 1909-1910

Cubism, the movement that soon eclipsed Fauvism, was also strongly inspired by Cézanne—specifically by his fascination with structure. The co-founders of the Cubist style, Georges Braque and Pablo Picasso, met in Paris in 1907, the year of the Cézanne memorial exhibition at the Salon d'Automne. Braque was a renegade Fauve who began painting almost monochromatic canvases that emphasized geometry rather than color. Like Cézanne, he rearranged nature and even distorted perspective to bring out the geometric qualities of trees and buildings in landscapes like the one at the left, which was executed in the same village where Cézanne had painted years earlier. Picasso used similar techniques to create carefully structured still lifes *(above left)*, and Fernand Léger, who joined the Cubists in 1910, simplified the forms of his subjects to such mechanical shapes that his seamstress *(above, right)* was dubbed "The Sewing Machine" by a later critic.

Robert Delaunay: *The Towers of Laon,* 1911

T here is only one painter in the world: myself," Cézanne once told his dealer Vollard. This extreme individualism was Cézanne's great lesson for those who followed him. It was a lesson taken to heart. Robert Delaunay early in his career painted the Cubistic scene above, resembling one painted by Cézanne *(page 149),* but later turned to purely abstract arrangements of color. The contemporary French abstractionist Jean Bazaine paints canvases, like the one at right, that show little

similarity to those by Cézanne. But Bazaine claims he is a disciple of Cézanne, inspired by the master's willingness to allow his instinct for what was right to push him on to new ways of painting. "The sincerity of an artist," Bazaine has written, "is without doubt in letting himself be led without knowing where. But it is also, apparently contradictorily, to test his limits, that is to say, those of his epoch. . . . Cézanne is the greatest, one who clashed unceasingly, unhappily, with what he believed to be his limits."

Jean Bazaine: *Roche-Taillé*, 1955

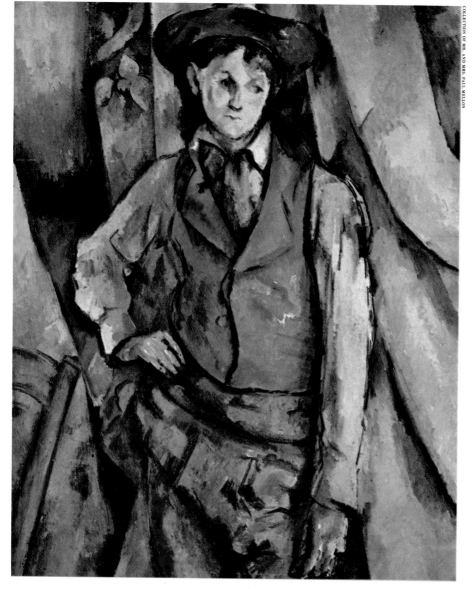

Boy in a Red Vest, 1890-1895

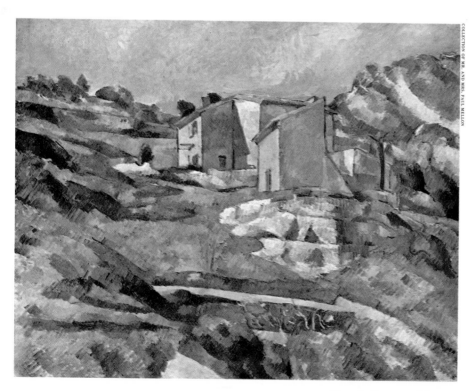

House in Provence, 1882-1885

A triumph in the market place

On the night of October 15, 1958, in the tapestry-walled main room of Sotheby's auction gallery in London *(opposite)*, the modern world paid special homage to Cézanne's genius. As newsreel cameras whirred and a modishly dressed crowd of 1,400 art lovers burst into applause, Cézanne's *Boy in a Red Vest (left, top)* was sold to an agent for the American financier-collector Paul Mellon for the astounding sum of $616,000. The unprecedented price, a new record for a modern painting, was more than had ever before been paid for any work sold at auction, and more than double the prices then fetched by paintings by Cézanne's contemporaries.

During his own lifetime, Cézanne might have starved if he had been forced to rely on painting for his income. The original price paid for the *Boy in a Red Vest*, around the turn of the century, has been estimated at only $350. Other Cézannes had been sold earlier for as little as nine dollars each.

Today, the cost of owning a Cézanne continues to soar. Paul Mellon broke his own record in 1965 by paying $800,000 for the landscape at the left. But no matter how high the market value of his works, no amount of money can ever measure the value of Cézanne's artistic contribution to the world.

Artists of Cézanne's Era

FRANCE
JEAN-AUGUSTE DOMINIQUE INGRES 1780-1867
EUGÈNE DELACROIX 1798-1863
HONORÉ DAUMIER 1808-1879
FRANÇOIS MILLET 1814-1875
GUSTAVE COURBET 1819-1877
CAMILLE PISSARRO 1830-1903
ÉDOUARD MANET 1832-1883
EDGAR DEGAS 1834-1917
PAUL CÉZANNE 1839-1906
ODILON REDON 1840-1916
AUGUSTE RODIN 1840-1917
CLAUDE MONET 1840-1926
PIERRE-AUGUSTE RENOIR 1841-1919
HENRI ROUSSEAU 1844-1910
PAUL GAUGUIN 1848-1903
GEORGES SEURAT 1859-1891
ARISTIDE MAILLOL 1861-1944
LUCIEN PISSARRO 1863-1944
HENRI DE TOULOUSE-LAUTREC 1864-1901
PIERRE BONNARD 1867-1947
ÉDOUARD VUILLARD 1868-1940
HENRI MATISSE 1869-1954
GEORGES ROUAULT 1871-1958
JACQUES VILLON 1875-1963
RAYMOND DUCHAMP-VILLON 1876-1918
MAURICE DE VLAMINCK 1876-1958
RAOUL DUFY 1877-1953
FRANCIS PICABIA 1879-1953
ANDRÉ DERAIN 1880-1954
FERNAND LÉGER 1881-1955
GEORGES BRAQUE 1882-1963
MAURICE UTRILLO 1883-1955
ROBERT DELAUNAY 1885-1941
JEAN ARP 1887-1966
MARCEL DUCHAMP 1887-1968

ITALY
CARLO CARRA 1881-1966
UMBERTO BOCCIONI 1882-1916
GINO SEVERINI 1883-1966
AMEDEO MODIGLIANI 1884-1920
GIORGIO DE CHIRICO 1888-1978
GIORGIO MORANDI 1890-1964

AUSTRIA
OSKAR KOKOSCHKA 1886-1980

GERMANY
LOVIS CORINTH 1858-1925
EMIL NOLDE 1867-1956
FRANZ MARC 1880-1916
ERNST LUDWIG KIRCHNER 1880-1938
MAX PECHSTEIN 1881-1955
MAX BECKMANN 1884-1950
KARL SCHMIDT-ROTTLUFF 1884-1976
AUGUST MACKE 1887-1914
KURT SCHWITTERS 1887-1948

SWITZERLAND
FERDINAND HODLER 1853-1918
THÉOPHILE STEINLEN 1859-1923
PAUL KLEE 1879-1940

HOLLAND
VINCENT VAN GOGH 1853-1890
PIET MONDRIAN 1872-1944

BELGIUM
JAMES ENSOR 1860-1949
PAUL DELVAUX 1897-

ENGLAND
J.M.W. TURNER 1775-1851
JOHN CONSTABLE 1776-1837
WILLIAM HOLMAN HUNT 1827-1910
DANTE GABRIEL ROSSETTI 1828-1882
EDWARD BURNE-JONES 1833-1898
WALTER SICKERT 1860-1942

SCANDINAVIA
EDVARD MUNCH (NORWAY) 1863-1944

SPAIN
PABLO PICASSO 1881-1973
JUAN GRIS 1887-1927
JOAN MIRÓ 1893-
SALVADOR DALI 1904-

EASTERN EUROPE AND RUSSIA
WASSILY KANDINSKY 1866-1944
FRANK KUPKA 1871-1957
CASIMIR MALEVICH 1878-1935
MARC CHAGALL 1887-
CHAIM SOUTINE 1894-1943

UNITED STATES
JAMES McNEILL WHISTLER 1834-1905
WINSLOW HOMER 1836-1910
THOMAS EAKINS 1844-1916
MARY CASSATT 1845-1926
ALBERT RYDER 1847-1917
JOHN SINGER SARGENT 1856-1925
CHILDE HASSAM 1859-1935
ROBERT HENRI 1865-1929
JOHN MARIN 1870-1953
LYONEL FEININGER 1871-1956
JOHN SLOAN 1871-1951
MARSDEN HARTLEY 1877-1943
HANS HOFMANN 1880-1966
MAX WEBER 1881-1961
GEORGE BELLOWS 1882-1925
EDWARD HOPPER 1882-1967
CHARLES DEMUTH 1883-1935
CHARLES SHEELER 1883-1965
MARK TOBEY 1890-1976

MEXICO
JOSÉ CLEMENTE OROZCO 1883-1949
DIEGO RIVERA 1886-1957
DAVID SIQUEIROS 1898-1974
RUFINO TAMAYO 1899-

1800 1855 1910 1965

Cézanne's predecessors, contemporaries and successors are grouped here in chronological order according to country.

Bibliography *Available in paperback

CÉZANNE-HIS LIFE AND WORK

Badt, Kurt, *The Art of Cézanne.* Translated by Sheila Ann Oglivie. University of California Press, 1965.

Barnes, Albert C. and Violette De Mazia, *The Art of Cézanne.* Harcourt, Brace & Co., 1939.

Beucken, Jean de, *Cézanne: A Pictorial Biography.* The Viking Press, Inc., 1962.

Chappuis, Adrien, *Les dessins de Paul Cézanne au Cabinet des Estampes du Musée des Beaux Arts de Bâle.* 2 Vols., Editions Urs Graf, Olten and Lausanne, 1962.

Dorival, Bernard, *Cézanne.* Translated by H.H.A. Thackthwaite. Continental Book Center, 1948.

*Fry, Roger, *Cézanne: A Study of His Development.* The Macmillan Company, 1927.

Huyghe, René, *Cézanne.* Translated by Kenneth Martin Leake. Oldbourne Press, London, 1961.

*Longstreet, Stephen (editor), *The Drawings of Cézanne.* Borden Publishing Co., 1964.

Loran, Erle, *Cézanne's Composition.* University of California Press, 1963.

Mack, Gerstle, *Paul Cézanne.* Alfred P. Knopf, 1936.

Neumeyer, Alfred, *Cézanne Drawings.* Thomas Yoseloff, London, 1958.

Novotny, Fritz, *Paul Cézanne.* Phaidon Press, Ltd., London, 1948.

*Perruchot, Henri, *Cézanne.* Translated by Humphrey Hare. Grosset & Dunlap, 1963.

Raynal, Maurice, *Cézanne.* Translated by James Emmons. Albert Skira, Geneva, 1954.

Rewald, John (editor), *Paul Cézanne: Correspondence.* B. Cassier, Oxford, 1946.
Paul Cézanne. Translated by Margaret Liebman. Simon & Schuster, Inc., 1948.

Schapiro, Meyer, *Cézanne.* Harry N. Abrams, Inc., 1962.

Schmidt, Georg, *Water-colours by Paul Cézanne.* Translated by Glyn T. Hughes. British Book Centre, 1953.

Taillander, Yvon, *Paul Cézanne.* Translated by Graham Snell. Crown Publishers, Inc., 1961.

Venturi, Lionello, *Cézanne, Son Art-Son Oeuvre,* 2 vols. Paul Rosenberg, Paris, 1936.

Vollard, Ambroise, *Paul Cézanne: His Life and Art.* Translated by Harold L. Van Doren. Nicholas L. Brown, 1923, Crown Publishers, Inc., 1937.

ART HISTORICAL BACKGROUND

Barr, Alfred H. Jr. (editor), *Masters of Modern Art.* The Museum of Modern Art, 1954.

Matisse, His Art and His Public. The Museum of Modern Art, 1951.

Canaday, John, *Mainstreams of Modern Art.* Holt, Rinehart and Winston, Inc., 1959.

Crespelle, Jean-Paul, *The Fauves.* Translated by Anita Brookner. New York Graphic Society, 1962.

Golding, John, *Cubism: A History and An Analysis, 1907-1914.* George Wittenborn, Inc. 1959.

*Haftmann, Werner, *Painting in the Twentieth Century,* 2 vols. Translated by Ralph Manheim. Lund Humphries, London, 1960.

Leymarie, Jean, *French Painting, The Nineteenth Century.* Translated by James Emmons. Albert Skira, Geneva, 1962.

Myers, Bernard S., *Modern Art in the Making.* McGraw-Hill Book Company, 1949.

Read, Herbert, *A Concise History of Modern Painting.* Frederick A. Praeger, Inc., 1959.

Rewald, John, *The History of Impressionism.* The Museum of Modern Art, 1961.
Camille Pissarro. Harry N. Abrams, Inc., 1963.
Post-Impressionism: From Van Gogh to Gauguin. The Museum of Modern Art, 1956.

Sloane, Joseph C., *French Painting Between the Past and the Present.* Princeton University Press, 1951.

Van Doren, Harold L., *France Erects a Monument to Cézanne.* The Arts, Vol. 5, June, 1924.

White, John, *The Birth and Rebirth of Pictorial Space.* Faber and Faber, Ltd., London, 1957.

Wilson, Angus, *Émile Zola.* William Morrow & Company, 1952.

CULTURAL AND HISTORICAL BACKGROUND

*Brogan, D. W. *The Development of Modern France, 1870-1939.* Harper Torchbooks, 1966.

Clough, Shepard Bancroft, *France: A History of National Economics, 1789-1939,* Charles Scribner's Sons, 1939.

Duby, Georges and Robert Mandrou, *A History of French Civilization.* Translated by James Blakely Atkinson. Random House, Inc., 1964.

Gooch, George Peabody, *The Second Empire.* Longmans, Green and Co., Ltd., London, 1960.

Josephson, Matthew, *Zola and His Time.* Garden City Publishing, Inc., 1928.

*Kedward, H. R., *The Dreyfus Affair.* Longmans, Green & Co., Ltd., London, 1965.

Shaw, M. B. and D. W. Pitt. *Your Guide to Provence.* Alvin Redman Ltd., London, 1966.

Acknowledgments

For their help in the production of this book the author and editors wish to thank the following people: Mme. Hélène Adhemar, Conservateur des Musées du Jeu de Paume et de l'Orangerie, Paris; Mrs. Alexander Albert; Jean Bazaine; Catherine Bélenger, Service des Relations Extérieures du Louvre; Elvira Bier, Phillips Collection; Dominique Paul-Boncourt; Olive Bragazzi; Jean-Pierre Cézanne; Philippe Cézanne; Adrien Chappuis, Aix les Bains; Mrs. Marshall Field III; Wendy Goodell, Boston Museum of Fine Arts; Mme. Guynet-Péchadre, Conservateur, Service Photographique, Musée du Louvre; James Humphrey III, Mrs. Elizabeth Usher, Patrick Coman, Harriet Cooper, Metropolitan Museum of Art; Erle Loran; Gerstle Mack; David McIntyre, Baltimore Museum of Art; Pearl Moëller, Richard Tooke, Museum of Modern Art; William Morrison, Susan H. Myers, National Gallery of Art; Charles C. Neighbors, Clark-Nelson Ltd.; Mr. and Mrs. John Rewald; David Saltonstall, Gordon Grant, Brooklyn Museum; Pierre Schneider.

Picture Credits

The sources for the illustrations in this book appear below. Credits for pictures from left to right are separated by semicolons, from top to bottom by dashes.

The works on pages 169, 180, 182 and 183 are published by arrangement with A.S.D.G.P., by French Reproduction Rights, Inc. The works on pages 65, 70(left), 166, 167, 174(top), 176, 178(top), and 181 are published by arrangement with S.P.A.D.E.M., by French Reproduction Rights, Inc.

SLIPCASE: Robert S. Crandall

END PAPERS:
Front: Collection Norton Simon, Los Angeles.
Back: The Courtauld Institute Galleries, London.

CHAPTER 1: 6—Courtesy Mr. and Mrs. John Rewald. 9—Photo Bulloz. 10—Courtesy Jean-Pierre Cézanne. 11—From *Paul Cézanne*, Gerstle Mack, Alfred A. Knopf, 1936, Plate 28—Courtesy Jean-Pierre Cézanne. 16—Cliché Musées Nationaux(2). 18—Courtesy Adrien Chappuis. 19—Lee Boltin—Courtesy Wadsworth Atheneum, Hartford. 21—Photo Bulloz. 22, 23—Courtesy Jean-Pierre Cézanne; Eddy van der Veen courtesy M. LeBlond-Émile Zola (3)—Daniel M. Madden. 24—The Art Institute of Chicago photo. 25—Yves Debraine—Walker Art Gallery, Liverpool photo. 26,27—Dmitri Kessel; From the Collection of Mrs. Enid A. Haupt, New York—The Metropolitan Museum of Art, Wolfe Fund, 1951; from The Museum of Modern Art, Lizzie P. Bliss Collection. 28—Sabine Weiss from Rapho Guillumette—Henry Ely, Aix-en-Provence. 29—Robert S. Crandall. 30,31—Scala; Larry Burrows.
CHAPTER 2: 32—Culver Pictures, Inc. 34—Collection Sirot, Paris. 35—The Bettmann Archive. 36—Courtesy Madame D. David-Weill—© February 1968 by The Barnes Foundation. 37—Musée de Montpellier—Cliché Musées Nationaux. 38—Fogg Art Museum photo. 41—André-Moulinier, courtesy Éditions Tisné—Galerie Brenheim-Jeune, Paris. 45—The Bettmann Archive. 46,47—Culver Pictures, Inc.(5). 48—Chevojon(4)—Culver Pictures, Inc. 49—New York Public Library photo from *La Tour Eiffel*, Jean A. Keim, Éditions "tel," Paris, 1950, Plate 9. 50,51—The Bettmann Archive; Bibliothèque Nationale, Paris—Eddy van der Veen courtesy M. LeBlond-Émile Zola (2). 52—Culver Pictures, Inc. (2). 53—Culver Pictures, Inc.; *L'Aurore*—Roger Viollet.
CHAPTER 3: 54—Courtesy Mr. and Mrs. John Rewald. 56—Brown Brothers. 58—The Bettmann Archive—Culver Pictures, Inc. 59—Roger Viollet—Courtesy Jean-Pierre Cézanne. 60—Kindler Verlag, GmbH, Munich. 61—Lee Boltin (2). 65—Lee Boltin. 66,67—Eric Schaal(2). 68—Courtesy Mr. and Mrs. John Rewald—Eric Schaal. 69—Archives Photographiques—N. R. Farbman. 70—Fogg Art Museum photo; Alan Clifton. 71—Eddy van der Veen.
CHAPTER 4: 72—Yves Debraine. 74—Maps by Rafael Palacios. 78—Photo by Erle Loran from *Cézanne's Composition*, University of California Press, 1963, pages 66,68. 79—© February 1968 by The Barnes Foundation. 80—Giraudon—Kupferstichkabinett der Öffentlichen Kunstsammlung, Basel. 83—Cliché Musées Nationaux. 85—Eric Schaal. 86,87—Eric Schaal; Henry B. Beville. 88,89—Solomon R. Guggenheim Museum photo(2)—The Art Institute of Chicago photo. 90,91—Robert S. Crandall.
CHAPTER 5: 92—Robert S. Crandall photo (painting in Collection The Museum of Modern Art, New York, given anonymously, the donor retaining life interest). 94—The Art Institute of Chicago photo(2). 99—Bibliothèque Nationale, Paris. 103—Boymans-van Beuningen, Rotterdam. 104—The Art Institute of Chicago photo. 105—Boston Museum of Fine Arts photo; Yves Debraine—Robert S. Crandall; The Art Institute of Chicago photo. 106—Scala; Derek Bayes—Eric Schaal; Heinz Zinram. 107—Henry B. Beville. 108—Frank Lerner. 109—Alan Clifton. 110,111—Robert S. Crandall; Courtauld Institute Galleries, London. 112—Photo © Museum of Modern Art, New York. 113—Eric Schaal—The Art Institute of Chicago photo. 114,115—Philadelphia Museum of Art photo by A. J. Wyatt.
CHAPTER 6: 116—Eric Schaal. 118—John R. Freeman courtesy Sir Kenneth Clark—Courtesy Jean-Pierre Cézanne. 119—From *Paul Cézanne*, Gerstle Mack, Alfred A. Knopf, 1936, Plate 15. 120—No Credit. 125—Cliché Éditions Robert Laffont, Paris. 129,130—Ken Kay. 131—Kupferstichkabinett der Öffentlichen Kunstsammlung, Basel—The Art Institute of Chicago photo. 132—Photo courtesy Borden Publishing Co., Los Angeles; Brooklyn Museum of Art photo. 133—Derek Bayes. 134—Philadelphia Museum of Art photo; Heinz Zinram—National Gallery of Art, Washington, D.C., photo; Metropolitan Museum of Art photo—Eric Schaal. 135—J. R. Eyerman; Eric Schaal—Eric Schaal (2)—Clark, Nelson Ltd. photo; National Gallery of Art, Washington, D.C., photo. 136,137—Eric Schaal. 138,139—Eric Schaal.
CHAPTER 7: 140—National Gallery of Art, Washington, D.C., photo. 144—Giraudon—Kupferstichkabinett der Öffentlichen Kunstsammlung, Basel. 146—Walter Drayer, Zurich. 147—John R. Freeman courtesy Sir Kenneth Clark—Photo © Museum of Modern Art. 149—Eddy van der Veen. 150—From the Collection of Mrs. Enid A. Haupt, New York—Cleveland Museum of Art photo. 151—National Gallery of Art, Washington, D.C., photo—Yves Debraine. 152, 153—Robert S. Crandall—The Burrell Collection, Glasgow Art Gallery and Museum; Courtauld Institute Galleries, London. 154—Robert S. Crandall. 155—Frank Lerner. 156,157—Yves Debraine. 158,159—Henry B. Beville.
CHAPTER 8: 160—Eric Schaal. 163—Frank Lerner. 166—Cliché Musées Nationaux. 167—Roger Viollet. 169—Yale University photo. 171—Miss Thérèse Bonney from Wide World. 173—Collection Sirot. 174—Charles Phillips—Kindler Verlag, GmbH, Munich. 175—Miss Thérèse Bonney. 176—Giraudon. 177—The Art Institute of Chicago photo. 178—Photo © Museum of Modern Art, New York—Eric Schaal. 179—Photo *Éditions Ides et Calendes*, Neuchâtel, Switzerland. 180—Heinz Zinram. 181—Pierre Boulat; Eric Schaal. 182—Eric Schaal. 183—Robert S. Crandall. 184—National Gallery of Art, Washington, D.C., photo—Clark, Nelson Ltd., photo. 185—Larry Burrows.

Index

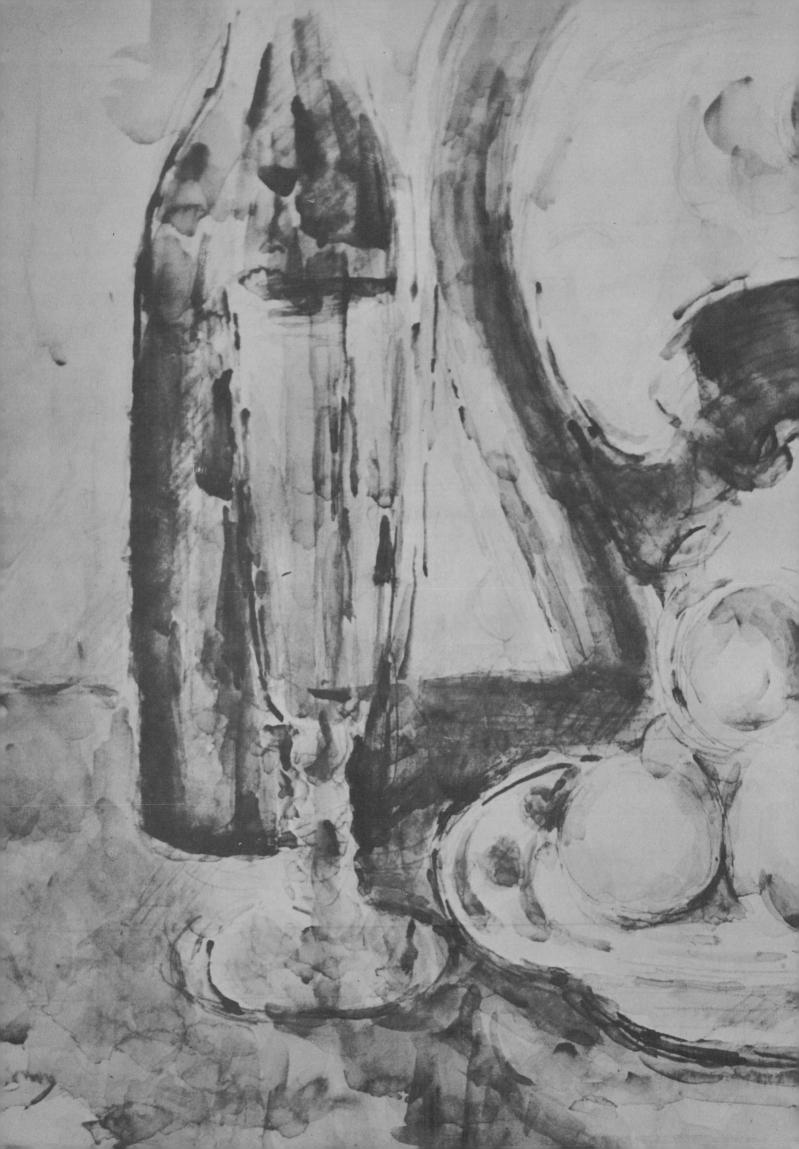